T0016701

A HISTORY
OF THE
20TH
CENTURY

A HISTORY OF THE 20TH CENTURY

CONFLICT, TECHNOLOGY AND REVOLUTION

JEREMY BLACK

PICTURE CREDITS

Bridgeman Images: 51, 94, 113, 205
Getty Images: 70, 86, 97, 117, 133, 155, 159, 178, 194, 199, 226, 229
Library of Congress: 54, 62
Shutterstock: 83
State Library of New South Wales: 42
Wikimedia Commons: 25, 30, 44, 89, 108, 124, 129, 164, 170, 211

This edition published in 2022 by Arcturus Publishing Limited
26/27 Bickels Yard, 151–153 Bermondsey Street,
London SE1 3HA

Copyright © Arcturus Holdings Limited

All rights reserved. No part of this publication may be reproduced, stored in a
retrieval system, or transmitted, in any form or by any means, electronic, mechanical,
photocopying, recording or otherwise, without prior written permission in
accordance with the provisions of the Copyright Act 1956 (as amended). Any
person or persons who do any unauthorised act in relation to this publication may be
liable to criminal prosecution and civil claims for damages.

AD008795UK

Printed in the UK

Contents

A Western View of the World – Imperialism – The Russo-Japanese War, 1904–5 – Revolution in China – The Alliance System and Great Power Politics – American Ambitions – State-building – Migration and Race – The World Economy, 1900–14 – New Technologies

The Great War – The World Economy at War – Women's Suffrage – The Russian Revolutions, 1917 – The Peace of Versailles – Spanish Flu – The League of Nations — Retrospectives

The Versailles Legacy – The United States – Warlord China – The Real Cold War – Turkish Transformation – The Islamic World – Indian Nationalism – Mussolini and Italian Fascism – Weimar Germany – Japan – The World Economy, 1920–29 – The Tools of Transmission

The Great Depression – The Rise of Hitler – Stalinism – China – Japanese Imperialism – The Western Empires under Pressure – Latin America – The Spanish Civil War – Cultural Icons – The World Economy, 1930–9 – Technological Advances

Beginnings – German Successes, 1939–41 – Britain Fights On – The Battle for North Africa – The Importance of Oil – The Eastern Front, 1941–3 – The War at Sea – America Joins the War – Japanese Advances – 1943: The Allies Fight Back –

CONTENTS

Introduction

More people were alive in the 20th century than in any previous age. And what a century they lived through, a period that, more than any other, has had the greatest impact on our lives today. The shock of the new has been particularly apparent in recent times. Indeed, most of the material culture of the present dates to that century, whether with aircraft or computers. The foundations of most modern states are in the 20th century, too, as are the origins of almost all political parties.

The 20th century, of all centuries in human history, was one of change and it is that change that will be the main focus of this book. That's not to say we will ignore the continuities. Religion, for example, long pre-dates the 20th century and remains a major factor in society today. The influence of religion in the 20th century will certainly be featured here. The same applies to another of the great continuities, namely the environment. For some, the 20th century was when humankind entered a new period in the history of the world, the Anthropocene, that saw irreversible forces such as global warming and climate change come to the fore; for others, these claims are over-stated or even incorrect. In either case, the 20th century saw environmental concerns come to the fore from the 1960s. They will play an important role in this story.

Another important continuity that changed gear in the 20th century was the linked phenomenon of unprecedented population growth and the increasing urbanization of the world. The maybe 1.6 billion people of 1900 became 2 billion in 1927, 2.55 billion in 1950, 3 billion in 1960, 4 billion in 1975, 5 billion in 1987, and 6 billion in 1999. This growth – and where in the world that growth took place – proved a major environmental burden and was, and continues to be, highly disruptive socially. The urbanization of humanity that accompanied population increase occurred to a degree never before seen in world history and was a change of fundamental social, economic, political and cultural significance. It happened everywhere, with 'mega-cities' developing, for example, in Istanbul, Kinshasa, Lagos,

Manila, Mumbai and Tokyo. Moreover, there was a larger expansion in the number of cities with a population of over 1 million. In part, this urbanization reflected the mechanization of agriculture and a relative lack of opportunities in rural life. This was an instance of the ability of technological diffusion to reframe the parameters of life. Urbanization was also accompanied by a decline in political and social deference. A number of factors contributed to this, including the increase in literacy that arose from the extension of compulsory education.

Large-scale population growth was accompanied by a major rise in living standards. Whereas in no previous century had the world GDP doubled, in the 20th century it did so more than four times over. The growth in GDP was distributed in a very unequal fashion, geographically and socially, but growth there was, and this growth sustained the whole range of human activity, individual, collective and governmental, from the eating of meat, to the building of churches and the pursuit of war.

There is also the 'When?' question. So much of the treatment of the 20th century focuses on the two world wars and the inter-war period; but they were all over by 1945. Instead, it is necessary to give due weight to the period since World War II ended that year, a time span that comprises more than half of the century, and more clearly looks toward the present situation. Moreover, it was in this period that much of the world became independent. As a result, there were more independent 'players' in the second half of the century and the narrative of history was no longer so preponderantly a tale of the successes and failures of empires.

Lastly, there is 'Where?'. The century was very much one of interaction across the world as a whole, such that the term globalization was increasingly used. Indeed, it is no accident that the century's major conflicts are referred to as world wars. Many other 20th century political developments, such as decolonization and the Cold War, were also global in their occurrence and, even more, impact. Migration, trade and currency movements became increasingly globalized in the 20th century, too. Other trends, such as democratization, were widespread if not quite global.

The most important country, as a trendsetter and cultural, economic, political and military model for much of the world, was the United States. It was also the most successful imperial nation, not so much by exerting territorial control over other states as Britain or France had, for example, but by the informal use of its considerable power and influence. This

only increased as the 20th century progressed, with the fall of the Soviet Union in the 1990s in particular leaving the United States as the key global power. As a consequence, we will devote particular attention to the United States and its impact on 20th century affairs.

These are different narratives, and there are more that can be offered. Yet, they interacted to help produce the exciting mélange of developments, at once transformative and contentious, that made up the history of the century.

1900

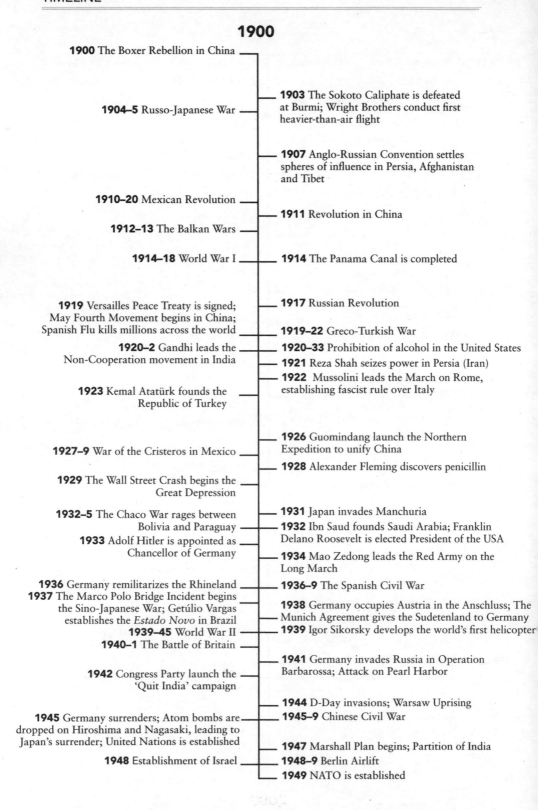

1900 The Boxer Rebellion in China

1903 The Sokoto Caliphate is defeated at Burmi; Wright Brothers conduct first heavier-than-air flight

1904–5 Russo-Japanese War

1907 Anglo-Russian Convention settles spheres of influence in Persia, Afghanistan and Tibet

1910–20 Mexican Revolution

1911 Revolution in China

1912–13 The Balkan Wars

1914–18 World War I

1914 The Panama Canal is completed

1919 Versailles Peace Treaty is signed; May Fourth Movement begins in China; Spanish Flu kills millions across the world

1917 Russian Revolution

1919–22 Greco-Turkish War

1920–2 Gandhi leads the Non-Cooperation movement in India

1920–33 Prohibition of alcohol in the United States

1921 Reza Shah seizes power in Persia (Iran)

1922 Mussolini leads the March on Rome, establishing fascist rule over Italy

1923 Kemal Atatürk founds the Republic of Turkey

1926 Guomindang launch the Northern Expedition to unify China

1927–9 War of the Cristeros in Mexico

1928 Alexander Fleming discovers penicillin

1929 The Wall Street Crash begins the Great Depression

1932–5 The Chaco War rages between Bolivia and Paraguay

1931 Japan invades Manchuria

1932 Ibn Saud founds Saudi Arabia; Franklin Delano Roosevelt is elected President of the USA

1933 Adolf Hitler is appointed as Chancellor of Germany

1934 Mao Zedong leads the Red Army on the Long March

1936 Germany remilitarizes the Rhineland

1936–9 The Spanish Civil War

1937 The Marco Polo Bridge Incident begins the Sino-Japanese War; Getúlio Vargas establishes the *Estado Novo* in Brazil

1938 Germany occupies Austria in the Anschluss; The Munich Agreement gives the Sudetenland to Germany

1939–45 World War II

1939 Igor Sikorsky develops the world's first helicopter

1940–1 The Battle of Britain

1941 Germany invades Russia in Operation Barbarossa; Attack on Pearl Harbor

1942 Congress Party launch the 'Quit India' campaign

1944 D-Day invasions; Warsaw Uprising

1945 Germany surrenders; Atom bombs are dropped on Hiroshima and Nagasaki, leading to Japan's surrender; United Nations is established

1945–9 Chinese Civil War

1947 Marshall Plan begins; Partition of India

1948 Establishment of Israel

1948–9 Berlin Airlift

1949 NATO is established

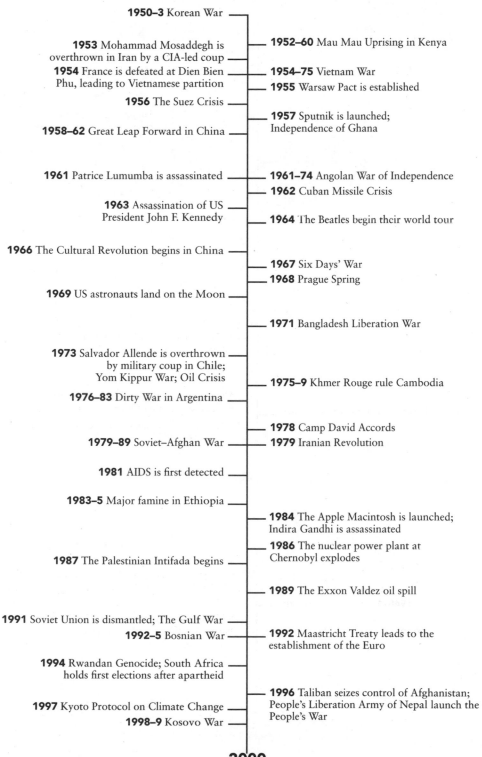

1950–3 Korean War

1952–60 Mau Mau Uprising in Kenya

1953 Mohammad Mosaddegh is overthrown in Iran by a CIA-led coup

1954 France is defeated at Dien Bien Phu, leading to Vietnamese partition

1954–75 Vietnam War

1955 Warsaw Pact is established

1956 The Suez Crisis

1957 Sputnik is launched; Independence of Ghana

1958–62 Great Leap Forward in China

1961 Patrice Lumumba is assassinated

1961–74 Angolan War of Independence

1962 Cuban Missile Crisis

1963 Assassination of US President John F. Kennedy

1964 The Beatles begin their world tour

1966 The Cultural Revolution begins in China

1967 Six Days' War

1968 Prague Spring

1969 US astronauts land on the Moon

1971 Bangladesh Liberation War

1973 Salvador Allende is overthrown by military coup in Chile; Yom Kippur War; Oil Crisis

1975–9 Khmer Rouge rule Cambodia

1976–83 Dirty War in Argentina

1978 Camp David Accords

1979–89 Soviet–Afghan War

1979 Iranian Revolution

1981 AIDS is first detected

1983–5 Major famine in Ethiopia

1984 The Apple Macintosh is launched; Indira Gandhi is assassinated

1986 The nuclear power plant at Chernobyl explodes

1987 The Palestinian Intifada begins

1989 The Exxon Valdez oil spill

1991 Soviet Union is dismantled; The Gulf War

1992–5 Bosnian War

1992 Maastricht Treaty leads to the establishment of the Euro

1994 Rwandan Genocide; South Africa holds first elections after apartheid

1996 Taliban seizes control of Afghanistan; People's Liberation Army of Nepal launch the People's War

1997 Kyoto Protocol on Climate Change

1998–9 Kosovo War

2000

CHAPTER 1

The Old Order, 1900–1914

It was far from obvious in 1900 that the century to come, let alone its first two decades, would bring an end to the old order, whether in China, Europe, Mexico or the Middle East. At the same time, as so often, there was a strong sense that the new century would bring both opportunities and problems. Perceptions, however, varied greatly depending on the state and the social, religious and political groups in question.

A WESTERN VIEW OF THE WORLD

In these first years of the new century, people examined the world in new ways and they changed greatly as the world became more globalized. Western ideas were increasingly dominant, and many in the West took their control for granted – to many, it seemed both normal and necessary. These mental assumptions were important in attitudes towards imperialism, for example, but should also be considered more generally when attempting to understand the history of the century.

In 1912, the American Congress finally agreed that the official prime meridian should not be the Naval Observatory in Washington, as decided in 1850, but instead should follow the British line that passed through Greenwich in London, as decided upon in the international 1884 Prime Meridian Conference. This became the zero meridian for timekeeping, and for the determination of longitude, and was a critical step in the development of international rather than national standards. But for 'international' read 'Western', which is why it was appropriate they be set by Britain, the West's – and the world's – leading and most far-flung empire. Such standards were of growing importance due to the development of more rapid land and sea transport, with their implications for timekeeping and mapping, and also of international telegraphic systems.

Mapping was also important to the delimitation of imperial claims and the exploitation of empire. For example, when determining the boundaries

between the British colony of Uganda and the Belgian colony of Congo, the British Colonial Office suggested to the Foreign Office in 1906 that the British frontier commissioners carry out a geodetic triangulation along a line east of the Greenwich Meridian as a matter of international importance.

Mackinder's Geopolitics: Determinism or Possibilism?

In his 1904 lecture 'The Geographical Pivot of History', the influential London School of Economics professor Halford Mackinder put the idea of a Eurasian 'heartland' as central to the developing subject of geopolitics. For Mackinder, rail links such as the Trans-Siberian Railway united the Eurasian heartland and helped it to exert its commercial and military strength. Russia and Germany, he said, were the key powers that would contest this heartland, which he saw as the 'pivot' of history. Other powers were seen as resisting expansion from the heartland, notably Britain, including its major imperial possession, India, and Britain's ally from 1902, Japan.

However, at the lecture, Leo Amery, a young British journalist and later politician, argued that air power, only recently taken forward by the Wright brothers, would transform the situation:

> a great deal of this geographical distribution must lose its im-
> portance, and the successful powers will be those who have
> the greatest industrial basis. It will not matter whether they
> are in the centre of a continent or on an island; those people
> who have the industrial power and the power of invention
> and of science will be able to defeat all others.

The tension between these views was to be important to the international power politics of the century.

Environmental determinism played a crucial role in early 20th century organic ideas of the country, nation and state, and in the treatment of the culture of particular peoples and countries as defined by the integration and interaction of nature and society. These ideas were associated in particular with a German, Friedrich Ratzel, and a Swede, Rufolf Kjellén, who invented the term geopolitics. In his *Die Erde und das Leben* (*The Earth and Life*, 1902), Ratzel, a keen advocate of German expansionism, focused on the struggle for space and deployed the concept of *Lebensraum*

(living space), an idea that was to influence German views on Eastern Europe in the 1920s and under Nazi rule (1933–45).

In response, in his *Tableau de la géographie de la France* (*Outine of the Geography of France*, 1903), Paul Vidal de la Blache argued that the environment created a context for human development, rather than determining that development. His work was taken forward by Lucien Febvre, another French scholar, who argued in favour of '*possibilisme*', as opposed to determinism. This debate over the nature of environmental determinism was significant for much of the disagreement over explanations of the importance of circumstances, and this very much remains the case today. The debate can relate to individuals and groups as well as states.

Looking at the World: The Van der Grinten Projection

Devised in 1898 by Alphons J. van der Grinten, patented in 1904 and serving from 1922 until 1988 as the basis for the reference maps of the world produced by America's National Geographic Society (NGS), a lodestar of cartographic standards, this map projection, which superimposes the entire earth into a circle, was a compromise that largely continued the familiar shapes of the standard Mercator world map from 1569 and carried over its exaggerated size of the temperate regions as opposed to tropical ones. In 1988, the latter was redressed to a degree with the adoption of the Robinson projection by the NGS. Originally devised in 1963, the Robinson projection was designed to reduce the area-scale distortions of previous maps. The underlying principles of both the van der Grinten and Robinson maps would in time be challenged by the Peters projection (see chapter seven).

IMPERIALISM

Before conquest by Western empires, local states and economies could be dynamic. For example, Kano, the metropolis of the Sokoto caliphate in what was to become northern Nigeria, had a population

that, by 1900, had grown to about 100,000, half of them slaves. It was a major centre of agriculture and industry, with leather goods and textiles manufactured and exported to much of the *sahel* belt south of the Sahara and to North Africa. This activity drew on slave labour, including, in a practice longstanding in Islamic societies, the army itself, which also produced more slaves through raiding. A similar pattern could be seen with other industrial cities in the *sahel*. Britain established a protectorate in northern Nigeria in 1900, and the continuation of slave raiding was in 1902 a pretext for Britain going to war with the Sokoto caliphate. At Burmi in 1903, the Sokoto caliphate was defeated and the caliph and his two sons were killed. Resistance to British rule in northern Nigeria came to an end, although the British took care to recognize Islamic interests there.

In the 1880s and 1890s, adding to their dominance of the oceans, much of the world's surface area had been conquered by Western European powers, and notably so in Africa. This process continued in 1900–13, especially with the French gaining control of much of Morocco by 1912, and the Italians taking over coastal Libya that same year, neither areas hitherto conquered by Europeans. Indeed, the Knights of St John had been driven from Tripoli in Libya in 1551 and the invading Portuguese had been spectacularly defeated in Morocco in 1578.

This imperial expansion happened elsewhere, as in 1904 when a British army entered Lhasa, the capital of Tibet, and, in 1911–12, when the Russians established a protectorate in Mongolia, replacing Chinese influence. Imperial power also spread around the Pacific. From their existing base in Java, the Dutch forcibly took control of what they called the Netherlands East Indies, now Indonesia. Meanwhile, the islands of the Pacific were allocated among the great powers, notably Britain, Germany, France and the increasingly assertive United States. They also named them, as with New Caledonia and the New Hebrides. In 1900, Tonga became a British protectorate.

In Europe and the United States, there was greater governmental, political and public interest in distant imperial enlargement than had been a case a century earlier. In part, this was a question of competition between Western states and of optimism about imperial expansion and racial roles, especially regarding the idea of innate national destinies expressed by some states. These concepts drew on lobbies and on intellectual trends,

such as ethnographical research employed at the service of racialized ideas of national hierarchies.

In part, interest in expansion was also a matter of economic pressures focused on both raw materials and markets, although frequently opportunities were a case of expectation rather than reality, as with British hopes of the consequences of constructing a railway from Cape Town to Cairo. Economic pressures became more intense as the range and volume of goods traded internationally grew. The international relations of mass production were necessarily concerned with both supplies and markets, and imperial expansion, preference and prohibition shut down supplies, markets and routes for other countries. This process, and fears about it, greatly encouraged the sense, and thereby reality, of imperial competition.

Conquering the Sahara

The French conquest of the Sahara and its surrounds demonstrated a capacity to operate deep into the African interior, as had not been the case even 60 years earlier. Rabih-az-Zubayr, the 'Black Sultan', who led resistance in Chad, was defeated and killed in 1900 at Kousséri to the south of Lake Chad after his room for manoeuvre had been limited by converging French forces from Algeria, Congo and Niger. This may appear only a footnote to history, but to Chad, which remained a French colony until 1960, it was transformative. Indeed, the degree to which much of Africa is scarcely, if at all, mentioned in major world histories is serious.

The submission of the Ahaggar Tuareg in 1905 ended effective resistance in the Sahara, but the further extension of French authority still involved military action. In 1909, Abéché, the capital of Wadai in eastern Chad, was occupied, as was Drijdjeli, the capital of Massalit, in 1910. In consolidating their positions in Sudan and East Africa, the British advanced deep into the interior of the continent.

Support for Empire

Ultimately, of course, the Western colonial empires disappeared, and this has led to a tendency to treat imperialism as something always destined to fail, and therefore as inherently weak and anachronistic. Linked to this is the practice of failing to acknowledge the local support on which empires could draw. Local assistance was crucial in military terms, in part because of the logistical, environmental and financial difficulties of

deploying large numbers of Western troops overseas – particularly when some of those troops were needed to deal with rivalries closer to home. As a consequence, there was a need to recruit forces locally in order to make and retain conquests, as with the British use of Indian soldiers in the Indian Ocean region as well as further afield, and France and Italy's use of Senegalese and Eritrean troops in West Africa and East Africa respectively.

These imperial relationships were not based entirely on force, either. In India, traditional local élites were co-opted into a shared rule of their localities, rajahs complementing the British Raj and the Brahmin *babus* who served it. This represented a continuation of longstanding responses to imperial control, which generally involved compliance as well as coercion. This same tactic was employed by Britain in Malaya and northern Nigeria. Co-option was also seen with mercantile networks. In the Persian Gulf and East Africa, the British benefited from such alliances with Indians.

The nature and terms of cooperation shifted as Westerners became the dominant partners, but they generally did so without overthrowing the existing practices and assumptions with which they were familiar.

The Idea of the Dominions

Sentinels of the British Empire (The British Lion and his Sturdy Cubs), the 1901 painting by England's William Strutt, was produced to coincide with the federation of the six Australian colonies to form the Commonwealth of Australia. It offers an idealized notion of the relationship between Britain and Australia, with the still vigorous lion surrounded by a large number of well-grown cubs. Active support for empire in the Boer War demonstrated this appeal. Developing separate identities coincided with a strong sense of Britishness, as in Australia.

Opposition to Empire

As a mirror-image of the rise of empire, there was increasing opposition to it. Those facing imperial expansion resisted, as with the Boers (Afrikaners: whites of Dutch descent), who, based in independent republics in the

Transvaal and the Orange Free State, fought British expansion in southern Africa in the Boer War of 1899–1902, and the Filipino nationalists who mounted a guerrilla war when the United States annexed the Philippines from defeated Spain in 1898. They were, however, both defeated as, in 1900, was the Boxer Movement which violently opposed Westernization in China. An uprising aimed against the humiliation and pressure of foreign imperialism, this anti-foreign movement began in 1897. The murder of Christian converts was followed by the siege of the foreign legations in Beijing and their eventually successful relief by an international force, the swords and lances of the Boxers providing no protection against firearms. Aside from the significance of Japanese and Western intervention, the Boxers were opposed by powerful provincial governors in the Yangtze area and in the south.

In 1904–5, the Nama and Herero of modern Namibia and the Maji of modern Tanzania, who all resisted German imperialism in Africa, were crushed with very heavy casualties. Revolts in Madagascar and Morocco against the French, and in Natal against the British, were suppressed in 1904, 1906 and 1907 respectively.

Yet these risings, and other opposition, which included the development of nationalist movements in French-controlled Algeria and British-run Egypt and India, revealed the growing range and scale of hostility to Western imperial control. There was an overlap, indeed, between resistance to the imposition of imperial control and, on the other hand, opposition once that control had been imposed; although there were also major differences between them.

Within Western colonies, such as India, and in composite empires, such as, in Europe, Austria-Hungary, movements for national consciousness and self-government underlined the extent to which great-power status was constantly changeable. National consciousness encouraged the pursuit and propagation of distinctive cultures and languages in would-be independent states such as Finland, Czechoslovakia and Ireland. Great-power status was being challenged, if not unmade, at the same time as it was consolidated – and understandably so, as perceptions were a key to power while the domestic as well as international alliances that contributed to power shifted in their character and goals. Overlapping both supporters and opponents within empires, there was the large tranche of the population that simply went about their business, a tranche that was generally the majority.

Imperial Surrogates

Alongside the conventional list of imperial powers, came powers that were imperial in attitude, but within or abutting their own territories. This was certainly true of Argentina, Brazil, Chile, Canada and Australia as they expanded control over indigenous peoples. Thus, Argentina and Chile expanded southwards toward the tip of South America, while Brazil increased its power in Amazonia. A similar process was seen with Abyssinia/Ethiopia under Menelik II. Having fought off Italian expansion in 1896 at the Battle of Adua, he greatly extended his territory toward what is now Somalia. Rama V of Siam (Thailand) imposed central control in border areas in the 1900s. Chinese control of Xiankiang, Mongolia and, to a degree, Tibet was also imperial in character, matching, indeed, the imperial expansion of Britain, Japan and Russia in Asia.

The Partition of Bengal

The Indian National Congress protested when George Curzon, viceroy of India, partitioned the province of Bengal into separate Hindu and Muslim sections in 1905. A boycott of British goods was organized, while extremists began a campaign of bombings and assassinations of British officials. Many Muslims, already hostile to the Hindu-dominated Congress, were sufficiently alarmed by the protests to form a separate All-India Muslim League (later the Muslim League) in 1906. The League lobbied to give Muslims their own separate voice in India's political affairs. To placate the nationalists, the British introduced the Morley-Minto Reforms in 1909. These reforms allowed Indians to elect representatives to provincial legislative assemblies. Bengal was reunited in 1911.

Imperial Economics and Africa

The end of the transatlantic slave trade had led to the development of plantation economies in parts of Atlantic Africa, especially the large Portuguese colony of Angola. This development reflected labour availability in Africa and a shift in the terms of Western trade, away from a willingness to pay for labour in the shape of slaves, and toward a

willingness to pay for it in the form of products, and thus of labour located in Africa. Imperialism drew on the exports of 'legitimate commerce' from the areas of Africa now seized as colonies by European powers, for example of cocoa from the British-ruled Gold Coast (Ghana).

Such a transformation was an aspect of the extent to which the globalization of the period integrated much of the world into a system of capital and trade, that reproduced cycles of dependence. Racism was part of the equation as it helped justify imperial rule and colonial control. Such racism was more central to the intellectual and cultural assumptions of the period than it is now comfortable to recall.

Rival Empires

A major drive in imperialism was competition between empires. In part, this competition was an extension of rivalries within Europe, as in Franco-Italian competition in North Africa, and tension between Germany and France over Morocco, notably in 1905. France thwarted Italy over Tunisia and Germany over Morocco. There were also longer-established rivalries outside Europe, as with that between Britain and Russia in Persia (Iran) and Afghanistan, or between Britain and the United States in the Caribbean and Central America.

These rivalries tended to be susceptible to negotiation, as with those between Britain and Russia, and Britain and the United States. Having yielded to American expansionism in the Pacific, notably in Hawaii, Britain in effect accepted American views, for example on the Canadian frontier and the Caribbean. Britain and France handled differences in South-East Asia and sub-Saharan Africa without violence. In 1906, Britain, France and Italy signed agreements dividing Ethiopia into spheres of influence and regulating its arms supply. An Anglo-Russian convention of 1907 settled hitherto competing issues in Persia, Afghanistan and Tibet. In 1911, Germany recognized French interests in Morocco, in return for territorial concessions in sub-Saharan Africa. However, rivalries in Africa, which led to a war-panic between Britain and France in 1898, contributed to a more general tension in international relations.

Staging Empire

'When we marched into the market square headed by Lord Roberts to raise the flag they took our photo by the cinematograph so I expect you will see it on some of the music halls in London.'

Jack Hunt, a British soldier, describing the entry of British troops into Pretoria, the capital of Transvaal, in 1900 during the Boer War understood that new technology meant that this success could be followed in London. Loyal songs were performed on music hall stages, as was patriotic orchestral music such as Sir Edward Elgar's *Pomp and Circumstance March No 1* and *Land of Hope and Glory* in more exalted surroundings. In Britain, and elsewhere, there was no uniform attitude to empire, but rather a range of engagements. However, empire was inherently seen as a patriotic mission.

THE RUSSO-JAPANESE WAR, 1904–05

Competing Russian and Japanese interest in the Far East interacted with domestic pressures, including the view in certain Russian political circles that victory would enhance the internal strength of the government, and a foolish unwillingness to accept Japanese strength, interests and determination – a view that prefigured Japanese assumptions about the United States in 1941. The Russian government did not seem to have been looking for war, but it failed to see that serious dialogue with Japan was necessary if war was to be avoided. Tsar Nicholas II and his advisors did not think the 'yellow devils' would dare to fight, and this arrogance did much to create ultimate unity in Tokyo in 1904 behind war. Japan did not accept the Russian occupation, as a result of the Boxer Rising, of the strategically important and economically valuable Chinese province of Manchuria. This occupation limited Japanese prospects for expansion, both commercial and political.

Two rapidly industrializing powers fought a war that neither was completely prepared for. Each did better than it might have been reasonable to anticipate, with Russia, demonstrating Mackinder's point about Eurasian links, able to sustain its forces across Siberia. Japan found

itself cripplingly short of manpower and saddled with an intolerable debt burden in London and New York. More seriously, it confronted the problem of translating battlefield success into victory in war.

Nevertheless, crushing the Russians at sea, notably at Tsushima off Korea in 1905, and heavily defeating them on land in Manchuria, Japan became the dominant regional power. This delivered a potent message about Western weakness, one that to a limited extent encouraged opposition to Western empire elsewhere, for example in India. Japan used the victory to consolidate its control of Korea and to increase its power in southern Manchuria. Agreements with Russia in 1907 and 1910 delimited spheres of influence in Manchuria and paved the way for the Japanese annexation of Korea in 1910. It became a harshly-administered colony. The war also left Japan clearly the principal foreign power as far as China was concerned, and that was to be important to their later relationship.

The United States mediated the peace settlement, thus underlining its concern with East Asia, which was another theme of the century. Allied with Japan in 1902, Britain viewed its rise as a way to offset Russian power. In Mackinder's geopolitical terms, this was part of the necessary containment of the Heartland by the Periphery. Germany was encouraged by Russia's defeat, as it was seen as weakening Russia's ally France.

The 1905 Revolution

Many people wished to topple the tsar's regime, but there was disagreement about what kind of government should take its place. Liberals favoured a Western-style parliamentary government; socialists wished to foment simultaneous revolutions by the peasants and the urban workers; Marxists – orthodox followers of the German philosopher Karl Marx – wished to promote revolution among the industrial working class.

Between 1899 and 1904, there were frequent workers' strikes and anti-government protests. In January 1905, government troops fired on striking workers in St Petersburg, igniting an uprising that quickly spread through Russia. The liberal leaders of the 1905 revolution demanded constitutional reforms, which Nicholas was forced to agree to, including the establishment of an elected assembly, the Duma. The Duma functioned intermittently between 1906 and 1914. Its more radical proposals were quashed by Nicholas, but working with prime minister Pyotr Stolypin (1862–1911), significant reforms were enacted, such as providing peasants with loans to buy land.

The revolution was ultimately crushed, and the end of the war with Japan was important to the stabilization of the situation in Russia. Yet, this also served as a warning that defeat in war would pose major problems for the ruling Romanov dynasty.

REVOLUTION IN CHINA

In contrast to the earlier Taiping and Boxer movements in China, the origins of the 1911 revolution were fundamentally military. Defeat by Japan in 1894–5 had led to a military modernization which gathered pace, after the failure of the Boxer Rebellion, in the reform programme adopted by the government in the 1900s. The modernizing, nationalist, military increasingly pressed for governmental change; as also happened in Turkey in 1908, and was a factor in Portugal, where the monarchy was overthrown in 1910, in Siam (Thailand), where a constitution was imposed in 1932, and in some Latin American countries.

Intellectuals, such as the historian and philosopher Liang Qichao, claimed that the Manchu had destroyed Chinese vitality. Military defeats by Japan and the failure of the Boxer Rebellion showed China's weakness and made it impossible to reconcile imperial legitimacy with radical change. The revolution against the Manchu emperor began on 10 October 1911 with a military uprising in Wuhan. With the news rapidly transmitted, and action coordinated, by telegraph the revolt spread across most of China. Sun Yat-sen, a revolutionary of old, became provisional president on 29 December, but his government had no military force. The fate of the Manchu dynasty was sealed when Yuan Shikai, a key commander, decided after some hesitation to back the revolt. Yuan became president on 10 March 1912 after the emperor, Puyi, abdicated on 12 February. Only six years old, he was not the figure to stop the revolution.

This was a major break in the continuity of Chinese history, one that was not to be reversed. Imperial rule had provided coherence, continuity and religious sanction. These were not readily replaced. The Confucian order was historically relativized, and thus ceased to be useful in the new era.

China, hitherto a poorly defined concept, was recast as a nation-state that had inherited the position of the Manchu dynasty and that was coterminous with it territorially. The Manchu dynasty was presented as non-Chinese by the new nationalist regime, its history effectively rewritten. The future, however, would prove harder to arrange than the past.

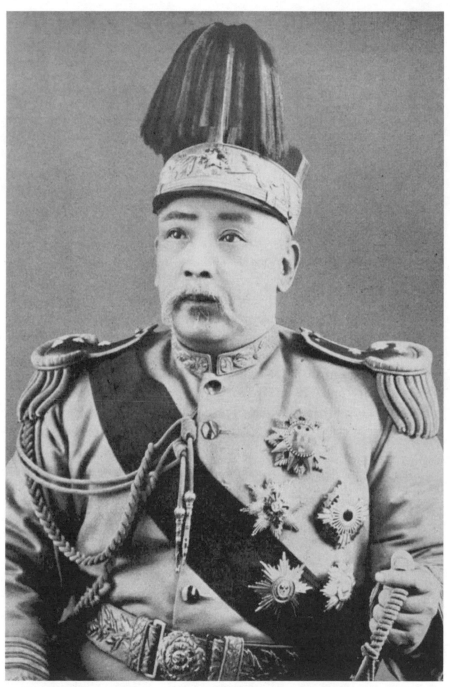

Yuan Shikai, 1859–1916. A general and minister who became the President of the Republic of China in 1912–15 and Emperor in 1915–16.

The Boxer Uprising

Battered by foreign encroachment and internal dissent, Qing rulers turned to the scholar official Li Hongzhang to introduce reforms. He attempted to transform China into a modern military and industrial state along Western lines, but his efforts were blocked by conservative forces close to the powerful dowager empress Cixi (reigned 1862–1908). The anti-Western attitudes of Cixi and her court in Beijing were shared by a growing number of Chinese. Nationalist and xenophobic sentiments lay behind the Boxer Uprising of 1900–1901. It was begun by the Yihetuan, a secret society known in the West as the Boxers, who wished to exclude all foreigners from China. They attacked Christian missionaries in the north-eastern provinces and foreigners in Beijing. Cixi supported the rebellion with imperial troops, which besieged foreign legations in Beijing. The rebellion ended only when an international force occupied the capital. Under the International Protocol (1901) the Qing was ordered to pay an huge indemnity payment and offer further trade concessions. Russia increased its influence in Manchuria, supplanted by Japan in 1905.

THE ALLIANCE SYSTEM AND GREAT POWER POLITICS

Specific international emergencies in the 1900s, notably the First Moroccan crisis of 1905–6 and the Bosnian crisis of 1908–9, encouraged brinkmanship and led to an accumulation of distrust between states. The Balkan Wars of 1912–13 made a broader war appear more likely at the same time as they led to the end of the Turkish empire in Europe, with the exception of a small territory around Constantinople (Istanbul). Serbia, Romania, Bulgaria, Greece and Montenegro all made gains in the first Balkan War in 1912–13, only to fall out in the second one later in 1913, in which Bulgaria was defeated.

Competition between the major powers became more acute as they were linked in alliance systems. Whereas these had exercised a measure of

deterrence, the situation became less benign when some policymakers were increasingly ready not just to consider military solutions to international issues, but to favour them as a way to bring about an appropriate outcome. As a result, the pacts between powers helped spread crises. In the case of World War I in 1914, the key links, those of Germany with Austro-Hungary (Austria hereafter), and of Russia with France, spread a Balkan crisis produced by the unexpected assassination by a Serbian-run terrorist group in Sarajevo of Franz Ferdinand, the heir to the Austrian empire, into a Europe-wide war. Germany, a militaristic state, proved unwilling to restrain Austria.

Germany's marked economic and population growth helped to underscore its substantial army and its aggressive stance; but the latter also reflected the militaristic attitudes of an anti-socialist regime, drawing on a landholding élite based in the east of Germany, notably Prussia, that felt itself under pressure from economic growth in the west and from the related domestic social change and its political consequences. By 1912, benefiting from an electoral system of full male suffrage, the left-wing Social Democrats were the largest party in the *Reichstag* and had won a third of the vote in national elections. In its opposition to them, the regime could draw on the illiberal, anti-socialist and anti-Semitic side of German society and culture, a situation that looked towards similar developments in the 1930s. The Marxist language of the Social Democrats energized widespread fears.

The Naval Race

Competitive emulation between navies was a focus of governmental and public attention. Anxious to win its 'Place in the Sun', already being pursued with colonial gains in Africa and the Pacific, Germany, under the Anglophobic Wilhelm II and Admiral Alfred von Tirpitz, wished to be able to compete with Britain at sea, a foolish goal. The German navy, the fourth-largest in the world by number of battleships in 1905 had become the second-largest by 1914, alongside the United States. In response to Germany's naval build-up, Britain was prepared to more than keep pace: between 1906–12, Britain launched 29 capital ships to Germany's 17. This arms race helped cement Britain's position in the anti-German camp, an outcome that otherwise would not have been inevitable. It also enhanced Britain's better relations with France and Russia, from 1904 and 1907 respectively, and was important to the development of the

international conflict in 1914 (although Germany's invasion of Belgium that year in order to attack France was more significant in leading Britain into World War I).

AMERICAN AMBITIONS

The dispatch of 16 battleships of the 'Great White Fleet' to show the American flag by sailing around the world in 1907–9 was significant as an affirmation of power, one made by a state that was already the leading industrial power in the world. Theodore Roosevelt had gone to Cuba as a volunteer fighter during America's conquest of this Spanish colony in 1898, and, as a dynamic president from 1901 to 1909, he was a strong supporter of a more assertive American stance, notably in the Americas, and of a naval build-up to back it up. By 1909, American battleships were being designed with larger coal bunkers to allow a steaming radius of 10,000 nautical miles. This was partly in response to concern about an apparent threat from Japan to America's new Pacific interests. Energetic and domineering, Roosevelt, who was committed to an American nativism born of a love of the environment, notably the West, personified a confident power keen and able to take its economic strength on to the world stage. He played the key role in the United States taking over the project for a Panama Canal. His 'big stick' policy was particularly apparent in intimidatory dealings with Latin American powers, and it was made clear to European powers that the USA would not tolerate their interference in the region, as they had tried to do with Venezuela in 1902 when the president of that country refused to pay debts owed to Britain, Germany and Italy.

The Panama Canal

Politics were not the only form and means of development. Completed in 1914, the 82 km-long (51 miles) Panama Canal was an instance of humans radically changing the world around them. Built in far more difficult circumstances than the earlier Suez Canal (opened in 1869), the canal had initially been attempted by a French consortium, starting in 1881, but it was defeated by yellow fever and mismanagement. The Americans, who took over the project in 1904, provided a more systematic, engineering- and public health-centred, solution, and one that drew on a stronger economy and a better understanding of the environment.

American support for the canal was linked to power politics. Panama's independence from Colombia in 1903 was facilitated by the United States as part of its practice of intimidatory intervention, and the new state ceded control over the Canal Zone to the United States.

The canal became a key project for American naval power, with some valuable economic side effects. The fleet of a potential enemy could be restricted to the Atlantic or the Pacific, while the American fleet could move between them through the canal and by means of protected bases. This was a response to the rise of Japanese power in the Pacific. By 1914, America was a major power in the Pacific, ruling Hawaii, Midway, Johnston, Palmyra, Tutula and Wake Island, Guam and the Philippines, and was becoming more interested in China and the Far East, and more concerned about Japan.

Banana Wars

The United States carried out a series of military interventions and occupations of countries in Central America and the Caribbean during the first few decades of the 20th century, known collectively as the Banana Wars. The wars were carried out in order to protect US commercial interests in the region, especially those of the United Fruit Company, which had stakes in the production of bananas, tobacco, sugar cane and other products. Between 1898 and 1934, the US mounted attacks in Panama, Honduras, Nicaragua, Mexico, Haiti and the Dominican Republic.

Latin America

By 1914, the region was producing 18 per cent of the world's cereals, 38 per cent of its sugar and 62 per cent of its coffee, cocoa and tea. Yet it remained in the shadow of American and British economic power, and largely produced raw materials for the developing global economy. Latin American states were divided by rivalry between conservatives and liberals. This rivalry frequently led to coups, such as that in Venezuela in 1908, and civil wars, for example in Venezuela (1898–1900), Colombia

(1899–1903), Uruguay (1904), Ecuador (1911–12) and Paraguay (1911–12). There were no significant international struggles, but, in 1906–7, civil wars were intertwined in such struggles in Central America, involving Guatemala, El Salvador, Honduras and Nicaragua.

The Mexican Revolution

The overlapping complexity of factionalism, coups and rebellions that was particularly apparent in Latin America was amply demonstrated in Mexico. Economic and social strains during modernization there created political pressures, not least because the benefits of growth and power were very unfairly spread under the progressive dictatorship of Porfirio Díaz (r. 1877–1911). Most farmers were landless, while much of the middle class was uneasy. Rivalry within the élite came to a head in 1910–11, as Francisco Madero, who pressed for economic and political liberalization, stood for the presidency, only to be jailed and to lose. In turn, Madero was elected president in the election of 1911, but could not control the disorder he had helped provoke. The fall of the Díaz system

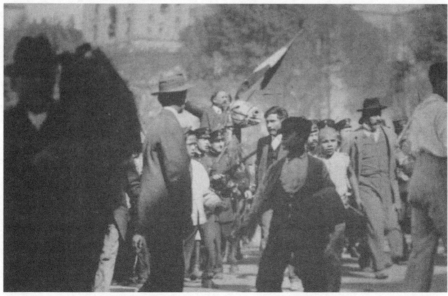

Entering Mexico City in triumph in June 1911, Francisco Madero represented an opportunity for moderate reform that suggested a middle path between revolution and reaction. President from November 1911, he faced rebellion in 1912 and was overthrown and killed in a coup in 1913 in the Ten Tragic Days: the photo is from the first day of that when he sought to rally support against the coup.

proved highly disruptive. This was true at the local as well as the national level: landless peasants took part in regional rebellions while, as in China with the warlords, military figures became regional powerbrokers and also intervened on the national level. In 1913, a military coup overthrew and killed Madero, leading to a sustained period of violence. There was a long-established practice in Mexico of seeking and contesting power by force, as well as tension between the central state and the regions. These tensions rose to a height in the 1910s.

The Mexican Revolution lacks the resonance and global significance of its later, Russian, counterpart, but, as with the revolution in China, it indicated the significance of change achieved through violence and the absence or weakness across much of the world of democratic practices and norms. Mexico remained unstable until the 1920s, with civil war an issue until the 1930s.

STATE-BUILDING

Nationalism was a key theme in the public understanding of past, present and future, with nations presented as having inherent characteristics. In Japan, state-sponsored Shinto developed as an amalgam of an existing religion with a new authoritarian form of government after the Meiji Restoration of 1868. Militarism and the new past played a role, with the foundation, in 1869, of the Yasukuni Shrine in Tokyo, a symbolic monument to nationalism where the war dead were commemorated. The Meiji slogan was *fukoku kyohei* (enrich the country, strengthen the army).

In Latin America, power rested with the descendants of Portuguese and Spanish conquerors, excluding those of Native or African (slave) descent. The long-term creolization of European societies in Latin America, as new racial and ethnic identities were created, was a process that was not well recognized in practice. The historical emphasis was on the struggle for independence in the early 19th century, but this underlined the division between secular liberals and pro-clerical conservatives. Nevertheless, education was used, as in Argentina, to try to integrate diverse peoples and help create an Argentine nation.

The Young Turks

The repressive measures of Sultan Abd al-Hamid II provoked opposition in many quarters. A coalition of nationalist anti-government groups, known collectively as the Young Turks, organized a coup in 1908, forcing the sultan

to restore the constitution and introduce parliamentary government. When the sultan's conservative supporters rebelled in 1909, Abd al-Hamid was deposed and banished. The Young Turks, under their leader Enver Pasha, took full control of the empire. The Young Turks introduced liberal reforms, but were unable to stem the haemorrhage of Ottoman power and territory. In 1911, Italy occupied Tripolitana, and in the Balkan Wars (1912–1913) the Ottomans lost all their Balkan lands except eastern Thrace. In 1914, Enver Pasha concluded a secret pact with Germany, believing it to be the only country capable of protecting Ottoman interests.

The Japanese Annexation of Korea

In 1894 Japan launched a surprise attack on Chinese forces in Korea. Japan's newly modernized armed forces defeated the Chinese in nine months. Under the subsequent Treaty of Shimonoseki (1895), China recognized Korean independence. The Russo-Japanese War of 1904–5 brought more Japanese troops into Korea and in the Treaty of Portsmouth (1905), Russia officially acknowledged Japanese influence in Korea and permitted its establishment as a protectorate. In 1910 Japan formally annexed the country. The new rulers sought to subsume Korean historical and cultural identity under a dominant Japanese past. Schools were forbidden from teaching the Korean language and vast numbers of texts and historical documents were burned. Much of the royal palace in Seoul, which had been built in 1395, was torn down. Some resisted Japanese rule. The 'Righteous Army' led an attempt to liberate Seoul with 10,000 troops in 1907, but was ultimately defeated and continued a low-lying guerrilla war for several years. It was only after the end of World War II that Korea regained its independence.

MIGRATION AND RACE

Unprecedented global population growth, the demand for labour in areas of opportunity and the transformation of communications through steamships and railways, helped spur large-scale migration. The biggest

sources of emigration were China, India and Europe, but the resulting patterns varied greatly. The Indians, who were subjects of the British Crown, moved largely to destinations in the British empire, notably South and East Africa (Kenya and Uganda), Fiji, Guyana and Trinidad; the Chinese to the other shores of the Pacific, especially California, Queensland (in Australia) and Peru; and the Europeans to the Americas and Australasia. Thus, for example, Italians went en masse to the United States and Argentina. Scandinavians, Irish and Poles also emigrated to America in large numbers.

These moves were very welcome in some destinations as they met labour needs. However, there was also concern about competition with existing workers, as well as racism which was directed in particular against non-European migrants. The White Australia movement reflected disquiet about Chinese immigration, and there were similar concerns in the United States. By the 1900s, anxiety about immigration was growing, and racial prejudice was taking a bigger role in society and politics. Thus, anti-Semitism became more prominent. In 1905, Britain passed the Aliens Act. In the United States, which took in nearly a million immigrants annually between 1901 and 1914, nativism was directed against immigrants, particularly from Mediterranean countries.

Anti-Semitism

Anti-Semitism became increasingly central to those unhappy with change. Jews were decried as cosmopolitan and plutocrats, at the same time that older prejudices circulated. Paranoia played a part, notably with *The Protocols of the Elders of Zion*, a document forged in Russia around 1902–3 that purported to reveal Jewish plans for world domination. Pogroms in Russia, notably in 1903–6, were the violent product of such attitudes, not least as the tsars were consolidating their power around a Russian nationalism. In Austria, anti-Semitism became much stronger, notably in response to the social and economic fluidity of a rapidly changing empire. Hostility to Jews was important in itself, as well as a way to express concern about the roles and demands of non-Germans within the Austro-Hungarian empire that appeared to threaten the state with dissolution.

African Americans

The position of black people (or African Americans or Negroes – terms varied during the century, as did their acceptability) was a particular scar on

American notions of opportunity and inclusion. Although no longer slaves, black populations were actively segregated, not just in the Southern states, but also at the national level, for example in the armed forces and sport. They were also subject to racist violence, notably in the form of lynching. In the South, there was a disproportionate number of black men in prison, and penal labour was widely used, notably for public construction.

The black people in the South were very much left as second-class citizens, vulnerable to economic and political exploitation. Exacerbated by the rise of *de jure* segregation in the South in the 1890s, this situation persisted until the 1950s and 1960s. The South became a poor agricultural society with oppressive labour relations, in part because the white élite wished to maintain such a society, with itself at the top, rather than to join the new industrial order whose urbanization and mechanization would threaten their superiority.

This decision, which accentuated regional divisions in America, contrasted with the willingness of much of the Brazilian and Russian élites to work with the end of slavery and serfdom respectively and to accept industrialization and, therefore, social mobility and urbanization. These approaches were unwelcome to Southern whites who were resentful of defeat by the industrial North in the American Civil War (1861–5). The Southern novelist William Faulkner observed in *Requiem for a Nun* (1951) 'The past is never dead. It's not even past.'

Booker T. Washington (1856–1915)

Booker T. Washington was born a slave in Virginia. He managed to educate himself and then made it his mission to help teach other African Americans. He became the head of the Tuskegee Institute in Alabama, where he established his position as one of the civil rights leaders of the day. He called for self-improvement and education as the route to obtain equality. While this approach brought him into conflict with contemporaries like W.E.B. Dubois, who couldn't countenance his meek acceptance of segregation, it did lead to meetings with President Taft and President Roosevelt, who sought out his counsel on racial issues.

The World Economy, 1900–1914

The spread of Western imperial power was matched by the effective Western dominance of heavy industry, and, especially by Britain, of the service structure of shipping, finance and telegraphy. This dominance ensured that the major imperial powers enjoyed economic influence, even control, including outside the formal span of their empires. Thus, much of Latin America was part of the American or British informal empires. Moreover, the most significant non-Western economic state, Japan, was itself an imperial power.

Heavy industry focused on the products of iron and steel, notably shipbuilding, heavy engineering and armaments manufacture as with the expanding Krupp factory at Essen in Germany's Ruhr region. Krupp produced the artillery for the German army. In 1912, Krupp also began to manufacture stainless steel. It had diversified, however, to an extent with the growth of different industries drawing on new technologies, notably the chemical industry in which Germany was particularly successful. New industries and activities included motor cars and the cinema. In 1903, the Wright brothers launched powered manned flight.

In much of the world, nevertheless, the pattern of economic activity was more traditional. Agriculture remained a key economic sector and one that employed many people, notably in Asia. At the same time, agriculture had been changed during the century, with an increasingly commercial approach fostered by the impact of large steamships with refrigerated holds and railways on the possibilities of moving bulk goods with ease. These means became even more significant in the 1900s and served to integrate important economic sectors. Thus, for example, Brazilian coffee was shipped to Europe and the United States, and Argentine beef and Australasian lamb and mutton to Britain. There was a measure of protectionism, but free trade was also significant. It underpinned Britain's dominant commercial

position. There was also a system of international production and trade underlying consumption. Thus, in the tea that British workers drank, the tea had been imported from India and Ceylon (Sri Lanka), the sugar they sweetened it with came from the West Indies, while the milk and teacups were home-produced.

It is unclear if this global integration of economies into a world economy was necessarily a good thing. For a start, it was a highly disruptive process, both environmentally and in human terms, a point that remained relevant throughout the century. Producing goods for distant markets, for example tea in India and Ceylon for Britain, could be accompanied by an arduous, even harsh, labour regime. The extent to which production, for example of tea in Ceylon and of rubber in Malaya, rested on crops, the cultivation of which had been introduced by the imperial systems, underlined the active roles of the imperial nations.

Another critical note can be struck by noting the extent to which the economy, at every level, was intertwined with efforts to profit from transactions and needs by a range of illegal and semi-legal practices. These alternatives to state control and to government-regulated capitalism reflected the extent to which these, together or in competition, did not meet the needs of many. Thus, smuggling, black market activity in production, transport and sales, pilfering, hawking goods and begging were all important. Moreover, they were not add-on features of society, but integral to it. Thus, the ability of the state to find support for its policies in poor neighbourhoods tended to be limited.

NEW TECHNOLOGIES

The range of new technology created expectations of revolutionary change, both in the technological sense, but more generally across life as a whole. This underlined the tension between those who looked to the past and saw it as the frame of reference for goals, expectations and practices, and those who argued that the inherent character of life was now one of

an inevitable move towards the future. Some viewed this with pessimism, but more with hope, notably the young and urban.

Airships

Balloons had serious deficiencies in terms of navigable free flight but, in the 1870s, engines and balloons were joined to create 'airships'. This was followed by enclosing the balloon within a metal frame, which made the airship more navigable. Gas-filled airships were developed by the German Count Ferdinand von Zeppelin who, in 1899, began experimenting with a cylindrical (rather than globular) container for the gas. In 1908, his LZ-4 airship flew over 386 km (240 miles) in 12 hours. This led to military interest, as well as to science fiction discussion, as in H.G. Wells' *War in the Air* (1908) and Edgar Rice Burroughs' *John Carter of Mars* (1912).

Aircraft

Earlier successes with airfoils and manned flight with full-sized gliders were thwarted by a lack of a suitable small power plant. However, the arrival of the internal combustion engine permitted heavier-than-air flight. The achievement of the American Wright brothers in 1903 was anticipated, for example by Clément Ader. However, it was the success of the bicycle-manufacturing Wright brothers that made controlled flight possible.

Moreover, the Wright brothers anticipated a market for military reconnaissance and in 1908 obtained a contract for a military aircraft, one able to fly 200 km (125 miles) at 64 km/h (40 miles per hour). Separately, in 1909, Wilbur Wright appears to have been the first pilot to take photographs, and Louis Blériot flew across the English Channel. Four-engine, long-range aircraft were developed from 1913, the year in which the first pilot flew across the Mediterranean. However, most of the aircraft in 1914 were little more than slow and underpowered flying boxes.

Physics

The world of classical physics was revolutionized in the early 20th century by a series of new insights. First, German physicist Max Planck showed in 1900 that energy was not released in a continuous stream, but in tiny, indivisible chunks, or quanta. Five years later, another German, Albert Einstein, published his Special Theory of Relativity, which proposed that

space and time are relative to the observer, contradicting Newton's laws. Einstein's discovery that matter is energy in a different form paved the way for nuclear power. In 1915, Einstein submitted his General Theory of Relativity, showing that gravity is not a force but a distortion in space–time created by the presence of mass. In the 1910s, Niels Bohr and Ernest Rutherford proposed theories of the atom, and in the 1920s Werner Heisenberg and Erwin Schrödinger developed quantum theory, using mathematics to explain the physics of the subatomic world. Heisenberg's uncertainty principle showed that the attributes of a subatomic particle can never be completely known. In the latter part of the 20th century, physicists attempted to unite quantum theory with Einstein's General Theory of Relativity to create a unified theory to explain all physical laws. Many hoped to find the answer by experimenting with powerful accelerators, which smash particles together at very high speeds to reveal more about their nature.

Vitamins

In 1901, British biochemist Frederick Gowland Hopkins discovered the existence of amino acids, organic molecules that are needed by the body but which the body cannot produce by itself. By experimenting on rats, Hopkins proved in 1906 that foods contained these amino acids. In 1912, Polish biochemist Casimir Funk named the substances vitamins, short for 'vital amines'. Researchers later identified a number of vitamins and the diseases linked to a deficiency in them. These included vitamins C (scurvy), B-1 (beriberi), D (rickets) and B-12 (pernicious anaemia). The discovery of vitamins led to greatly improved diet and nutrition and brought an end to deficiency diseases in the developed world.

Radio

In 1904, Edouard Estaunié coined the word telecommunications, 'tele' meaning distance. Originally developed for long-range communication to warships, and as a more flexible alternative to telegraphs, radio clearly had the potential to effect even greater changes. Addressing the Institute of Journalists in 1913, Robert Donald, a British newspaper editor, considered the future of radio news:

> *People may become too lazy to read, and news will be laid on to house or office, just as gas and water are now. The*

*occupiers will listen to an account of the news of the day,
read to them by much improved phonographs while sitting
in the garden.*

Changing Weaponry

Submarines and aircraft were among the more spectacular developments
that were to be important in the forthcoming world war, but other
changes in warfare were also already apparent. A letter signed 'Colonel'
entitled 'The Boer War - Attacks of Positions', published in *The Times* on
27 December 1899, noted:

*The modern method of fortifications, introduced with the
breech-loading rifle, is based upon the practical indestructi-
bility by modern artillery fire of properly designed earth-
works, and the improbability of an attacking force being able
to rush a properly prepared position defended by a sufficient
number of troops armed with the breech-loading rifle. This
improbability became impossibility, now that the magazine
rifle is substituted for the breech-loader, until the defences
shall have been seriously injured by artillery fire.*

In the Russo-Japanese War (1904–5), machine guns and barbed wire
played a major role. Such changes were to be readily apparent in the
world war that followed.

World War I, 1914–1918

A conflict of unprecedented scale and range, World War I was a traumatic military struggle that transformed the countries involved and the world as a whole. The war had major political, social, economic and cultural consequences for all the leading participants. Russia changed dramatically through the Bolshevik revolution, while a deadly new disease swept across the world just as the war was coming to an end.

THE GREAT WAR

The occasion of the war was the assassination of Franz Ferdinand, the heir to the Austro-Hungarian empire, by Serbian terrorists in Sarajevo, the capital of Bosnia. While Austria was understandably outraged by the attack, it also gave the country the useful pretext it needed to provoke what it thought would be a small conflict in the Balkans to check Serbia's growing influence in the region. The Austrians presented Serbia with a list of ten extremely harsh demands to resolve the crisis that they knew would be rejected, enabling them to declare war. What Austria did not know was that Serbia's ally Russia had promised to support it in any conflict, come what may. And what Russia did not know was that Germany had made exactly the same promise to its ally, Austria.

When Austria declared war on Serbia on 28 July 1914 it brought into play a complicated system of alliances. Germany, discovering it was now obliged to go to war with Russia, made a strategic decision to first launch a surprise attack on that country's other ally, France, to avoid having to engage in battles on two fronts. In 1905 Germany had developed a strategy for precisely this purpose. It was called the Schlieffen Plan and it meant that to take Paris Germany first had to invade Belgium.

Timeline of World War I

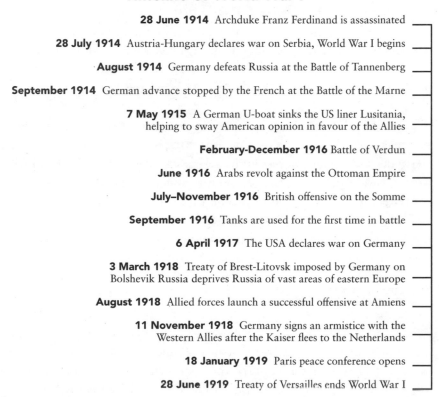

28 June 1914 Archduke Franz Ferdinand is assassinated

28 July 1914 Austria-Hungary declares war on Serbia, World War I begins

August 1914 Germany defeats Russia at the Battle of Tannenberg

September 1914 German advance stopped by the French at the Battle of the Marne

7 May 1915 A German U-boat sinks the US liner Lusitania, helping to sway American opinion in favour of the Allies

February-December 1916 Battle of Verdun

June 1916 Arabs revolt against the Ottoman Empire

July–November 1916 British offensive on the Somme

September 1916 Tanks are used for the first time in battle

6 April 1917 The USA declares war on Germany

3 March 1918 Treaty of Brest-Litovsk imposed by Germany on Bolshevik Russia deprives Russia of vast areas of eastern Europe

August 1918 Allied forces launch a successful offensive at Amiens

11 November 1918 Germany signs an armistice with the Western Allies after the Kaiser flees to the Netherlands

18 January 1919 Paris peace conference opens

28 June 1919 Treaty of Versailles ends World War I

The Western Front

The German invasion of Belgium in 1914 brought Britain into the war. This may not have unduly worried Germany. Britain at that time was largely a naval power and had not fought another major power on the European mainland since the Crimean War with Russia in 1854–6. But Germany's hopes of delivering a quick knockout blow to France was thwarted by a successful Allied counterattack in the Battle of the Marne in September 1914. This was followed by the failure by both sides to outflank each other in the 'Race to the Sea', resulting in a stalemate as the Allies and the Germans became bogged down along a front that embraced eastern France and a portion of Belgium. To protect the troops from the deadly ravages of rapid-fire artillery, both sides dug in. This was the beginning of what became known as trench warfare.

41

What followed was a true war of attrition. Unsuccessful British and French attacks in 1915 were followed in 1916 by a large-scale German attack on the French at Verdun and a British offensive on the Somme, all with much loss of life. Although these Allied assaults did not result in major breakthroughs they did have a strategic purpose, notably to take pressure off allies fighting on other fronts, particularly France and Russia in 1916.

In 1917, the British and French, in separate offensives, again failed to break Germany's lines, yet again taking very heavy casualties. The Germans had greater success in the spring and early summer of 1918, but were eventually stopped and left with a vulnerable front line.

Later that year, the Allies broke through. They benefited from the availability of American troops and the use of tanks and aircraft, but the key element was successful infantry-artillery coordination by the British and French. Outfought and driven back, and with their alliance

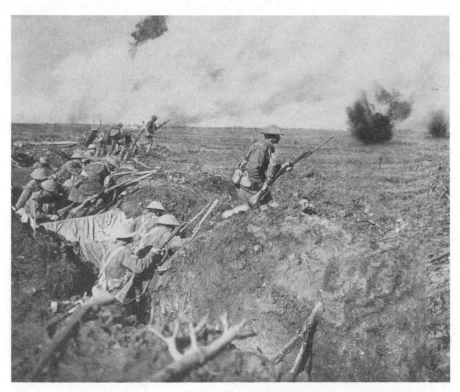

Crossing the killing ground for World War I soldiers was particularly difficult due to the strength of the defences and the lethality of rapid-firing weapons.

system in collapse, the Germans asked for, and were granted, terms. The fighting on the Western Front ended more or less in the same area in which it had started.

The Eastern Front

Although able, from 1914, to make major gains at the expense of the lacklustre Austrians, the Russians were repeatedly unsuccessful at the hands of Germany. Having crushed a poorly coordinated Russian invasion of East Prussia in 1914, at the battles of Tannenberg and the Masurian Lakes, the Germans conquered Russian Poland in 1915, and, in 1917, the strains of war led to two revolutions in Russia. Fresh German gains forced Russia's new Communist government to accept terms in 1918 with the Treaty of Brest-Litovsk. The war on the Eastern Front destabilized both the Russian and the Austro-Hungarian empires, and did not bring Germany the gains anticipated.

War in the Balkans

Austrian attacks on Serbia in 1914 failed, but, with Bulgaria's entry into the war on the side of Austro-Hungary and Germany in 1915, Serbia, attacked from several directions, was swiftly conquered. This was an instance of an ability to deliver decisive military verdicts that contrasted with the situation on the Western Front that is generally used to define the war as a whole.

The war broadened out, as Anglo-French amphibious forces failed to knock out another new opponent, Turkey, in the Gallipoli campaign in 1915, and similarly failed against Bulgaria in the Thessalonica campaign of 1915. Romania joined the side of Britain, France and Russia in 1916, only to be largely conquered by a successful Austro-Hungarian and German invasion. The Balkans remained a secondary campaign zone until the closing stage of the war, when Bulgaria was knocked out by Allied forces advancing from Thessalonica, leading to the unravelling of the Central Powers' alliance system.

Italian Offensives

Entering the war in 1915, Italy sought gains from Austro-Hungary which were presented as the last stages of the Italian unification process begun in the mid-19th century. Britain and France were willing to promise these gains by the Treaty of London in 1915. However, successive Italian attacks

on the Austrians, notably on the Isonzo River, brought only very heavy losses with only a scant gain of territory that was swiftly swept away by the surprise Caporetto counter-offensive of 1917. Avoiding the fate of Russia in 1917, the Italians eventually rallied, with the assistance of their allies, and in 1918 drove back the Austrians. However, the war did much damage to Italy's self-confidence and was a major burden on its society.

Empires at War

The conflict between the European powers encompassed their empires. Large numbers of non-Europeans served in Europe, especially Africans in the French army and Canadians in that of Britain. This contribution was even more significant outside Europe, where combatants attacked the colonies and territories of opponents. Australian, Indian and New Zealand troops played a key role on behalf of Britain as the German overseas and Turkish empires were conquered. Both processes, however, took longer than anticipated, with German forces fighting in Tanzania until the end of the war. Palestine (Israel), Syria and Mesopotamia (Iraq), were only gained from the Turks after difficult campaigns, and there were significant British defeats on the way.

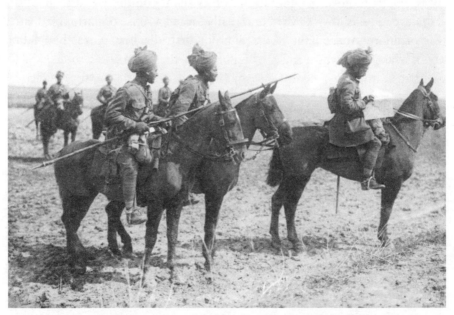

Indian cavalry. The scouts of Hodson's Horse regiment near Vraignes, France in April 1917, shows the range of imperial military deployments.

The war both took forward imperial cooperation, and yet tested it as never before. This was particularly so when conscription was introduced. In the British empire, it proved contentious in Australia, Canada and Ireland. In other colonies, the war also proved burdensome. There was violent opposition to conscription in Russian Central Asia in 1916, but it was crushed.

The war also saw the attempted consolidation of empire in the face of concerns about its stability. Faced by the Turkish contacts of Ali Dinar, the Sultan of Darfur in what became western Sudan, the British conquered the sultanate in 1916. In West Africa, in the Volta-Bani War in 1915–16, the French responded to opposition by deploying 5,000 men, mostly West African troops, and by employing anti-societal warfare, including the slaughter of men, women and children, poisoning wells and killing animals in order to destroy the environment among which their opponents operated. About 30,000 of the local population were killed in suppressing the rising.

Australia and New Zealand

The constitutional development of Australia into a single nation began with the federation of the six colonies as a commonwealth in 1901. However, it was World War I that really forged a sense of national identity for ordinary Australians. At Gallipoli, Australia lost more than 8,000 men. The battle was a military failure, but the heroism of the ANZACs (Australia and New Zealand Army Corps) passed into Australian legend.

America Enters the War, 1917

As part of a key process of industrialization and of economic mobilization for war, and reflecting Britain's ability to dominate the naval situation, American financial, industrial and agricultural resources were very important to the Allies prior to American entry. Unrestricted German submarine warfare, against which the United States had specifically warned, led the Americans into the war in 1917. Their force on the Western Front played a role in the German defeat in 1918, and the prospect of many more American troops arriving was crucial in signalling a sense of shifting advantage towards the Allies. Moreover, American naval support helped consolidate Britain's dominance at sea. However, the real American military and industrial achievement was post-1941 and not post-1917. Compared to World War II, shipbuilding was still

modest, while in terms of tanks and aircraft the USA was dependent on Britain and France. The financial strain was also acute: America's national debt went from $1 billion to $27 billion, and, by November 1918, 70 cents in the dollar of state spending was borrowed. Although the Americans purchased the Danish West Indian Isles – St Croix, St John and St Thomas – in 1917, a precedent for later interest in buying Greenland, they made no attempt to gain territories as a result of the war, as they might have sought to do from the German overseas empire in Africa and the Pacific.

The War at Sea

The inability of surface combat to deliver a decisive blow, notably at the Battle of Jutland in 1916 in the North Sea, the greatest of all battleship clashes, helped ensure that Germany turned to submarine warfare in an attempt to blockade Britain, a country reliant on food imports, into submission. The introduction of unrestricted submarine warfare by Germany, however, brought the United States into the war in 1917. Moreover, although much tonnage was sunk, the use of convoys ultimately thwarted the submarines which did not have the anticipated strategic impact. The Allies' dominance of the oceans was a crucial strategic aspect of the war. It enabled them to move supplies and troops, and to blockade Germany. This dominance was a geopolitical element that Mackinder had underplayed.

The War in the Air

The novelty of the war was most apparent in the air. Aircraft had first been used in conflict after the Italians invaded Libya in 1911. Large-scale military use of airships and aircraft began in 1914. There was a rapid development in the specifications of aircraft, whereas gas-filled airships, used in particular by the Germans to bomb Britain, proved too vulnerable to interception. Aircraft were principally employed for reconnaissance purposes and notably to map trench systems for opposing forces. This was a crucial prelude to accurate artillery fire. As a result, fighters were deployed to drive away reconnaissance aircraft, and then to compete with other fighters. Bombing developed, and the Germans launched a major campaign against London in 1917, but, as yet, payloads, accuracy and range were limited. The conditions for air crew were primitive and hazardous. There were no parachutes.

The Home Front

The war tested the strength and stability of economies and societies. Thus, important limitations remained in the German economy, including an agricultural sector much of which was characterized by a low-efficiency peasantry, and industrial activity that often did not match the characteristics of the leading German companies. The importance of domestic stability and industrial production, notably of munitions, particularly shells for the artillery, encouraged a scrutiny of the situation within the major states. This became more significant both as the war continued, creating unprecedented burdens, and because of increasing signs of dissidence and of the willingness of opponents to exploit it. Thus, the Allies sought to encourage nationalist opposition to the Austro-Hungarian empire, especially in what became Czechoslovakia, while the Germans did the same within the British empire. Indeed, they encouraged the Turks to declare a jihad that was designed to ensure Muslim opposition to Britain, France and Russia, only to find that its impact was limited. Occupied areas could be harshly treated. Thus, Germany conscripted Belgian civilians for forced labour in the Ruhr. Nevertheless, World War II was to show the Germans in a far harsher light.

Public Opinion and Propaganda

A concern about the Home Front led states to turn to established and developing forms of propaganda. Alongside the print media came the use of cinema. Propaganda was often directed at the iniquities of opponents, such as German atrocities against civilians in Belgium, and German submarine warfare against passenger liners. There were also exhortations to morale and more specific campaigns, for example on behalf of the purchase of war loans. Such propaganda became more significant as the war became longer.

The Easter Rising, 1916

The small scale of violent Irish opposition to Britain ensured that the rising in Dublin in 1916 by 1,200 men was swiftly crushed. In comparison, far more Irishmen fought as volunteers in the British army. However,

the attempt to extend conscription to Ireland in 1918 fuelled nationalist support, as did war-weariness. The Easter Rising was to play a misleading, but important, role in the foundation account/myth of the Irish state. This was an aspect of the more general process by which World War I was important, for good and ill, to the foundation accounts of many states. Thus, Britain's Balfour Declaration of 1917 about Jewish settlement in Palestine was to be cited in the case of Israel, although the contradictory nature of British undertakings helped exacerbate what became serious differences over the issue.

Atrocities

Although not on the scale of those in the following world war, there could be appalling treatment of civilians, not least with the German slaughter of Belgians in 1914 and the German use of unrestricted submarine warfare. The group worst treated was Turkey's Armenian population in 1915. Concerns about Armenians comprising a possible fifth column within Turkey, and of the identification of Armenians as being the same as Russian invaders, led to large-scale slaughter, including the driving of many into arid, desert regions where they died. Turkish racism and a hatred of Christianity in part fuelled this activity. About 1.5 million were killed or died and their property was seized. Leslie Davis, the American Consul in Erzurum, reported: 'The Turks have already chosen the most pretty from among the children and young girls. They will serve as slaves, if they do not serve ends that are more vile.'

Consequences

The war was a considerable force for social change. Traditional assumptions were questioned, and social practices were affected by higher inflation, greater taxation, rationing, the absence of men at the front line, and the spread of both female employment and trade unionism. The political and economic privileges and situation of established élites and middle classes were qualified and challenged, and the stability of entire countries threatened or lost.

The World Economy at War

The war put enormous pressure on the economies of the participants, both on their productive capacities and on their resources, for example leading to the destruction of much merchant shipping. Already powerful, the United States was the prime beneficiary of the war. The European powers, especially Britain, sold many of their foreign investments in order to finance the war effort, and this increased American control of its domestic economy. British economic interests in Latin America were also in large part sold to the Americans. The British were left with a heavy war debt which they eventually paid off.

The disruption of European trade, and the diversion of European manufacturing to war production, encouraged the growth of manufacturing elsewhere, and the United States benefited most of all. The British war effort rapidly became heavily dependent on American financial and industrial resources. Japan was another major economic beneficiary of the war, not least with a significant expansion of its shipping. Within the British empire, there was a transfer of a degree of economic independence to the Dominions and colonies, including India.

WOMEN'S SUFFRAGE

Women's major wartime contribution to the war economy, notably in factory work, helped lead to an extension of the franchise in Britain in 1918, although the position was not equalized with that of men until 1928, and it has been argued that in Britain women got the vote in order to counter the potential radicalism of the extension of voting to all working-class men. Women also gained the vote in Canada (1917), Germany (1918), Austria (1919), the Netherlands (1919) and the United States (1920). It was seen as a modern outcome. Many countries, however, moved more slowly, notably Catholic ones. France, for example, did not extend the vote until 1945; Argentina in 1947.

Emmeline Pankhurst (1858–1928)

As the founder of the Women's Social and Political Union (WSPU) in 1903, Emmeline Pankhurst is known for her efforts in securing voting rights for women.

Encouraged by her lawyer husband, Richard, in 1889 she campaigned for women's suffrage through the Women's Franchise League, establishing her own WSPU, with the slogan 'Deeds, not Words' in 1903. The Daily Mail dubbed its members 'suffragettes'. The WSPU's combative stance, which escalated from peaceful rallies to vandalism and arson, led to Pankhurst's arrest on many occasions. When she was handed a nine-month sentence in 1912 and a three-year sentence for a separate offence the following year, she responded like many of her colleagues by embarking on prison hunger strikes, securing her early release on both occasions.

The outbreak of World War I signalled the end of the WSPU's militant tactics as Pankhurst encouraged women to help with the war effort. In recognition of women's war work, the government passed the Representation of the People Act in 1918, which granted women limited voting rights. Emmeline Pankhurst died on 14 June 1928, just two weeks before Parliament granted women full suffrage on a par with men.

THE RUSSIAN REVOLUTIONS, 1917

The overthrow of the Romanov dynasty in the February Revolution led to the attempt both to create a Western-style democracy and to continue the onerous war with Germany. The burdens and failure of the latter helped undermine the former, and, in October, a Communist coup under Vladimir Lenin led to a radical government that brought the war to a close in 1918 and, in turn, bloodily established its power and programme in a civil war that largely ended in 1921. This was a struggle that was greater in scale, and led to more casualties in Russia, than World War I. The Communists were opposed by the conservative and royalist Whites, the Greens (Russia's peasant armies), by separatist non-Russians such as

Latvians and Ukrainians living under imperial control, and by foreign forces, notably British, French, Japanese and American.

The brutal tenacity of the Communists was a key element in their victory. They nationalized businesses, seized grain and imposed a firm dictatorship, while opposition was violently suppressed, including opposition on the Left. The Communist mindset was very much one of continual and unconstrained struggle. The Communists also benefited from controlling the central positions of Moscow and St Petersburg, and from serious divisions among their opponents. The foreign forces lacked persistence and scale.

The victorious Soviets ended independence movements in Ukraine and the Caucasus; but failed to do so in Finland, Poland and the Baltic Republics, their defeat by the Poles in 1920 being particularly important. Thus, war defined the new borders of Eastern Europe.

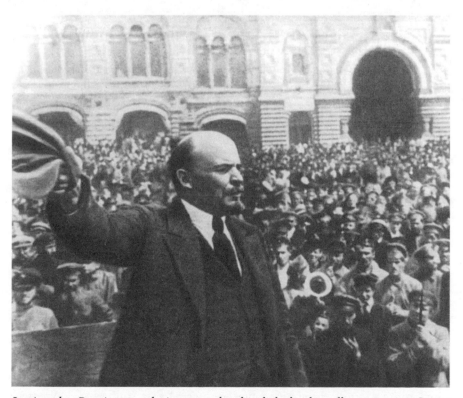

Lenin, the Russian revolutionary who headed the brutally repressive Soviet government from 1917 until his death in 1924, addressing a crowd in October 1917.

The Romanovs

When Tsar Nicholas II, his wife Empress Alexandra and their five children were executed by firing squad on the night of 16–17 July 1918 in Yekaterinburg, their deaths brought to an end the rule of the Romanov family which had been in power in Russia since 1613. There is still uncertainty as to who ordered the killings to take place: some say it was the Ural Regional Soviet; others that it was Vladimir Lenin himself. It was only in 1926 that the Soviets finally acknowledged that the family had been murdered, after the publication in France of a report into their disappearance. Initially, it was believed that the bodies had been cremated, but in 1979 Alexander Avdonin (a geologist interested in the story of what happened to the last Romanovs) and Geli Ryabov (a filmmaker) discovered their grave site in a field known as Porosenkov Log. While one grave was revealed that year, the second was not uncovered until 2007, 70 m (230 ft) from the first. After much investigation and scientific analysis, the bodies found in the first grave were laid to rest in St Catherine's Chapel in the Peter and Paul Cathedral in St Petersburg in 1998. The remaining two bodies (those of Alexei and his sister Maria) were interred after confirmation of their identity.

The Cheka

The large-scale use of terror by the Communists owed much to the secret police established in December 1917: the All-Russian Extraordinary Commission for Struggle Against Sabotage and Counter-Revolution, or Cheka. Arbitrary imprisonment, concentration camps, large-scale torture and the mass killing of suspected enemies were all part of the Cheka's repertoire. The argument that Joseph Stalin, the dictator from 1924, changed the direction of Russian/Soviet Communism by making it more paranoid and violent than it had been under Lenin ignores the extent to which it was already these things from the outset. The statue of Felix

Dzerzhinsky, founder of the Cheka and keen advocate of a murderous implementation of class warfare, was removed from outside the KGB headquarters in 1991 in response to public pressure.

Religious Warfare

The Communists were avowedly atheists and anti-clerical, and, during the Civil War and the 1920s, the Orthodox Church was crushed, with the slaughter of tens of thousands of priests and monks, and the desecration of churches, monasteries and the tombs of saints. The real and spiritual landscapes of Russia, and the psychological life of the people, were transformed as a consequence, although Orthodox belief continued. In Poland and Lithuania, in contrast, Catholicism played a role in successful opposition to the Communists. Indeed, an aspect of the history of the century that tends to be underplayed is that of a Cold War between Catholicism and Communism. This went on until the fall of the Soviet Union.

Vladimir Ilyich Lenin

Vladimir Ilyich Ulyanov (1870–1924) was born into a prosperous middle class family. His elder brother was hanged for plotting against the tsar in 1887, while Lenin himself was jailed for revolutionary activities in 1885 and then exiled to Siberia. It was at this point that he took the pseudonym Lenin. Working as a party organizer, journalist and pamphleteer, Lenin spent much of his life abroad, founding his revolutionary Bolshevik Party during exile in London. This would push, not for the equality of the masses, but for the dictatorship of the revolution. A democratic revolution had already taken place against the tsar in Russia when in 1917 the Germans allowed Lenin to return from exile in Switzerland in the hope that he would take Russia permanently out of the war. He called for armed insurrection and staged the October Revolution, overthrowing the moderate provisional government. Under his rule, Russian life was dramatically transformed. In 1922 he suffered a stroke and two years later he died.

THE PEACE OF VERSAILLES

The peace settlement after World War I saw major territorial changes. Germany lost land to France (Alsace-Lorraine), Poland, Belgium, Denmark and Lithuania, but the principal change was the end of the Austro-Hungarian empire. Czechoslovakia and Yugoslavia became new states, the first from that empire, while the second was a greater Serbia enhanced with land from the empire, notably Croatia and Slovenia. Due to the establishment of Yugoslavia and the principle of national self-determination, which was very much supported by America's president, Woodrow Wilson, Italy made only modest territorial gains from Austria. With territory from the Austrian, German and Russian empires, Poland became an independent state for the first time since 1795.

The principle of national self-determination, which proved destructive to the former empires, did not answer all of the questions of the new states that were created, not least due to a lack of agreement as to what nations actually were. Plebiscites, or referenda, were held in some areas,

Signing of Treaty of Versailles, 1919. Echoing the signature in Versailles in 1871 of the humiliating peace at the end of the Franco-Prussian War, the Treaty of Versailles was designed as both a practical and a symbolic victory for the Allies. Although many issues were solved for a while, the complexity of international relations prevented lasting peace.

for example on the Austrian-Yugoslav, Austrian-Hungarian and Danish-German frontiers. Lines on the map were also readily drawn in what was a period of particular volatility that saw some proposals accepted and others refused. For example, a plan for a corridor including Burgenland to link Czechoslovakia and Yugoslavia, in order to provide a pan-Slav union to act as a buffer against German and Hungarian nationalism, was unsuccessfully envisaged by the Czechs.

The principle of national self-determination was not applied outside Europe, where it would have wrecked imperial control. Instead, the victors divided up Germany's overseas empire and Turkey's Arab lands. Britain gained control of what is now Iraq, Jordan, Israel and Tanzania; and France of Syria, Lebanon, Cameroon and Togo. South Africa gained control of what is now Namibia. Australia, New Zealand and Japan gained Germany's Pacific territories.

The new 'colonies' were technically League of Nations' mandates, a status of trusteeship seen as an alternative to colonialism, both because the mandatory powers were subject to inspection by the League of Nations' permanent Mandates Commission and because the status was presented as a preparation for independence, as indeed happened with Iraq.

Reparations (compensation payments for wartime damage) were imposed on Germany similar to those imposed by Germany on France in 1871, and the size of Germany's armed forces was limited. Krupp had to stop making armaments.

The peace terms were designed to prevent Germany from launching new wars, and thus to provide collective security. Germany also had to accept an occupied zone along the French and Belgian frontiers, and a demilitarized zone beyond, the net effect of which was to end the possibility that the River Rhine could provide a strategic defensive frontier for Germany. However, talk of splitting Germany up, and thus reversing the unification of 1866–71, was not pursued. In geopolitical terms, the peace left a large Germany with to its east a series of weak and divided states that were unable to balance its power. Although ideologically different, the danger that Germany and the Soviet Union might unite was already being mentioned.

China in World War I

While Europe was preoccupied with the Great War, Japan seized the opportunity to expand its influence in China. In 1915, President Yuan

permitted, among other concessions, the transfer of German territories in Shandong to Japan. After Yuan's death in 1916, central authority crumbled and, although presidents continued to hold office in Beijing, for the next decade real power devolved to warlords in the provinces. In 1917, the Beijing government, under the control of northern warlords, entered World War I on the side of the Allies, hoping to win influence at the peace talks and check Japanese expansionism. But the Treaty of Versailles (May 1919) confirmed Japanese control of Shandong, causing widespread student demonstrations against the government and Japan.

The May Fourth Movement

In newly republican China in the 1910s, the already existing emphasis on revival and self-strengthening was given a more Western slant, as was the traditional ideal of governing through wisdom and knowledge. Nationalism in China was provided with new energy in 1919, when opposition to Japanese territorial claims led to the May Fourth Movement which also pressed for national regeneration through reform and a new culture that was scientific and democratic. This was part of a broader intellectual movement that had been building since the early 1910s. Thousands of young Chinese had become influenced by Western culture and ideas and were now determined to reform China. Many supporters of the movement were recruited into Sun Yat-sen's nationalist party, the Guomindang, which in 1917 had set up a rival government in Guangzhou, supported by southern warlords. Other student activists were attracted to Communism, inspired by the Russian Revolution of 1917, and in 1921 the Chinese Communist Party (CCP) was founded in Shanghai.

SPANISH FLU

Beginning in early 1918, a pandemic caused by the H1N1 influenza virus, known as Spanish Flu (which took its name from the misleading belief at the time that Spain was the country worst hit by the disease) swept through the world. It reached its deadly peak in October and saw

about 500 million people infected in total, approximately one third of the world's population, and estimates of the number of deaths it caused have ranged from 17 to 100 million.

The pandemic came in two major waves, with the second, which began in August 1918, the most virulent. It is unclear why the pandemic ceased. The mutation of the virus to a less deadly strain may have been the cause, but a more effective treatment of pneumonia may also have been the issue.

The source of the pandemic is contested, as is the virulence of the disease. It may have been able to overcome immune systems, or perhaps benefited from the circumstances of the period, notably disruption resulting from World War I that included food shortages as well as overcrowded wartime camps and hospitals. Young adults, and particularly pregnant women, were especially vulnerable to the disease. Most of the deaths were due to a secondary infection in the shape of bacterial pneumonia.

THE LEAGUE OF NATIONS

The Versailles settlement included the establishment of the League of Nations, an international organization, unprecedented at this scale, that was designed to keep the peace. However, fearing an erosion of national independence, the US Congress blocked American membership despite Woodrow Wilson's sponsorship of the League.

The League of Nations was designed to guarantee the peace settlement and to arbitrate international issues. Under Article Ten of the League's covenant, member states agreed 'to respect and preserve ... the territorial integrity and existing political independence of all members', while Article 16 provided for immediate economic and social, and possible military, sanctions against any aggressive power. Due to the opposition of the Senate, the USA refused to join the League, which proved to be a fatal weakness. However, Wilson's unwillingness to give the League its own army and to commit American troops to it (he preferred the armament of economic sanctions), was a major long-term drawback that cannot be blamed on the Senate, as also was his refusal, instead of a League army, to accept the compromise idea of alliance with Britain and France. This refusal weakened the ability of these states to sustain the peace settlement.

Wilson's support for national self-determination was hard to follow through, not only because Congress would not ratify the peace settlement but also because of the serious difficulty of implementing the idea in the

light of differences on the ground and the power politics of local and leading European states. The high hopes engendered were to collapse in the 1930s.

RETROSPECTIVES

The war was subsequently to be adopted as the key plank in anti-war literature and cinema, as with the British film *Oh! What a Lovely War* (1969) and the *Blackadder* television series of 1989. In Australia, there was a similar process, with Peter Weir's iconic film *Gallipoli* (1981) using that 1915 campaign to criticize the imperial link with Britain. In this deeply distorted account, the British contribution was downgraded and misrepresented. The impression offered was of British inefficiency, cowardice and dilatoriness leading to the sacrifice of the Anzac troops. It proved difficult by the 1980s to understand the culture, values and society that led so many willingly to serve during the war. This difficulty reflected changing assumptions in the West. Moreover, World War II was to be seen as a 'better' war, in part due to the Holocaust and in part because it was seen as more democratic; and, in contrast, the reason for acting against German expansionism in 1914 tended to be forgotten.

CHAPTER 3

The Twenties
1920–9

The 1920s saw considerable recovery from the instability of the 1910s, including the many millions killed from Spanish Flu in 1919. A devastating spread of an originally East Asian pandemic, it reflected the increased degree of linkage within the world. By 1928, East Asia, the Middle East and Europe were all largely at peace. At the same time, the pre-war political and economic order, and the related social norms, had gone, and there were significant pressures around the world for change. In the second edition of his *Imperialism*, published in 1918, the Soviet leader Vladimir Lenin argued that the Soviets should use agitation to drive colonial peoples to rebel against the Western imperial powers, and they indeed sought to do so.

THE VERSAILLES LEGACY

Far from the peace settlement sowing the seeds of a new war, as was frequently claimed, the international system it established actually worked better in the 1920s (at least from the perspective of Western interests), than was generally appreciated in the 1930s. That's not to say there was no domestic instability and international tension in Europe. They had existed prior to 1914, of course, but the experience of conflict made the post-war situation more volatile. Some countries had been very harshly treated, notably Hungary, where the borders had been drawn without any care for ethnic identity, ensuring that many Hungarians were left in Czechoslovakia, Romania and Yugoslavia. However, in most states, those opposed to the Versailles settlement lacked political traction.

To argue that Versailles led to Hitler gaining power is therefore inappropriate. Hitler rejected Versailles and the international system it sought to create. However, he was a marginal political figure in the 1920s, and far-right and far-left agitation in Germany was unsuccessful. Instead, the responsible *realpolitik* of the 1920s that entailed compromise and benefited from the idealistic currents of that decade's international relations

focused on another German, one far more prominent in the period: Gustav Stresemann, Germany's foreign minister from 1923 to 1929. He helped stabilize the Versailles settlement. After the Locarno Agreement of 1925 provided for a mutual security guarantee of Western Europe, Germany joined the League of Nations in 1926 as part of its reintegration into the new diplomatic order.

Meanwhile, the League played a role in solving some international crises, and also acted against problems such as slavery. Ethiopia was only allowed to join in 1923 when it agreed to ban slavery and the slave trade, which it was well on the way to eradicating before the Italian invasion of 1935. In 1926, the ratification of the League of Nations' International Convention with the Object of Securing the Abolition of Slavery and the Slave Trade marked the international abolition of both; although the drafting of the Convention had had to exclude from its definition of slavery both concubinage and forced labour, in the latter case to avoid problems for imperial powers in their colonies.

There were major agreements by the League on the control of drugs in 1925 and 1931, and the establishment of the International Opium Commission in Shanghai. The League's International Labour Office sought to regulate migration, while the Minorities Section was assigned responsibility for their care.

To subtract the failure, protectionism, misery and extremism produced by the Great Depression from the 1930s is to suggest that the 1920s order could have continued, in part because internationalism, liberalism, democracy and free-market capitalism would have retained more appeal, with both electorates and governments. In rejecting this order, however, the extremists in Europe turned to a politics of grievance based on anger with the verdict of World War I. There was plenty of such anger, and it also drew on a widespread anti-liberalism already seen prior to the outbreak of that world war.

THE UNITED STATES

World War I put a brake on the liberal progressivism seen in American society and political culture in the early years of the century, notably in the movement known as Progressivism and in opposition to industrial trusts (cartels) dominating the economy. The war was followed, instead, by a conservative reaction that reflected hostility to Socialism and concern about the example of the Russian Revolution. As a consequence, the

1920s saw an emphasis in America on a non-interventionist role by the state. However, by treating left-wing solutions as un-American, the once powerful Progressive tradition was marginalized.

At the same time, there was much social tension in the United States. This was especially so in 1919–22, when there was a very high level of labour conflict that had wider political and ethnic resonances. These included high levels of race violence, notably hostility in Northern industrial cities such as Chicago and Detroit to black workers, many of whom had moved from the South, as well as widespread concern about anarchism and radicalism that focused on immigrants and led to repressive government action. The presentation of a nation-state in which new whites were accepted provided they conformed to the standards of the old whites was seen as necessary in the 1920s, not only in response to immigration but also as a result of the apparent challenge from far-left politics. Indeed, the army devised War Plan White for action in the event of left-wing insurrection.

Warren Harding, Calvin Coolidge and Herbert Hoover, the successive Republican presidents between 1921 and 1933, benefited from the reaction against change, immigration and urban life that led, instead, to an enhanced stress on supposed white and Protestant values. In contrast, as in the previous century, Catholics, seen as new whites, were treated as second-class. Al Smith, the Democratic candidate in the 1928 election, suffered because he was a Catholic. As governor of New York, he also suffered from being identified as too 'urban', where indeed he polled heavily as in Chicago and Boston, but, for example, lost support in rural New York.

The reaction against urban life contributed directly to Prohibition (1920–33), the banning of alcohol, which was a focus of the culture wars of the age, and which both criminalized what had hitherto been seen as normal and provided a major source of opportunity for organized crime, most famously with murderous gang leaders, such as Chicago's Al Capone. At the same time, as a reminder that developments could draw on a range of factors, the Progressive movement had also influenced Prohibition.

The role of criminal gangs in American history looked toward the later influence of drugs and underlined the issue of criminality in the history of the century. In part, this was a matter of perception, and especially so thanks to the interest taken by newspapers and films.

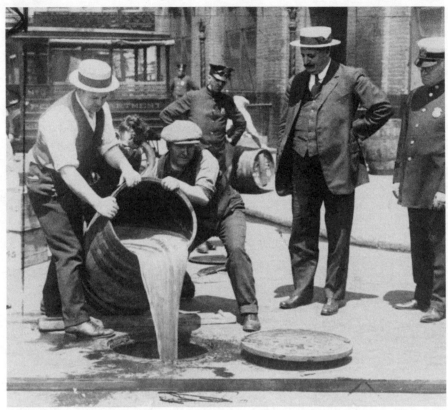

Pouring away liquor as part of the purge on alcohol seen when anti-alcohol campaigning led in 1920–33 to Prohibition, a US ban on the production, import, sale and transportation of alcohol. In practice, this encouraged the spread of criminal networks and fell foul of the end of Republican primacy.

Fed by panics about crime and other alleged consequences, immigration was restricted with the Emergency Quota Act of 1921 and the Immigration Act of 1924. The stress on a WASP (White, Anglo-Saxon, Protestant) United States remained potent until at least the 1960s, and bore no relation to what would be termed the melting-pot theory of America. Isolationism, not least refusing to join the League of Nations, was also an aspect of this reaction against the outside world. The reaction against change also led to a powerful revival of the anti-black and racist Ku Klux Klan movement in 1921–6. As with organized crime, such movements are a reminder of the variety of histories on offer during the century. A state-centred account can lead to the underplaying of this variety and of its significance at the national level.

The Roaring Twenties

In the 1920s, many young Americans reacted to the horrors of the previous decade by turning their backs on traditional ways and focusing instead on having a good time. With the advent of prohibition, young Americans took to visiting 'speak-easies'; these were bars run by gangsters, where they drank illegal alcohol and listened to jazz. Young women, known as 'flappers', adopted very short skirts, 'bobbed' their hair and smoked in public. The Roaring Twenties, as the decade is called, was an era of spectacular economic prosperity for many Americans. Large numbers moved to the cities, so that, in 1920, urban dwellers outnumbered the rural population for the first time. Affluence fed consumerism, and modern conveniences such as radios, telephones, refrigerators, washing machines and automobiles appeared in many American households.

Canada

As a dominion of the British Empire, Canada entered World War I alongside Britain in 1914. Over 600,000 Canadians served in the war and some 60,000 died. Canadians won a famous victory against German forces at Vimy Ridge in April 1917. Canada's contribution to the war effort encouraged many Canadians to demand greater independence from Britain, especially in foreign affairs. In 1926, Prime Minister William Lyon Mackenzie King successfully negotiated Canadian independence, officially recognized in 1931.

The American Empire and the Caribbean

Although the connection with domestic policy was not a directly causal one, there was also a determination to control the 'informal' American empire in Central America and the West Indies. But this attempt proved much harder than had been anticipated. In Haiti, the Dominican Republic and Nicaragua, occupying American Marines found it difficult to prevail in the face of popular guerrilla movements. Instead, as in Nicaragua, the Americans came to realize that it was easier to rely on local client regimes. These, however, had varying degrees of stability.

Latin America

Outside of discussions about American interventionism, Latin America does not feature much in consideration of the 1920s. This underplays the extent of tension there. Some issues were longstanding, notably with an ethnic dimension to social and political discrimination. In Bolivia, Mexico and elsewhere, this situation played a role in regional opposition to the state, as in the Mexican province of Sonora in 1926–7. Ideology also played a role in Mexico, in the War of the Cristeros in 1927–9. This was a major Catholic rising against the revolutionary state with its agrarian reforms and its attack on the Church. The rising led to intractable guerrilla warfare, with the army able to control the towns and railways, but not the countryside. A compromise between Church and state in 1929 ended a war that had cost 70,000 lives. This is part of the history of the century that tends, like that of Latin America as a whole, to be minimized.

WARLORD CHINA

Divisions in China led to the dominance of both the central government, weak as it was, and of military commanders or warlords in the localities. Their large-scale conflicts compromised Chinese stability in the early and mid-1920s, but, in 1926–8, much of China, bar Manchuria, was brought under the control of the *Guomindang*, or Nationalist movement, under its leader Jiang Jieshi. He was a military figure who had inherited the leadership from the civilian Sun Yat-sen, and was arguably the most successful of the warlords. Part of this success came from allowing the Guomindang to share power with provincial power-brokers.

In 1926, the Northern Expedition under Jiang against rival warlords benefited from Soviet advisors, money and equipment, including aircraft. However, the advisors were disparaging of the Chinese and provided help largely as part of a long-term plan to assist the Chinese Communists, who were then allied to the Nationalists as part of a united-front movement favoured by Joseph Stalin (in opposition to his rival Trotsky, who was an advocate of revolutionary integrity).

In 1927, after capturing Shanghai and Nanjing, Jiang turned on the Communists, then largely urban-based. Suspicious of their intentions, he crushed the Communists in a bloody 'white purge' that enabled him to improve his relations with the warlords, whom he was seeking to lead and manipulate as well as coerce or defeat. This crushing of the Communists also made it easier for Britain to accept Jiang.

In response, Stalin withdrew Soviet advisors and instructed the Chinese Communists to form a Red Army, embark on rural revolution and try to take over the *Guomindang*. In 1927, the Communists began a rebellion, only to be swiftly defeated.

Alongside conflict, there was considerable economic growth in China in the 1920s. In addition, a unified currency and a central bank were introduced, and the tax on internal trade was ended. However, growth was concentrated in Manchuria and the coastal provinces, and the impact on the remainder of the country was restricted. This was an aspect of longstanding regional differences within China, one also seen in more recent decades.

THE REAL COLD WAR

The very assumptions and core policies of the Soviet Union posed a major and continuing challenge to the international system. To this end it can even be said that the Cold War began with the Russian Civil War and not, as is conventionally dated, after World War II. Indeed, American and British troops fought Soviet Communists during the Civil War, and not subsequently. In response to capitalist attacks the Soviets sought to undermine Western expansion, for example by organizing a Congress of Peoples of the East in Baku in 1920 to explore ways of coordinating resistance to imperialism.

More generally, the Soviets employed and deployed future Communist leaders. Soviet influence in China, and notably in the Islamic world, including Turkey, Iraq, Persia and Afghanistan, challenged British interests. The Soviet Union backed opposition to Britain in each country, and provided arms, particularly to Afghanistan, with which Britain fought a war in 1919. The Soviets also supported the nationalists in Turkey, who successfully defied Britain and British interests in 1920–3. Moreover, the failure of Allied intervention in the Russian Civil War encouraged Britain's opponents in these countries. The Soviet role was an element in the curbing of British ambitions in the Islamic world in 1919–22, although nationalist opposition was more significant. The Soviets benefited from, and sought to exploit and mould, nationalist opposition to Britain.

Establishing Control

When the Bolsheviks took power, much of Russia was in turmoil. Peasants had seized farmland from Russian nobles, and workers had

taken control of many factories. At first Lenin supported these seizures, but after the civil war broke out, the government tightened its grip, taking over factories and forcing peasants to hand over most of their produce to feed the army and the urban population, in a policy known as 'War Communism'. This provoked widespread revolts in 1920–1922 and led to a famine in the Volga region that killed five million. Lenin was forced to compromise his socialist principles with the 'new economic policy' (NEP), introduced in 1921, which permitted small businesses and farms to engage in free trade while the government retained control of banking and heavy industry. During the 1920s, the economy steadily grew. In 1922 the Bolsheviks, now renamed the Communist Party, established the Union of Soviet Socialist Republics (USSR), or Soviet Union. Byelorussia, Transcaucasia and Ukraine joined Russia to form the union's first four republics. Eventually 15 republics made up the Soviet Union.

Industrialization

When Lenin died in 1924, a power struggle developed among members of the Politburo (executive committee of the Communist Party). One leading figure, Joseph Stalin, used his position as General Secretary to create a power base within the Party, and defeated his rivals one by one. By 1928 Stalin had achieved absolute control. Determined to make the Soviet Union a global power on a par with the West, he launched a programme of rapid industrialization. The first Five Year Plan was adopted in 1928. The Plan's over-optimistic targets led to tremendous inefficiency and waste, yet remarkable progress was made. Vast new mineral extraction plants, factories and power stations were established in the Urals, the Volga area and Siberia, and railways were built to link the new industrial hubs. The population of the big cities nearly doubled between 1928 and 1933.

Collectivization

To feed the expanding population of urban workers, Stalin had to radically reorganize the countryside. In 1929, he ordered the collectivization of agriculture. Private holdings were abolished and peasants were forced to work on giant collective farms. Wealthy peasant farmers, known as kulaks, were deported to the gulag (the prison camp system). Many peasants responded by slaughtering their livestock and only planting enough for themselves. This was forcibly requisitioned, causing famine. By 1933, some 14.5 million people had died, either from famine or in the gulag.

Stalin v Trotsky

Joseph Stalin and Leon Trotsky competed to dominate the situation after the death of Lenin in 1924. In 1926, the volatile Trotsky, a supporter of revolutionary integrity, accused Stalin of becoming 'the gravedigger of the revolution'. In practice, the hopes of world revolution, with Moscow as the centre and inspiration of this new power, and the carrying forward of wartime methods in order to ensure Communist success, were to a degree subordinated by Stalin to the more pragmatic interests of the Soviet state. Trotsky was forced into exile in 1929, sentenced to death in 1937 and murdered in Mexico in 1940 by a Soviet agent. By then, those accused of Trotskyism had been purged, part of the process by which the paranoid Stalin harshly destroyed all those he suspected of being his enemies. In the meanwhile, Soviet propaganda and the activities of the Comintern (Communist International), and of Communist parties, known and suspected, went beyond the confines of acceptable diplomacy.

TURKISH TRANSFORMATION

World War I left Turkey defeated, humiliated and subject to the onerous terms of the Treaty of Sèvres of 1920, which included the occupation of parts of the country by the Allies. The former territories of the Ottoman Empire were partitioned between the victorious European Allies. Britain strengthened its hold on Egypt and won control of Iraq, Palestine (out of which a separate emirate, Transjordan, was carved in the east), Kuwait, Bahrain, the Trucial States (modern United Arab Emirates), Oman and Aden (now part of Yemen). France gained Lebanon and Syria. Greece, Italy and France divided up Asia Minor between them. By 1925, the only independent countries in the region were Iran, Yemen and the Arabian territories of the warrior statesman Ibn Saud.

A nationalist reaction, under a capable general, Mustafa Kemal Atatürk, pushed out the occupying powers, particularly the Greeks, who were heavily defeated in 1921–2. A more satisfactory peace settlement was agreed in 1923 with the Treaty of Lausanne and the creation of a Turkish republic. The caliphate was abolished in 1924. Atatürk, the president from 1923 until 1938, drove forward modernization, secularism and Westernization, and overcame regional separatists, notably the Kurds in 1937.

Aside from secularism, the authoritarian pattern Atatürk established for the republic has continued to the present, as has the earlier idea

propagated by the Young Turks of hostility towards non-Turkish peoples within the republic, principally Armenians and Greeks. The large-scale brutalization and expulsion of non-Turks were linked to a destruction of their historical imprint, notably with the burning of churches and other sites that were at once monuments and living presences. Much of Smyrna (Izmir) was burned down after it was recaptured from the Greeks in 1922, while all surviving Christian men of military age were deported to the interior, where many were killed.

The emphasis on fostering a Turkish identity led to an abandonment of Arabic and Persian borrowings in the language. Separately, Atatürk forced through a change from an Arabic script to a Latin one. Western laws and jurisprudence were adopted, while there was an emphasis on education, including of women, and on improving literacy.

THE ISLAMIC WORLD

Turkey was not alone in avoiding outside imperial control. In Persia, Reza Shah, like Atatürk a military figure, seized power in a coup in 1921, overthrowing Qajar rule and reunifying the country after central power had effectively been dissolved during World War I. He also shifted the historic balance between the state and the tribes, in part due to good leadership, in part to the opportunities offered by new technology, notably armoured cars, and in part because the British, with extensive oil interests in Persia, no longer backed their former tribal protégés. Reflecting the continued appeal of monarchy, also seen for example with King Zog in Albania, Reza Shah founded the Pahlavi dynasty in 1925. In contrast, in Afghanistan in 1929, King Amanullah, another state-builder, suffered from a lack of British support and was overthrown by tribal opponents.

The colonial powers faced nationalist uprisings in Egypt (1919), Iraq (1920) and Syria (1925–1927). Britain granted partial independence to Egypt in 1922, while retaining control over military and foreign policy and the Suez Canal, the crucial gateway between the Mediterranean and Red Seas.

In Arabia, after the collapse of Turkish control and influence, tribal leaders vied for advantage, while the major families competed for dominance of the peninsula. Ibn Saud (1876–1953) drew on the energy and determination of the fundamentalist Islamic Wahhabi movement, and, in 1932, created Saudi Arabia, an achievement that has lasted to

the present. He had defeated the rival Hashemite family in 1919–25, as well as regional opposition, although he failed to conquer Yemen in the mid-1930s.

The differing trajectories of these countries serve as a reminder of the variety of developments that was possible. While the tension between centralizing nationalists viewing their armed forces as sources of integration, and, as a contrary force, hostile tribes, was an important theme, it played out through the particular circumstances of the individual states. Western political and economic intervention was important, particularly as oil became more significant. This encouraged interest in Persia, Iraq and Saudi Arabia.

INDIAN NATIONALISM

Opposition to British imperial rule became more significant from the 1920s, notably with a general strike in 1919 and a Non-Cooperation Programme in 1920–2, the latter led by Mohandas Gandhi, an effective advocate of peaceful protest. Gandhi condemned British rule:

> *as a curse. It has impoverished the dumb millions by a system of progressive exploitation … It has reduced us politically to serfdom. It has sapped the foundations of our culture … [and] it has degraded us spiritually*

India, as an imperial dominion, was a major source of manpower and resources for the British war effort during World War I. Some 750,000 Indian men served and over 36,000 gave their lives. In return for India's support and sacrifices, Britain promised further reforms, but could not prevent continuous nationalist protests. In 1916, Mohandas Gandhi, a rising star within the Congress, forged a pact with Mohammed Ali Jinnah, leader of the Muslim League, to campaign jointly for independence. In 1919, Britain introduced the Rowlatt Acts, restricting the civil liberties of Indians and increasing government emergency powers in order to control protests. Gandhi organized a series of non-violent protests against the Rowlatt Acts, including general strikes and demonstrations. At one protest at Amritsar, British troops opened fire on a peaceful crowd, killing nearly 400. The Amritsar Massacre caused deep public anger and stirred widespread popular sympathy for the nationalist movement.

However, despite a murderous and disproportionately panicked reaction to disturbances at Amritsar in 1919, a reaction that led to an appalling massacre that weakened the moral case for empire, the British were able to sustain control without on the whole having to rely on force. Indeed, India was more stable in the early 20th century than it had been in the early 18th or early 19th. The fear on the part of British ministers of Soviet subversion in India looked back to pre-Communist days, but, as in Indonesia, Soviet attempts to exploit anti-imperialism were unsuccessful.

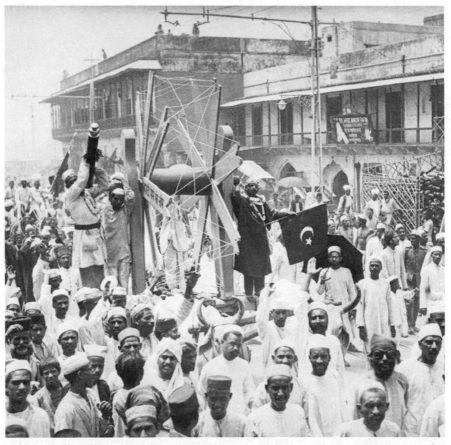

Non-cooperation movement. In a parallel to the May Fourth Movement in China, India from 1920 saw a similar nationalist upsurge launched by Mahatma Gandhi; but the challenge to British rule was lessened by widespread co-operation with the latter.

Mohandas Gandhi

Born in the state of Gujarat in western India, Mohandas Gandhi studied law at University College, London, before moving in 1893 to South Africa where he lived and worked as a barrister for 21 years. It was during that time that he became involved in a campaign for civil rights, advocating non-violent resistance and was given the title 'Mahatma' Gandhi ('Mahatma' means 'revered'). Gandhi and his family returned to India in 1915, and he began to organize workers to protest against land taxes and discrimination. In 1921, he became leader of the Indian National Congress and continued his work promoting an end to poverty, increasing women's rights and aiming for better inter-faith relationships as well as the country's right to self-rule. Gandhi, who became an instantly recognizable figure when he began wearing an Indian loincloth, practised what he preached, living a simple life, eating vegetarian food. Although Britain granted India independence in 1947, Gandhi continued his fight against religiously motivated violence, fasting several times to draw attention to the issue and to pressure the Indian government to return assets owed to Pakistan. Many Indians were upset by this, and it was one such nationalist, Nathuram Godse, who assassinated Gandhi on 30 January 1948.

The Montagu-Chelmsford Reforms, passed in late 1919, increased the powers of Indian-dominated provincial legislative councils and boosted Indian representation on the central legislative council. Nevertheless, real political power remained with the viceroy and the governors. The nationalists were unimpressed and in 1920, Gandhi, now leader of the Congress, began an organized campaign of non-violent disobedience, calling on Indians to boycott British goods and government services, and to refuse to pay their taxes. Many Indians gave up their jobs and risked fines and imprisonment to take part. Gandhi's campaign mobilized nationwide support, turning the Congress into a mass movement.

New Constitution

In 1929, the Congress officially declared its goal of complete independence. The following year, Gandhi led thousands of followers on a 386 km (240 miles) march to the Arabian Sea, where they extracted salt from evaporated seawater. The salt march was a protest against taxes, particularly the tax on salt. Gandhi and other Congress leaders were jailed, but the momentum was now with the nationalists. Gandhi was summoned to London for talks. The outcome was the Government of India Act (1935). This created a new constitution that increased the representation of Indians in government. Yet, crucially, the viceroy and the governors retained the power of veto and control of finances, which left the nationalists frustrated.

MUSSOLINI AND ITALIAN FASCISM

Dissatisfaction with the peace settlement was exploited by the Fascists under Benito Mussolini, who gained control of Italy in 1922, in part due to the exhaustion of Italian liberalism. An authoritarian politics established by Mussolini was put at the service of a vainglorious effort at modernization that had some achievements, for example in draining the malarial Pontine Marshes near Rome, but that ultimately found it difficult to fulfil its boasts. Much of the state's resources were expended on an increasingly militaristic foreign policy. Fascism had varied meanings for different groups and regions, which helped make it more potent, but also eclectic and confusing. This situation was accentuated by the change it experienced through time, not least in its exposure to power.

An important element was rural Fascism, as it was in the small country towns that Fascism first developed into a viable mass movement. This reflected the more general conservatism of country versus city, a common theme around the world.

Fascist apologists were to present it as a 'third force': a corporatist alternative to the divisions between capitalism and labour, and as embracing technology and an energetic means to modernization. However, alongside Mussolini's corporatist approach, the reality of Fascism was of crude and often violent anti-socialism and a willingness to ally with élites, old and new, against the assertiveness of labour. Mussolini was particularly opposed to liberalism. He promoted some aspects of reforming modernization, notably opposition to organized crime in Sicily and Sardinia, and also supported economic activity, particularly

shipbuilding. However, Mussolini did not understand how to secure the transformation he wanted.

WEIMAR GERMANY

A republic was created in Germany when the imperial system collapsed after defeat in World War I and the German Revolution in 1918–19. This republic faced many problems, notably hyperinflation in 1923, as well as violent political disorder from both far-left and far-right. This was part of a more general violent volatility across much of Europe in the aftermath of the war. Hopes on the far-left that the Russian Revolution could be emulated were quashed by anti-revolutionary groups, notably ex-army Freikorps, supported by military and political authorities, notably in Bavaria and Berlin, especially the Spartacist uprising in the latter city. The Munich putsch, or coup, attempted by Adolf Hitler in 1923 was a key instance of far-right violence. It failed and Hitler, a far-right demagogue, was briefly imprisoned.

However, after 1925, Germany became more stable and the political extremes were successfully contained. Social and political tensions continued, but did not threaten the social and political order. Weimar proved a dynamic society and culture, with a very active artistic world and social liberalism. There were improvements in the economic system, too, for example the installation of locks on the River Elbe to make it a more important commercial axis. This situation would probably have continued, but for the Great Depression of the early 1930s and the accompanying large-scale unemployment.

Hitler, 1889–1945

An Austrian-born veteran of the German army in the trenches, Hitler fed on the mistaken belief that victory had been within the grasp of the army in 1918 only for Germany to be 'stabbed in the back' by traitors at home, principally Jews and Communists. This defeat energized his anti-Semitism as did what he saw as a 'Jewish-Bolshevik' revolution in Munich in 1918–19. He aspired to reverse Germany's defeat, both morally (as he saw it) and territorially. Ignoring the many German Jews who had served in World War I, Hitler regarded Jews as the active force behind opposition to Germany and in his book *Mein Kampf* (*My Struggle*) inaccurately presented Communism as a cover for Jewish goals. He claimed 'the Bolshevization of Germany ... means the complete annihilation of the

entire Christian-western culture', and, in turn, saw Eastern Europe as a place for an expansionist Germany to find *Lebensraum* (living space). As such, Hitler sought to expand as well as refashion what he presented as a stronger people and state.

Hitler was more dangerous because of the context of the times and because he had backers. Faced by radicalism, conservative interests, notably the army's Information Department in Munich, sought to use him in order to oppose the Left.

JAPAN

Japan joined World War I on the side of the Allies. In the course of the conflict, it occupied several German territories, including Jiaozhou in north-eastern China and some islands in the Western Pacific, most of which it was allowed to retain at the war's end. The war brought economic prosperity to Japan, with an enormous boost in munitions exports, creating a large industrial labour force. Inspired by the growth of democracy in the West, many Japanese began to demand political reform. In 1925, the Japanese Imperial Diet (parliament) expanded the suffrage to include all adult males.

In foreign affairs, Japan became noticeably more pacific after the war, in keeping with the global mood. In 1920, it joined the League of Nations and, in 1928, Japan was one of 14 countries that signed the somewhat idealistic Kellogg-Briand Pact, which renounced war as a means of solving international disputes.

Hard times

Japan's wartime boom ended in 1920. The economy suffered a series of recessions through the 1920s; it was made worse by the Great Kantō Earthquake of 1923, which devastated Tokyo and Yokohama and caused up to 140,000 deaths. When the worldwide depression struck in late 1929, Japan's already faltering economic situation deteriorated even further. Factories laid off workers, prompting a new wave of strikes. Farmers suffered as agricultural prices plunged. Public opinion turned against the party leaders and the political establishment. Many regarded Western influences, including democratic government, as part of the problem, and wished for a return to traditional Japanese ways.

Such conservative, nationalist views, found a violent outlet with the formation of several extreme right-wing terrorist organizations. One of

these groups, supported by elements within the military, assassinated Prime Minister Inukai Tsuyoshi in 1932, ending Japan's brief flirtation with democracy. The major parties voted to dissolve themselves and form a single party, the Imperial Rule Assistance Association. The IRAA, which was dominated by military and bureaucratic figures and claimed to stand above party politics, continued to rule Japan until 1945.

THE WORLD ECONOMY 1920–9

Alongside a measure of post-war economic recovery around the world, the United States increasingly set the terms of the world economy. It became not only the world's leading industrial power, but also the principal trader and banker. Due to the availability of capital, New York replaced London as the world's financial centre. It was also the centre of consumption, with its great department stores fronted by plate glass showing the goods available to those with money to spend.

American industrial growth satisfied domestic demand, both in well-established sectors and in the rapidly growing consumer markets for cars and 'white goods', such as radios and refrigerators. The spreading use of electricity helped economic growth, as well as offering, with circuit diagrams, a new way to conceptualize relationships. Moreover, the rise of plastic as a product affected several branches of manufacturing.

New plant and scientific management techniques helped to raise American productivity, which increased profitability and consumer income, and, therefore, the domestic market. The mass production of cars associated in particular with Henry Ford was a key means of demonstrating the value of these new techniques, and also linked industry and the consumer. Based in Detroit, Ford introduced the inexpensive and easy-to-drive Model T in 1908 and established the moving assembly belt in his plants in 1913. By 1927, when production of that model ceased, over 15 million had been produced. The Model A followed in 1927, with 4.9 million produced by 1931. Ford had had to respond to competition, notably from General Motors (GM), which in the 1920s established a 'price ladder' with a car for 'every purse and purpose', a key element in consumerism. The styling of GM's cars was important to the visual character of American cities in this period.

Although there was industrial growth around the world, the scale of American economic expansion was not matched elsewhere. As a result, the United States became the major international lender in the 1920s. But

American protectionism and economic strength reduced imports, so that other countries were unable to finance their borrowing from the United States, which was a major challenge to fiscal stability.

In the Wall Street Crash, the overheating American economy collapsed in October 1929 as the result of a speculative boom in share prices. Confidence was hit hard as it had been assumed by many that shares could only go up in value. Moreover, the integration of the economy and the development of the media both focused attention on Wall Street. This bursting of an asset price bubble became far more serious when America's inexperienced central bank cut the money supply. The tightening of the financial reins, which included the calling in of overseas loans, hit America hard and caused financial crisis elsewhere.

THE TOOLS OF TRANSMISSION

Radio and cinema reached audiences in a more direct way than print media. They also benefited from an ability to offer novelty and a capacity to expand their market while satisfying it. By 1914, Manchester had 111 premises licensed to show films and even the more rural and less affluent Lincolnshire had 14 in 1913. In the 1920s, large numbers of cinemas were constructed, distribution chains were organized and going to the 'flicks' became an activity that spanned classes, not least because the motion pictures provided escapism.

The cinema was especially popular in working-class areas, and more popular with women than married men, although the very poor could not afford it. It offered an equivalent to the male patronage of the pub and the working men's club. Youths were also more likely to attend the cinema than their elders.

Commentators had little doubt that seeing moving images of very different lives could lead to a rethinking of assumptions that might itself be subversive, notably the depiction of independent women. It is clear that the cinema, far more than the radio, influenced fashions, especially in clothes, hairstyles, manners and language.

Radio

Radio proved a versatile means of communication, and one that took programmes into households, offices and factories. This was a new form for consumerism. Radio became a means of national conversation, and thus of cultural unification. It was an aspect of the changing nature of

noise in society, one also seen with cars and aircraft. Acoustics, indeed, became a more significant form of measurement and a topic for research. Radio was also to be important to the spread of advertising into new forms and to new audiences.

Radio, moreover, transformed existing services. Thus, in the 1860s, when the British storm warning service for shipping was introduced, use was made of telegraphy. From 1921, however, a weather message for shipping approaching the western coasts of the United Kingdom was broadcast twice daily from the wireless transmission station at Poldhu in Cornwall. From 1924, a weather bulletin, 'Weather for Shipping', was broadcast twice daily from the powerful Air Ministry transmitter in London.

International radio services began, from Britain to Canada, in 1926. The initial longwave radio technology was supplemented by shortwave, which was developed in the early 1920s. Shortwave was faster, and the concentrated signal ensured that it was more reliable and less expensive to operate. In the 1930s, the replacement of crystal sets by valve sets improved reception.

Cinema

Cinema had many early centres, and, in the 1920s, Britain and Germany remained especially important film-making nations. However, no other country matched the USA for their growth and impact. The world of film reflected America's rising economic and cultural ascendancy, with the clear skies of arid southern Hollywood the basis for a growing world industry. Thus, in Australia, American films had more of an impact than British ones. Prominent Hollywood figures, such as Rudolf Valentino, a romantic lead, and Fatty Arbuckle, Charlie Chaplin and Buster Keaton, all comedy stars, became household names around the world. Rapidly developing, with silent films succeeded by the talkies, cinema, organized by the studio system, offered a mass-produced uniform product that superseded local, face-to-face means of entertainment, such as music halls. In this, cinema was to be followed by television. Cinema also provided newsreels.

In the Soviet Union, the focus was on retelling the recent history of the Communist revolution of 1917, with films such as *Strike*, *Battleship Potemkin*, *The End of St Petersburg* and *Lenin in October*. Thus, very recent history was given the ideological treatment. Subsequently, Russian

history was harvested for useful subjects, especially peasant rebels against the tsars. Cinema trains were employed to increase viewer numbers.

American Culture

Hollywood was far from alone in moulding an American culture for consumption at home and abroad. Spread by the new technology of the radio, jazz was a major product of American culture in the 1920s. It reflected the American ability to bridge traditional cultural divides, and then to commodify and disseminate the resulting product. Distinctive American voices were also emerging elsewhere, for example in the architecture of Frank Lloyd Wright, which challenged the traditional American classicism, and sought, instead, to focus on an architecture that worked with the American landscape.

Debating Evolution

Fundamentalist religious groups rejected the theory of evolution from the outset, not least because it challenged Biblical accounts of the Creation and also proposed links between humans and apes. In 1925, in a much-reported trial that attracted leading lawyers, John Scopes was convicted for teaching evolution in the American state of Tennessee, where it was forbidden. Although the fundamentalists were castigated for intolerant ignorance, the state law was not changed for several decades. The trial was the basis of *Inherit the Wind*, a 1955 Broadway hit that was made into a Hollywood film.

CHAPTER 4

The Thirties, 1930–9

The 1930s are conventionally judged in terms of the world war that followed, but there was much beyond the shadow of international conflict in that decade. Indeed, the world war did not break out until towards the close of the decade and did not become truly global until late 1941. Instead, it was American political resilience that was most notable in the 1930s, and that indeed played a key role in the world war discussed in the next chapter. At the same time, in many countries the failure of democratic institutions to deal successfully with economic problems helped provoke authoritarian solutions and a decline in liberal democracy.

THE GREAT DEPRESSION

The crisis in the world economy that had begun with the Wall Street Crash spread rapidly in the early 1930s, hitting exports, production and employment, and indicating how much there was already a global integration of economic circumstances and trends. Far more than the mismanagement of financial and trading systems was involved. There was also a more fundamental problem, namely the weaknesses of liberal and international economic practices, now referred to as globalization, as a result of the political and ideological potency of nationalist economic views, in particular in the form of protectionism.

Causing a notable fall of confidence in the old market economy, the crisis led to higher levels of protest and violence, as well as to a widespread turn to authoritarian political solutions, and to corporatist, or state-driven, economic ones. The *laissez-faire* state was no longer popular, while, in the face of large-scale unemployment, self-help in social welfare was clearly inadequate. At the same time, the very different economic and political responses of countries to the socio-economic crisis revealed that there was no simple path from crisis to authoritarianism.

Keynesianism

The Great Depression resulted in a call for new policies, not least protectionism in the form of tariffs. In addition, the traditional belief in 'sound finance', which had meant, particularly in Britain and France, a balanced budget and low expenditure and taxation, was criticized by John Maynard Keynes, a British economist, in his *General Theory of Employment, Interest and Money* (1936). He called for public spending to be raised in order to stimulate the economy and cut unemployment, and was ready to see very low interest rates and to tolerate inflation, a departure from conventional monetary policy.

Although Keynesian economics became intellectually and politically fashionable after World War II, before being heavily criticized in the monetarist 1980s, it was far from clear, however, that such a policy was bound to work. Keynesian monetary policy really required a closed economy with very little liquidity. Moreover, pump-priming public spending could be inflationary and still leave unemployment high.

The New Deal

The welfare and economic reforms known as the New Deal, which the Democrat Franklin Delano Roosevelt introduced after he became America's president in 1933, satisfied the powerful political need to be seen to be doing something. In gaining the initiative, this set of policies set a tempo for change, one that resisted deflation and kept non-governmental populist options at bay. Roosevelt backed public works and also established work-creation schemes, such as the Works Project Administration, to fight unemployment. These schemes led to the development of infrastructure, especially roads, such as the Blue Ridge Parkway in the Appalachian Mountains. Well-publicized work schemes helped to create a sense that a corner had been turned.

Partly as a result of such pump-priming measures, the federal debt rose from $22.5 billion in 1933 to $40.5 billion in 1939. Nevertheless, unlike recent fiscal trends, Roosevelt favoured balanced budgets and put up taxes on the rich, rather than relying on deficit financing.

Although Roosevelt passed the Social Security Act in 1935, it was a very limited measure, not the state socialism decried by some critics. Indeed, a combination of the conservative nature of American public opinion, hostility to interference with property rights and growing political opposition from 1937 prevented him from doing more. Rather than

during the New Deal, it was only in World War II that the major moves toward a stronger and more expensive American state were made, while unemployment remained persistently high in the 1930s, falling definitively only with the war. Nevertheless, GNP per head recovered, rising from $615 in 1933 to $954 in 1940, and those in work became considerably better off, which increased domestic demand and helped the economy.

Roosevelt was rewarded with relatively easy re-elections in 1936, 1940 and 1944. He benefited from a coalition between Southern Democrats, who were white supporters of states' rights, and their big-city Northern counterparts, who were outsiders – trade unionists and immigrants, especially Catholics and Jews. The Republicans, in contrast, were the WASP party of the Northern states in the 1861–5 Civil War (and therefore hated in the South), and were particularly (but not only) the party of business and the affluent. The Republicans were especially strong in the Northeast and Midwest.

The Bonus Army

Veterans, many of them unemployed, pressed aggressively for money and formed the so-called 'Bonus Army'. They were bloodily dispersed by troops on 28 July 1932, because they were seen as left-wing radicals and because they were unwilling to move from their encampments in central Washington. Douglas MacArthur, the army's bellicose chief of staff, was unwilling to accept a subordinate role during this operation, but his ambitions were successfully restrained, there was no serious prospect of military intervention in politics, and America remained a democracy. Like the populist demagogue Huey Long of Louisiana, an advocate of a 'Share Our Wealth' policy including an asset tax, who was assassinated in 1935, the 'Bonus Army' proved not to be indicative of a politically damaging wider malaise.

THE RISE OF HITLER

The rise in unemployment with the Great Depression was exploited in Germany by the extremists of left and right. Concern about Communism, and support for his rabid nationalism, helped ensure a widespread rallying to the far-right Nazi Party under Adolf Hitler, who gained power on 30 January 1933, in part as an anti-Communist candidate and with other politicians on the right convinced they could control him. The latter played a key role, both in aligning with the Nazis and with thwarting

alternatives, notably by ensuring the early dissolution of the Reichstag (Parliament) in 1930 and 1932 and with overthrowing the Social-Democrat government of Prussia in 1932.

Once in power, however, Hitler totally changed the situation, benefiting from the burning down of the Reichstag and the subsequent suspension of civil and political rights. These decrees were supplemented by the Enabling Act which let Hitler override parliament. Thus, the support of a mass-party and much of the electorate was supplemented by that of many of the conservative élites. He pushed through a dictatorial remoulding of the German state, as well as large-scale rearmament, and the brutal repression of domestic opponents. This included frequent murder, mass arrests – about 200,000 people in his first year in power – and the establishment of concentration camps. There was also rabid propaganda against those disliked by the regime, notably Germany's Jews.

In the purge known as the Night of the Long Knives, from 30 June to 2 July 1934, Hitler destroyed the *Sturmabteilung*, the Nazis' own paramilitary organization, because he suspected the political intentions of its leader Ernst Röhm. Up to around 1,000 people were killed as Hitler entrenched his position and destroyed opponents, both within the Nazi Party and without, not least on the right. Key figures involved in the purge were Heinrich Himmler, head of the *Schutzstaffel* (SS) and Hermann Göring, the head of the Gestapo, or secret police.

After the death of President Hindenburg on 2 August 1934, Hitler combined the office of the president with that of the chancellor which he already held, and thus, as head of state, became supreme commander of the armed forces. At the suggestion of the army leadership, who thought it would bind Hitler to them, an oath of unconditional loyalty to him as *Führer* (leader) of the German people was taken by every member of the armed forces. Uniforms were altered to accommodate the swastika.

In 1933, Germany withdrew from the Geneva disarmament talks and the League of Nations. Rather than respond to the fiscal strains of 1934 by restraining rearmament, Hitler pressed ahead. From 1935, Germany acted to dismantle the Versailles peace settlement, particularly in May 1936 when the Rhineland was unilaterally remilitarized as Hitler took advantage of problems in the French government. He also went further in March 1938, when Austria was occupied in order to facilitate an *Anschluss*, or union with Germany. This was far more than a revision of the Versailles settlement. The map of Europe had been

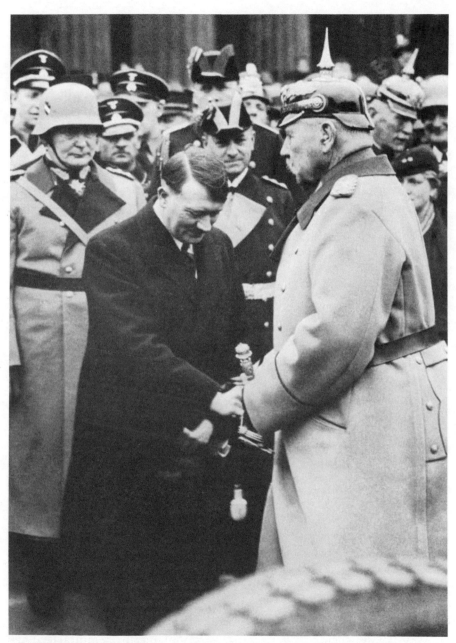

Hitler meets Hindenburg at a memorial service outside the Berlin State Opera House in 1933 just after Hitler was appointed Chancellor. President Paul von Hindenburg eased the path for Hitler by appointing him Chancellor in January 1933. Subsequently, Hindenburg accepted Hitler's pressure to extend government power and Nazi control, not least signing into law the Reichstag Fire Decree.

fundamentally redrawn and Germany gained frontiers with Hungary, Yugoslavia and Italy.

The Versailles settlement had left to Czechoslovakia those parts of Bohemia and Moravia where there was an ethnic majority of Germans: the Sudeten Germans. This was unacceptable to Hitler. A crisis built up in 1938 as Germany prepared for war. Let down by its allies in the Munich Agreement of 29 September 1938, Czechoslovakia, the only democracy in Eastern Europe, was intimidated into losing the Sudetenland, which left it highly vulnerable to invasion. In March 1939, Hitler pressed on to destroy Czechoslovakia, occupying Bohemia and Moravia, and benefiting in doing so from support from that half of the country which would later become Slovakia.

Hitler's Inner Circle

The men and women who were part of Hitler's 'inner circle' had varied backgrounds and motivations. Some, such as Franz Stangl, commandant of death camps Sobibor and Treblinka, maintained a loving family life while sending innocent people to the gas chambers. Others such as Amon Goeth, commandant of the Kraków-Płaszów concentration camp were clearly criminal and psychopathic.

The first attempt to understand the minds of the Nazi leadership came during the Nuremberg trials. The Allied prosecution hoped that by submitting some of the 21 accused to psychological tests, they might learn what had made them commit unspeakable crimes. Hermann Göring, Joachim von Ribbentrop, Rudolf Hess and Albert Speer took the tests supervised by psychologist Gustave Gilbert, PhD and psychiatrist Douglas Kelley, MD.

Gilbert suggested that the men had been conditioned to defer to authority without question and had not developed any critical faculties. Kelley contended that they were the pathological product of a 'socio-cultural disease', encouraged to commit criminal acts by their psychotic leader, like the members of a religious cult.

> In the end there was no single explanation for their evil actions. All had their reasons, and it seems that the Nazis were, on the whole, very common personality types who simply could not resist the primal urge to exercise unconstrained power over others.

Hitler's Views

National Socialism rested on a cult of the Führer, as well as on a confused, indeed incoherent, mixture of racialism, nationalism and a belief in modernization through force. Force certainly characterized Hitler's regime with, from the outset, a brutal attitude toward those judged unacceptable. His was a vicious anti-Semitism that would not be satisfied with discrimination. Hitler claimed that Jews were inherently prone to subversion, both from the left and the right. For Hitler, there had to be persecution, and it had to be not an ongoing aspect of Nazi rule, but a decisive and total step that would end what he saw as the Jewish challenge. To Hitler, this was a meta-historical issue, not an add-on designed to fulfil other policies, such as the redistribution of territory, the raising of funds or the rallying of popular support.

The pronounced cult of personality was linked to a sense of historical mission: history to Hitler was a lived process that he embodied, so that his personal drama became an aspect of the historic mission of the German people. To Hitler, racial purity was a key aspect of his mission, at once both a means and a goal. Propaganda was pushed hard, with propaganda minister Joseph Goebbels proving particularly adroit. He had produced the *Volksempfänger* (people's receiver), an inexpensive radio designed to link Hitler with the people. The *New York Times* noted in 1936, 'It is the miracle of radio that it welds 60,000,000 Germans into a single crowd, to be played upon by a single voice.' At the same time, the regime scarcely operated with such a voice. Instead, there were rival networks of power and influence including the competing agencies of the central government, as well as the Nazi Party, the SS, the *Gauleiters* (local governors) and the military. Hitler presided over the system, but, lazy and far from able, he could not provide consistency let alone direction, particularly in domestic government.

Anti-Semitic Action

Alongside violence came discriminatory legislation, such as the removal of Jews from much of professional life and landownership in 1933, and the banning of marriages between Jews and non-Jews in 1935. Inequality before the law became a feature of life in Nazi Germany, and encouraged Jews to emigrate. By 1938, more than half had done so, their assets being seized. That June, a decree requiring Jews to register their wealth was a prelude to moves towards expropriation.

Kristallnacht

In the *Kristallnacht*, Night of the Broken Glass, in Germany on 9–10 November 1938, synagogues and Jewish businesses and homes were destroyed and damaged, without the police intervening. Ordered by Hitler, this was a deliberate attempt not only to intimidate Jews, so as to speed up their emigration, but also to destroy their cohesion and presence in society, and thus to annihilate their identity in Germany.

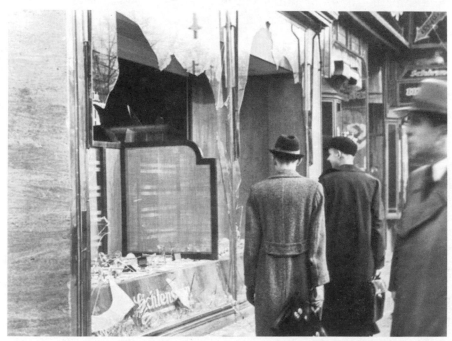

Kristallnacht, the Night of Broken Glass, a pogrom in Germany on 9–10 November 1938, took its name from the broken glass outside synagogues and Jewish-owned buildings. Alongside destruction including arson, there were murders and mass-arrests. This was a key move in the acceleration of the persecution of Jews.

About 1,000 synagogues were destroyed and as many as 7,500 businesses attacked. There was also much looting. The violence was at once brutal and symbolic. After the *Kristallnacht*, in which possibly several hundred Jews were killed, the number of Jews held in concentration camps sharply increased by about 30,000, as did their murder there.

Looking at the World: Pan-Regions

Hitler favoured right-wing German geopoliticians who, very much in reaction against defeat in the world war and the Versailles peace settlement, pressed the case for German territorial gains. The leading figure, Karl Haushofer, a former general, advanced the idea of pan-regions, notably *PanEuropa* (under Germany), *PanAsien* (under its Asian ally, Japan), and *PanAmerika*. These pan-regions were seen as providing these powers with security and resources. There was no real role for the British empire in this system.

The League of Nations and Appeasement

In the 1930s, the League was unable to restrain the expansionist powers. Instead, there was an attempt to restrain them through negotiation, notably the 1938 Munich Agreement. Castigated as Appeasement, and stemming in large part from the determination to avoid a repetition of the devastation of World War I, this attempt failed in the face of Hitler's continued aggression, leading to the outbreak of World War II in 1939. Appeasement was also an attempt to seek a peaceful solution, one stemming from concern about what another major war would bring, concern that was greatly enhanced by belief in the effectiveness of air power.

STALINISM

Under Stalin, Leninism was driven to fruition: the Soviet Union was taken into state ownership, the country was forced into centrally driven industrialization, and, in place of the willingness to allow peasants to trade in food under the New Economic Policy of 1921, collectivization was violently imposed on the countryside. Allowing for the deceptions of

Soviet propaganda and for the disaster of rural collectivization, there was important development in the Soviet economy, not least because there was continuing scope for recovery from war and revolution, as output in 1928 was still below that in 1913. There was a major expansion of the industrial sector and of electricity generation, albeit as a result of the state-driven focus of resources on developing industry at a heavy cost in terms of the everyday life of the population. Military industry was greatly expanded, with particular attention devoted to the production of tanks and aircraft.

Stalin's perceptions of encirclement by hostile powers, capitalist crisis and inevitable, imminent war, generated his policies of breakneck modernization, the total mobilization of resources to pursue the cause of the proletarian revolution. Terror and government-tolerated famine killed many millions, the latter notably so in Ukraine in 1931–3 where the peasants were treated as enemies of the people who deserved to die. It was the same story with the treatment of allegedly dangerous and traitorous Poles and Germans in the western borderlands of the Soviet Union in 1932–3, most of whom were soon killed. Frustrated by the persistent gap between intention and implementation, the regime in the 1930s adopted even more radical and totalitarian impulses and initiatives. These led, in the purges of 1937–8, to the large-scale killing, torture and imprisonment of those held to threaten the revolution or regarded as untrustworthy, including many former Communist leaders and much of the military leadership.

Trotskyism was an allegation that was frequently applied, and a key aspect of belief that there was plotting against the regime by internal and foreign enemies. The purges were designed to destroy a fifth column that did not really exist, but the so-called mass operations that were launched were intended to bring the civil war of the early 1920s to its culmination by purging society. Quotas for the arrest of enemies were imposed on the NKVD secret police, which was put under great pressure in order to ensure that the campaign fulfilled its purposes. This contributed to the many wrongful arrests and torture of the late 1930s.

The very large numbers imprisoned in the Soviet gulags, or labour camps – about 2.3 million in 1941 – played a major role in the economy and, in particular, in opening up the north in the 1930s, notably with construction, mining and forestry. Soviet demographic displacement can be related to earlier practices of imperial and colonial penal

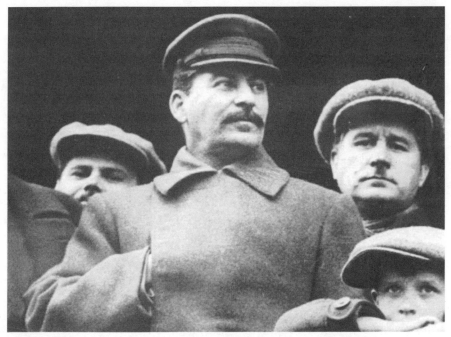

Joseph Stalin (1878–1953), brutal Soviet dictator and would-be modernizer from the mid-1920s until his death. Such posed images were characteristic of his rule.

transportation, including of Russians to Siberia prior to the Revolution; but, under Stalin, the scale was far greater, the cruelty more pronounced and the consequences more murderous. Aside from political prisoners, entire social categories were sent, notably *kulak* (peasant proprietor) deportees and their families in the early 1930s.

Stalinist Foreign Policy

The tensions within Soviet foreign power, already apparent in the 1920s, were seen again in the 1930s, not least in disagreement over how far to create popular fronts with non-Communist parties, as in France. The interplay of ideology, strategic goals and tactical advantage seen in these, and other, episodes was scarcely unique to the Soviet Union. It was also seen, albeit differently, in the Anglo-French

response to the rise of the Fascist dictators, which critics characterized as Appeasement. This interplay underlines the difficulties contemporaries found in evaluating Soviet intentions and policy.

In its own eyes, Stalinism was a modern form of government, reliant on scientific planning, and itself the expression of the direction of world history and human progress. However, in practice, Stalinism was pre-modern and dependent on myth and faith in place of adequate information and planning. The paranoia of the regime and its reliance on denunciation helped ensure the slaughter of many of the abler members of society. Informing on others was not new, but it was systematized.

From the late 1930s, there was a focus in Soviet cinema on tsars who could serve to demonstrate the need for transformative efforts against foreign threats, notably Peter the Great and Ivan the Terrible. Thus, Russian history was interpreted in the light of the present, with these rulers appearing as progenitors of Stalin.

The cruelty of Stalinism was underplayed by left-wing visitors and commentators in the West. Indeed, there was a disturbing level of wilful misrepresentation, one that was to be eventually mocked in George Orwell's parable novel *Animal Farm* (1945).

Joseph Stalin (1879–1953)

Born Josef Vissarionovich Dzhugashvili in Georgia, Stalin did not start to learn Russian until he went to school at the age of eight. He was beaten savagely by his drunken father who died when Josef was 11, then his doting mother groomed him for the Orthodox priesthood. At his seminary, he earned the nickname Koba, after a famous Georgian bandit and rebel, for his anti-tsarist views. He quit to become a revolutionary organizer.

When the Social Democrats split in 1903, he joined the Bolshevik faction under Lenin. He organized bank robberies to fund the party, joining the Central Committee in 1912, and

took the name Stalin, which means 'man of steel'. He became the editor of the Bolshevik paper *Pravda* – 'Truth' – but was exiled to Siberia in 1913, returning to Petrograd to play a key role in the revolution of 1917. He built up a loyal following as Lenin's Commissar for the Nationalities. During Lenin's illness, he became General Secretary of Party, and put himself in position to become the next leader of the USSR.

When Lenin died in 1924, despite Lenin's belated attempt to remove him, Stalin took over, ruthlessly crushing all opposition. In 1928, he began an ambitious Five Year Plan to industrialize Russia, funded by the export of grain, and continued the collectivization of farming which resulted in a major famine.

As the new leader of the party seeking to shore up his position, he worked quickly to remove his rivals. When they could not be discredited or quietly removed, he turned to more violent means. In 1934, Stalin organized the murder of his colleague and potential rival Sergey Kirov, and then used the assassination as a pretext for a purge. Between 1936 and 1938, there were a series of show trials, with thousands of party officials and senior army officers found guilty of treason and executed. By 1939, of the 1,966 delegates to the 1934 party congress that had backed Kirov, 1,108 were dead; of the 139 members elected to the Central Committee that year, 98 were dead. Meanwhile Stalin's secret police chief Lavrenti Beria, a fellow Georgian, had arrested millions of ordinary people, executing, exiling or imprisoning them in labour camps.

By 1939, there was no opposition in the Soviet Union, but the nation had been weakened by the extensive purges. Appalled, the Western nations refused to make any treaties with Stalin, leading him to sign a non-aggression pact with Hitler. Under a secret protocol, they agreed to divide Poland between them. During World War II, Stalin took personal control of the army, and threw millions of ill-equipped and poorly-trained men into the fight, eventually turning the tide with sheer weight of numbers. In 1953 he died of a brain haemorrhage.

CHINA

The challenge to the *Guomindang* from the Communists was affected by the latter's serious divisions over strategy, which overlapped, but were not identical, with those in the Soviet Union. Leading Communists, such as Li Lisan, secretary-general of the Communist Party from 1928 to 1931, followed the traditional interpretation of Marxist-Leninism, with its emphasis on cultivating the urban proletariat. In contrast, a number of leaders, including Mao Zedong, more correctly perceived that the real potential in China, very differently from the Soviet Union, rested with farm labourers. However, in considering Mao, it is necessary to appreciate the degree to which his reputation was subsequently enhanced and given a misleading consistency. Defeated in the cities, where they provided a concentrated target, the Chinese Communists' Red Army was more successful in resisting attack in rural areas, especially in the traditional hideouts of social bandits, namely remote and mountainous areas such as the Jinggang highlands of the Hanan-Jiangxi. Mao regarded the rural base as an essential part of his revolutionary strategy. Without a base, it was impossible to develop a fighting force or to implement a revolutionary programme in order to obtain/compel the support of the rural population.

The conflict escalated into a series of large-scale *Guomindang* 'anti-bandit' campaigns in 1930–4. The *Guomindang* was unable to destroy the Communists, but retained a position of dominance in China. However, they were greatly weakened by the long war with Japan.

The Long March

Under heavy pressure from increasingly successful *Guomindang* forces, the so-called First Red Army in October 1934 launched a break-out from Jiangxi, beginning the Long March across several thousand miles of difficult terrain to Shaanxi, in which most of those who set off fell by the wayside. Important to Mao's consolidation of control over the Chinese Communist Party, this march was to be important to the subsequent origin-account of the Communist state. In terms of power in society, however, it was a march from nowhere to nowhere.

JAPANESE IMPERIALISM

Hit by severe economic problems and weakened governments, Japan moved in a more militaristic direction in the 1930s. Politicians willing to stand up against the military were murdered, notably prime minister Inukai Tsuyoshi in 1932.

Invasion of Manchuria

In 1931–2, Manchuria, China's leading industrial region, was occupied by Japan. Bellicose Japanese officers, concerned that Japan's existing leased rights were under threat, overran the region, benefiting from Jiang's unwillingness to support the local warlord. Jiang was more concerned about the Communist challenge. There were several reasons for Japan's invasion of Manchuria. The vast areas of undeveloped land and abundant natural resources were ripe for exploitation. More urgently, Japan's existing economic interests in Manchuria were under threat from Chinese nationalists, who were hoping to drive out foreign-owned businesses from China. In September 1931, Japan engineered a crisis in Manchuria as a pretext for an invasion. A Japanese force moved in and asserted control. Manchuria was renamed Manchukuo and a puppet government was installed there under Emperor Henry Pu Yi. Japanese forces occupied the Chinese province of Jehol to create a buffer zone, and threatened Beijing. Denunciations of Japanese aggression at the League of Nations were not matched by action, and in May 1933 China agreed a truce that accepted Japanese control of Manchuria.

War with China

In 1937, full-scale war with China began. In part, it was the result of an unplanned incident: a clash between Chinese and Japanese troops near the Marco Polo Bridge outside Beijing during Japanese night exercises. However, it was felt in Japan that, in order to prepare for conflict with the Soviets, China should be persuaded to accept her fate as a junior partner of Japan. Jiang's uncooperativeness prompted Tokyo to try to give him a short, sharp lesson. The war was initially successful, with Beijing, Shanghai and Nanjing conquered in 1937, the latter two cities being conquered after very heavy fighting. By the end of 1938, the Japanese had progressed along the lower Yangtze River valley beyond Hankou and had won control of several ports in southern China, including the major cities of Guangzhou and Canton. This 'Incident', as it was misleadingly called

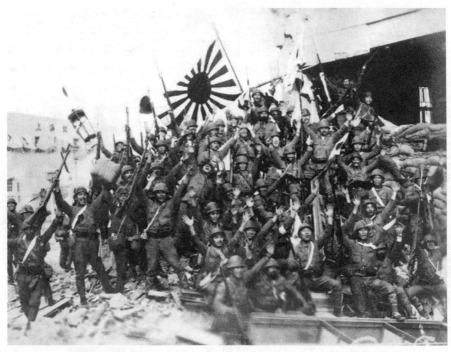

Japanese soldiers celebrating the capture of Shanghai, one of China's most important ports, in December 1937. This proved to be a key episode in the most successful campaign of what became an intractable war.

by Japan, left the country with an intractable commitment: an expensive war that could neither be won nor abandoned. The Chinese adoption of guerrilla tactics, scorched earth and sabotage effectively stalled the Japanese advance.

THE WESTERN EMPIRES UNDER PRESSURE

The European empires faced growing nationalist pressures in the 1930s. Thus, in India, there were demands for independence from Britain, as well as more specific agitation, such as a No-Rent campaign in 1930–2. The British also faced nationalist opposition in Burma (Myanmar), Malta and Palestine, where the Arab Rising of 1937–9 was a reaction against large-scale Jewish settlement. There was also criticism of the consequences of empire. In Australia, the Aborigines complained about their erasure from national memory. In 1938, a 'Day of Mourning' was held in Sydney by the Australian Aborigines' Progressive Association, at the same time that the sesquicentennial celebrations for the original British landing were

being held. Formed in 1925, the Association pressed for full citizenship rights and for land as compensation for dispossession.

Yet, it is far from clear that the British or other empires would have collapsed but for the disruption and turmoil of World War II. The Arab Rising was suppressed in 1939, and in no other colony was there as serious opposition. Moreover, the Commonwealth showed a capacity for development. In what was perceived as freedom within a developing system, the Statute of Westminster in 1931 ensured that no law enacted after that date by Britain should extend to a dominion state unless that state had requested and consented that it should be so. Moreover, legislation in 1935 opened the way for moves toward self-government in India. This was an instance of the extent to which European concepts such as liberalism were spread within imperial structures, alongside anti-imperial ideas, such as nationalism and Communism. Protectionism made imperial links more significant, as in the 1930s advertisement sporting the Union Jack: 'Wherever flies the flag that's braved a thousand years the battle and the breeze, there Beecham's Pills will triumph o'er disease.'

Canada
The worldwide depression during the 1930s hurt demand for Canadian exports, including food, minerals and timber. Thousands of Canadian factories, coal mines and shops closed, and hundreds of thousands lost their jobs. Relief camps were established and aid given to the poor, but strikers and protestors were harshly treated. Canada entered World War II in September 1939. Over a million Canadians served, and some 90,000 were killed or wounded.

New Zealand
New Zealand contributed more than 100,000 troops to the Allied war effort in World War I, and suffered appallingly high casualties of around 60,000 out of a population of just over a million. The Labour Party was elected in 1935, in the midst of the Great Depression, and embarked on an ambitious programme of social reform, establishing a national system of social security, free health care and free education. During World War II, New Zealand was once again an enthusiastic supporter of the Allied cause, conscripting 200,000 troops, most of whom were placed at the service of Britain. After 1941, much of New Zealand's

war effort was dedicated to providing food and equipment for US forces fighting the Japanese, and this earned them a place at the peace negotiations that followed.

Naming the Map

Imperial powers used mapping and naming as ways to stamp their presence in territories of interest. In 1932, Britain established the Antarctic Place Names Committee to ensure that British maps, at least, reflected official views and naming conventions. The excluded categories encompassed names of existing territories, towns or islands, names in any foreign language, names of sledge dogs, 'names in low taste', and 'names with obscure origins'. British maps omitted names found on Argentine and Chilean maps. The creation by Britain in 1945 of the Falkland Islands Dependencies Survey was followed by more mapping in order to consolidate British territorial claims.

Empire and Aircraft

Geopolitical considerations encouraged the development of air services to link imperial possessions, notably by the British to Hong Kong, Australia and South Africa, by the Italians to Libya, and by the French to Syria and West Africa. Air travel was very important to the development of individual colonies and offered Britain a way to administer a global empire. In particular, air services were both faster than steamships and could move into the interior of countries.

Air power was also employed against insurrections. It appeared to marry what was presented as inherently desirable Western control to modernization, which was very much a theme of imperial ideology.

LATIN AMERICA

The Great Depression hit the Latin American economies hard, as their export revenues fell greatly, savaging public finances. Social tension rose with economic difficulties. Economic nationalism, which was a major response, was matched by the establishment of authoritarian rule, as

in Brazil under Getúlio Vargas, the Dominican Republic under Rafael Trujillo, Peru under Óscar Benavides and Uruguay under Gabriel Terra. National identity and unity were presented as requiring authoritarian policies and a politics of self-reliance, for example in the Brazilian *Estado Novo* (new state) established by Vargas, president from 1930 to 1945 and again from 1951 to 1954. A populist anti-Communist, Vargas acted as dictator from 1937 to 1945, modelling himself on Mussolini. Political parties were abolished and censorship imposed. Benavides, president of Peru from 1933 to 1939, who came from a military background, banned opposition parties. Trujillo ran the Dominican Republic from 1930 until he was assassinated in 1961. Commander-in-chief of the army, he established a one-party state, killed opponents and founded a personality cult.

Coups and attempted coups played a major role in Latin American politics. The military, which were a major call on public finances, tended to enforce the conservative social order. Thus, the army in Honduras was used to crush peasant opposition in 1932 and 1937, while, in El

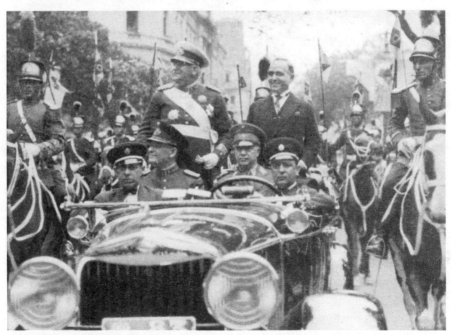

Getúlio Vargas, on the right in the car, was President of Brazil from 1930 to 1945 and 1951 to 1954. A modernising populist, he benefited from the military revolution in 1930 and created from 1937 a more centralised government.

Salvador, General Martínez, who had seized control of the country in 1931, suppressed peasant opposition with a series of massacres in 1932, the year in which the labour movement was suppressed in Bolivia and a 'constitutionalist' revolt defeated in Brazil.

American political and economic influence was to the fore in Latin America, with British influence largely limited to Argentina. However, the only international conflict of the period, the Chaco War between Bolivia and Paraguay in 1932–5 over competing territorial claims, did not spread, as conflict in the 1860s had done. Paraguay won the war, defeating the more affluent Bolivia.

THE SPANISH CIVIL WAR

Discontent had been growing in Spain throughout the first few decades of the 20th century. Society was deeply polarized, as a tiny minority owned a majority of the country's land, the Catholic Church was in thrall to an extremely reactionary faction, and, in the 1930s, the Great Depression hit workers hard. Various protests, ranging from anticlerical to anarchist and separatist, wracked Spain in the 1920s, and 1931 saw the fall of the dictator Primo de Rivera, the abdication of King Alfonso and the establishment of the Second Republic.

The instability of the new republic declared in 1931 was taken to a height in July 1936 when a right-wing military coup sought to seize power. This represented a culmination of the pre-war polarization in which too few politicians and commentators across the political spectrum were willing to acknowledge the essence of democracy: a willingness to accept results that benefited opponents. Instead, violence became more persistent and the threat of violence even more pervasive. Those who mounted the coup were opposed to the modernizing policies of the left-leaning government, concerned about anti-clericalism and Communism, and, in practice, against the republic and, with it, democracy and freedoms. The coup, however, did not fully succeed, and this led to a bitter civil war that lasted until 1939. Outside powers provided assistance: Italy and Germany to the right-wing Nationalists, and the Soviet Union to the left-wing Republicans. The latter were both divided and outfought, in part suffering from their inability to master logistics, and a brutal Fascist dictatorship was created under Francesco Franco, an authoritarian general who ruled until his death in 1975. The civil war attracted considerable international attention as an ideological struggle of left versus right.

Spanish Voices

Federico García Lorca (1898–1936), a noted Spanish poet and playwright, questioned established social norms. His play *The House of Bernarda Alba* (1936) explored practices of repression and family control by a callous matriarch who is concerned only with public reputation, tradition and chastity. It was not performed until 1945, and then in Buenos Aires, not Spain. A Socialist and a homosexual, Lorca was murdered by Nationalist militia in 1936.

Lorca's close friends included Luis Buñuel (1900–83) and Salvador Dalí (1904–89) who together made *Un Chien Andalou* (1929), a Surrealist film shocker. Buñuel's film *Las Hurdes: Tierra Sin Pan* (1933) was a bitter criticism of peasant poverty. Having experimented with Cubism, Dalí became a leading Surrealist painter.

CULTURAL ICONS

The cultural maelstrom of the 1930s reflected the contention of styles, politics and markets. Intellectuals tended to focus on Modernism and its challenge to traditional forms and assumptions, but most popular art was Realist in style even if the plots offered were often improbable. This was the case with Agatha Christie and with other 'middlebrow' and 'lowbrow' writers and the availability of inexpensive books and periodicals and of increased leisure. Popular styles tended to suggest continuity, not the new, and Lorca's challenge to the social order, for example, was less common than works that rested on a desire to satisfy the popular market. Thus, John Galsworthy received the Nobel Prize for Literature in 1932 and contrasted greatly with the interior monologues of Virginia Woolf's *The Waves* the previous year. There was a similar contrast between the architectural Modernism of Walter Gropius and his Bauhaus movement and the revived Classicism that was so popular.

The World of Christie

The most successful detective writer of the century, Agatha Christie (1890–1976), a very different writer to Lorca, had American parents, but

was born and lived in Britain. The popularity of her work reflected that of detective fiction as a whole, a field in which women proved particularly important as writers in the 20th century. Her most famous detective, the Belgian-born Hercule Poirot, was a cosmopolitan figure, introduced in *The Mysterious Affair at Styles* (1921), but was comically naturalized by Christie, so as to understand Britain or, at least, England. Abroad, Poirot visited France but also the British empire, notably Egypt and Iraq. The murders the conservative Christie reported were generally the product of an arrogant rejection of social norms, and bad blood was a standard Christie theme. Television and film gave Christie's novels another life, while her plays include *The Mousetrap* (1948). Christie's image of England was one of lasting appeal to her readers and viewers. The march of technology has brought it still more life with audiobooks.

The World Economy, 1930–9

Protectionism was a key element in the economic politics of the decade. The Hawley-Smoot Act of 1930 put up American tariffs and depressed demand for imports. Other states followed suit, leading to a worldwide protectionism that, in what became the Great Depression, dramatically cut world trade, and therefore hit the economic system that the United States and Britain dominated. As export industries all over the world were affected by protectionism in markets, so unemployment rose substantially. Thus, alongside a fall in manufacturing, came depressed demand that greatly hit commodity producers in mining, forestry and agriculture. This affected Latin America badly. Unemployment and poverty played a part in the extent of looting during political violence, for example anti-Semitism in Germany and Austria. Indeed, in one respect, anti-Semitism was a gigantic looting exercise, although far more was involved.

At the same time, the period saw the growing production of consumer goods, notably cars, radios and electrical goods. Moreover, electricity was regarded as a great force for economic modernization, for example in the Soviet Union.

There and in the USA, there was major investment in an ambitious programme of dam building, as with the Hoover Dam.

Both Stalin and Hitler supported protectionist policies of economic self-reliance or autarky, and were opposed to the free-market international economic system centred on Britain. Hitler claimed in 1931, 'My job is to prevent the millions of German unemployed from coming under Communist influence.' Other authoritarian political systems made the same claim, as in Vargas' *Estado Novo*. Industrialization was a common theme. At the same time, there were major differences: Hitler was ready to court businesses, and scarcely challenged social inequalities, whereas the Soviet Union focused on state ownership and state-controlled social promotion.

Democracies, including Britain, also moved toward more protectionism. The abandonment of the Gold Standard – the exchange for currencies into gold at a fixed rate – was another aspect of the move toward national, rather than international, standards of value.

One aspect of the change in economic values was a general move against immigration. This affected those seeking economic opportunity, but also others fleeing persecution, notably Jews desperately seeking to leave Germany and Austria.

TECHNOLOGICAL ADVANCES

The worldwide spread of advanced technology was important in the 1930s to the global economy and to societies across the world. Trade encouraged the diffusion of new processes, as did a determination to match other powers and a quest for progress. Americanization was at play, but so were narratives of development presented by the Soviet Union and by imperial powers. Thus, the British used mechanical dredgers to attack the *sudd* (blockages of vegetation) seen in major Sudanese rivers, constructed new port facilities at Port Sudan and extended the territory's railway system.

The cumulative impact was that of a change that did not always meet hopes, as with Soviet collectivization, but that represented an implementation of the potential of the new, an implementation driven in particular by consumerism, capitalism and state action. Transport was a key aspect of this and an enabler of further change. In his futuristic novel of foreboding *Brave New World* (1932), Aldous Huxley prophetically noted: 'From the grounds of the Internal and External Secretion Trust came the lowing of those thousands of cattle which provided, with their hormones and their milk, the raw materials for the great factory at Farnham Royal.'

Penicillin

The medical repertoire improved in the inter-war years, in part because Alexander Fleming's serendipitous discovery of penicillin in 1928 launched the antibiotics revolution. Its isolation and production as a drug led to the antibiotics revolution that began in the 1940s and that transformed the treatment of diseases such as gonorrhoea, and also made it possible to combat epidemic diseases such as tuberculosis. There was also progress in other areas of medical and surgical practice, including transplants, although not at all on the scale that was to follow World War II.

Cars and the News

The spreading use of cars affected many aspects of society, including design, policing and the news. A speeded-up quality to the news was provided by the role of cars in both crime and policing. Cars also offered a means for the authentication of news. Journalists were made individual as well as mobile by getting out of the office and into cars. Going to the news, to witness it, made it easier to provide items, and thus to file newspaper copy, and in a distinctive fashion. The news could be telephoned in (albeit without the mobile phones of the present day, so that the journalist required a plentiful supply of coins for coin-operated phones), or the journalist could race back to the office. Cars that did not need to be cranked but, instead, had self-starting engines were faster.

Radar

While the idea of a death ray, which was considered in 1935 by the British Aeronautical Research Committee, was not viable, radio waves were used as the basis for radar. In 1904, the German inventor and physicist

Christian Hülsmeyer first used radio waves to detect the presence of distant metallic objects, and from 1936 Britain built a chain of radar-equipped early-warning stations. Able to spot aircraft 160 km (100 miles) off the southern coast of England, these stations were linked to centralized control rooms where data was analysed and then fed through into instructions to fighters.

Aircraft Technology

Manned heavier-than-air flight, first officially achieved by the American Wright brothers in 1903, was rapidly followed by the development of the military and commercial possibilities of air power, and by its technological range. World War I greatly accelerated changes in air capacity. The use of aircraft for combat led to considerable investment in their development, and to a marked rise in the specifications of machines, for example their speed and manoeuvrability. Air power exemplified the growing role of scientific research in military capability: wind tunnels were constructed for the purpose of research. Strutless wings and all-metal aircraft were developed. Engine power increased and size fell. The speed and rate of climb of aircraft rose. In 1919, a converted British bomber was the first aircraft to cross the Atlantic non-stop.

From the 1910s, water-cooled aircraft engines were replaced by the lighter and more reliable air-cooled engines, while some aircraft came to be made of an alloy of aluminium, which provided strength and durability. In the 1920s and 1930s, major advances included improved engines, high-octane fuels and variable-pitch propellers. The 1930s saw the diffusion of important developments, including all-metal monocoque construction, which gave aircraft strength and lightness: loads were borne by the skin as well as by the framework. Retractable (as opposed to fixed) landing gear helped with wing resistance. There was also night-flying instrumentation and radio-equipped cockpits.

Air services developed rapidly in the 1920s and 1930s, notably in the United States, with the network of routes and the number of airports and aircraft expanding. Journey times progressively shortened, but the range of most aircraft was such that frequent refuelling was necessary. It was not until 1939 that a passenger aircraft was introduced that was able to fly the Atlantic non-stop. Nevertheless, by then, aircraft had clearly established their superiority to the earlier technology of gas-filled airships. Commercial air services became a challenge to long-distance rail ones. They also crossed

oceans. In 1938, Italy began services from Rome to Rio de Janeiro via Lisbon and the Cape Verde Islands.

The Potential of Flight

The pace of technological development led in a number of directions. In his presidential address to the American Rocket Society in 1931, David Lasser discussed the potential of rocket shells, which could carry their own fuel, and of rocket aircraft flying at over 4,800 kph (3,000 mph) and threatening 'an avalanche of death'. In the Soviet Union, Konstantin Tsiolkovsky developed a theory of rocket flight that encouraged the use of liquid propellants for rockets. Igor Sikorsky, a Russian who had emigrated to the United States, developed the first successful helicopter, the VS-300, in 1939. The Germans made progress with developing radio-guided gliding bombs, which became operational in 1943, and the British, Germans and Italians with aircraft jet engines.

World War II, 1939–1945

On 9 December 1941 following the Japanese attack on Pearl Harbor two days earlier, President Roosevelt declared, 'All the continents in the world, and all the oceans, are now considered by the Axis strategists as one gigantic battlefield...' Indeed, World War II was a global conflict to a degree not seen in World War I, and one unprecedented in scale in world history. This war saw terrible damage for the countries of Europe and East Asia, and was the only one so far in which atomic weaponry was used. The war left a world in which the United States was clearly the leading power. It also saw the Soviet Union become the leading power in Eurasia. Approximately 22–25 million military personnel and 38–55 million civilians died.

BEGINNINGS

Europeans usually begin the war in 1939, when the German invasion of Poland on 1 September led Britain and France, which had guaranteed Poland's sovereignty, to go to war with Germany two days later after Hitler had refused to draw back. However, in the Soviet Union, the 'Great Patriotic War' with Germany is taken as starting on 22 June 1941. This year also engages American attention, as on 7 December it saw the Japanese attack on Pearl Harbor force America's entry into the war despite strong isolationist sentiment.

Nevertheless, as discussed in the previous chapter, large-scale warfare really began with the Japanese invasion of China in 1937. This launched the chain of events that was to lead eventually, with Pearl Harbor, to a determination to prevent the United States from blocking Japan's dominance of East Asia. Japan's inability to knock China out, despite not having to fight other opponents, also prefigured Germany's failure to do the same with Britain and the Soviet Union. Both Germany and Japan were aggressive as well as expansionist powers, and their aggression drove the pace of the early stages of the war.

As with World War I, the view that the war was a general systems failure of the international system is wrong. Instead, it also arose due to aggression by particular powers – Germany and Japan – that gained valuable, additional benefit from the neutrality of the United States in the crucial early stages. However, the revisionism seen in discussions of the origins of World War I suggests what may follow with World War II. In particular, German revisionism is gathering pace in a fashion that would have been considered surprising 30 years ago.

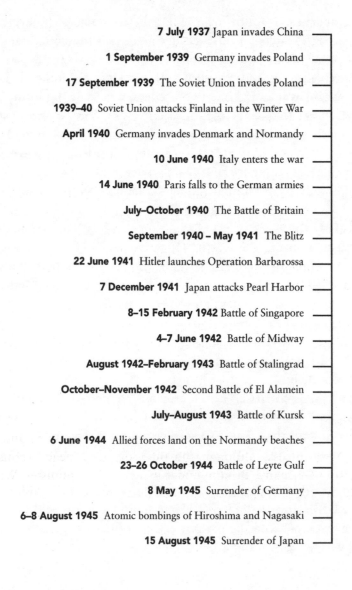

7 July 1937 Japan invades China

1 September 1939 Germany invades Poland

17 September 1939 The Soviet Union invades Poland

1939–40 Soviet Union attacks Finland in the Winter War

April 1940 Germany invades Denmark and Normandy

10 June 1940 Italy enters the war

14 June 1940 Paris falls to the German armies

July–October 1940 The Battle of Britain

September 1940 – May 1941 The Blitz

22 June 1941 Hitler launches Operation Barbarossa

7 December 1941 Japan attacks Pearl Harbor

8–15 February 1942 Battle of Singapore

4–7 June 1942 Battle of Midway

August 1942–February 1943 Battle of Stalingrad

October–November 1942 Second Battle of El Alamein

July–August 1943 Battle of Kursk

6 June 1944 Allied forces land on the Normandy beaches

23–26 October 1944 Battle of Leyte Gulf

8 May 1945 Surrender of Germany

6–8 August 1945 Atomic bombings of Hiroshima and Nagasaki

15 August 1945 Surrender of Japan

GERMAN SUCCESSES 1939–41

The rapid conquest of Poland was followed by other triumphs won at modest cost to German forces. In 1940, Denmark, Norway, Luxembourg, the Netherlands and France were conquered. The first two were attacked on 9 April, the others on 10 May. Yugoslavia and Greece followed in early 1941. These German successes owed much to the combined arms tactics and operational seizure of the initiative and mobility all summarized as blitzkrieg (lightning war). Tank advances played a dramatic role. In practice, poor Allied strategy also played a major role, notably defending overlong perimeters (Poland; Yugoslavia; France moved forces too far forward into Belgium), placing reserves in the wrong place (France), and responding too slowly to the pace of developments (France). Nevertheless, the net result was a Germany that dominated the European landmass west of the Soviet Union. France surrendered on 22 June, and much of it was occupied by Germany, with a rump and partly demilitarized France ruled by a pro-German regime established in Vichy.

This process was eased for Germany by its alliance with the Soviets from 1939 to 1941 under the Ribbentrop-Molotov Pact, named after their foreign ministers. Indeed, on 17 September 1939, in accordance with the Pact, the Soviets invaded Poland, although Britain and France did not declare war. In 1939–40, the Soviets also attacked Finland, in the 'Winter War', in which, after initial failures, they were finally successful; and, in 1940, annexed the Baltic Republics and territory from Romania. In each case, there was a brutal treatment of the population, with large-scale slaughter and the wholesale movement of people to labour camps. Whereas in Poland the Germans acted brutally in accordance with their racist ideology, in the Soviet zone the slaughter was on class grounds. That does not make it any better.

BRITAIN FIGHTS ON

British forces were defeated and driven from the Continent in 1940 (from Norway and France, the latter particularly at Dunkirk) and 1941 (Greece). Nevertheless, although the offer of good peace terms was available from Germany, Britain, under its new prime minister, Winston Churchill, fought on. The assistance of the empire was tremendously significant on the global scale, but, in repelling German air attacks in the Battle of Britain (1940), and staying resolute in the face of a bombing campaign in the Blitz (1940–1), Britain ultimately relied on its own

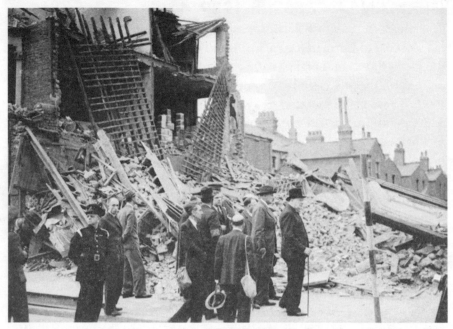

The Blitz. The destruction wrought on British cities, notably London, by German bombers in 1940–1 did not have strategic effect as it failed to break morale. The photograph shows Winston Churchill, the Prime Minister, surveying the damage.

efforts. Both were damaging, but neither wrecked civilian morale nor could act as a substitute for the German inability to mount an invasion. Such an invasion, Operation Sealion, was planned in 1940, but the failure to win air and sea superiority meant that the Germans, who had not made adequate preparations, had to abandon the plan. In contrast, the Allies were to be far, far better prepared when they invaded Normandy in 1944. This left Germany from late 1940 with an enemy in its rear as it prepared to attack the Soviet Union, an enemy, however, that was not able to challenge Germany's dominance of Europe.

Winston Churchill (1874–1965)

Though he entered politics in 1900, it was not until 40 years later when he became Britain's wartime prime minister that Winston Churchill found the role he was born to fill.

He had been born into an aristocratic life at Blenheim Palace, in 1874, joining the army in 1895. He began his political career in 1900, first as a Conservative, then from 1904 to 1924 as a Liberal. He returned to politics as a Conservative in 1924 and for five years was Chancellor of the Exchequer.

In the 1930s Churchill called for British rearmament to counter the growing threat of Nazi Germany and by 1940 replaced Neville Chamberlain as Prime Minister, promising that 'I have nothing to offer but blood, toil, tears and sweat'. His indefatigable spirit was just what Britain required in wartime and he is widely acknowledged as being the main reason Britain was able to repel fascism.

When the Conservatives were ousted from power in 1945 he warned presciently of the 'Iron Curtain' coming down in eastern Europe. He returned as PM for four years in 1951, but was weary and preoccupied with foreign policy including the Korean War.

Although acts like the Bombing of Dresden, his failure to ease the Bengal famine crisis and views on imperialism and race caused controversy, it is generally considered that his achievements far outweighed these faults.

THE BATTLE FOR NORTH AFRICA

Hitler's victories in Western Europe encouraged Italy under Mussolini to enter the war against France and Britain on 10 June 1940. Axis forces tried to cut off British oil supplies from the Middle East and seize control of the Suez Canal by attacking the Allies in Africa. He pressed on that year to attack British colonies, notably Egypt, from Italy's neighbouring colony of Libya; as well as Greece from Albania, which Italy had conquered in 1939. The total failure of these attacks led to German intervention on his behalf in early 1941 in North Africa, against Greece, and also in the Mediterranean where the British had done well against the Italian navy.

This intervention helped drive the British back in North Africa, although, elsewhere, the British, with much support from imperial forces, notably from Australia, India, New Zealand and South Africa, conquered Eritrea, Ethiopia and Somalia from Italy, Lebanon, Syria and Madagascar

from Vichy forces, and Iraq from anti-British nationalists. Combined, this was a formidable achievement, one that receives insufficient attention but that affected the subsequent history of many countries. The range of Axis options was dramatically reduced by these British successes, notably the possibility of a global strategy designed to see cooperation with Japan.

In the summer of 1942, the Germans advanced to within striking distance of the Nile Valley. German forces under Rommel were just 320 km (198 miles) from the Suez Canal. However, the British held back the German advance, before successfully counterattacking that autumn in the Battle of El Alamein. The Germans fell back, across Libya, to Tunisia, while also under pressure from a largely American force that had successfully invaded Morocco and Algeria in November, seizing them from Vichy forces. In the spring of 1943, affected by the converging advance of their opponents, the Germans in Tunisia were defeated and forced to surrender. Italy was now vulnerable to invasion.

The Battle of El Alamein

El Alamein marked the high-point of German expansion in World War II. Axis forces had continued to advance through North Africa under the command of Field Marshal Erwin Rommel. Tobruk fell to Rommel in June 1942, opening a path to Egypt and towards the Suez Canal, a vital point in the Allied supply chain. The German spearhead reached the Allied defences at El Alamein on 30 June 1942. The Allied forces comprised a mix of British, Australian, South African, New Zealand and Indian troops. The initial combat resulted in a stalemate as Rommel's Afrika Korps reached the limits of its supply line. On 13 July 1942, the First Battle of El Alamein began. Rommel's attack was swiftly followed by a counter-attack from the Allied Commander, Sir Claude Auchinleck. While it stopped Rommel's advance, it failed to drive him back. The line between the two forces was heavily fortified and mined. Any attempt to dislodge the opponent would prove extremely difficult. The Allied forces awaited reinforcements, but Auchinleck's extreme caution led to his replacement on

13 August by Bernard Montgomery. The next attack began on 31 August. But shortly before it began, the RAF launched an attack of its own. Again, the result was stalemate. On the night of 23 October, the Second Battle of El Alamein began in earnest. The entire line, with more than 1,000 guns, opened fire on the German position and the infantry began its treacherous advance through the minefields. After ten days of vicious fighting, the result was an unquestioned Allied victory. The Axis forces would not be able to recover their position in North Africa after the defeat and soon it was the Allies who dominated the Mediterranean.

The Tools of War

Mobility dominated the images of the war: tanks on land, aircraft carriers at sea, aircraft in the air. The numbers built were unprecedented, and their skilful tactical use provided the opportunity for operational impact and strategic effect. At the same time, less dramatic weapons systems also had a key impact, notably artillery, which was the most significant killer in the war, as had also been the case in the previous world war.

The same applied at sea, where understandable emphasis on the significance of carriers ensured an underplaying of the continued value of battleships, not least in bombarding coastal targets in support of invasions. Submarines failed to starve Britain, but American submarines proved highly effective against Japan, hitting the military and economic articulation of the imperial system.

The significance of numbers ensured that mass-produced weapons, such as the Soviet T-34 tank and the American Sherman tank, proved extremely important. Indeed, they were more useful weapons than German tanks, notably the Tiger 1, Tiger 2 and Panther, that, while individually having

better specifications, could not be so readily produced in large numbers and also faced serious maintenance issues. The focus on tanks leads to an underplaying of the effectiveness of anti-tank guns which were cheaper and easier to use. There was room for the enhancement of weapons systems, as with the successful development of long-range fighters by the Americans, notably the Mustang. These proved important to the viability of the large-scale Anglo-American bombing campaign against Germany. It was the employment of powered landing craft which enhanced the range of targets for amphibious forces. As a result, Allied forces could land on beaches, rather than needing to capture ports.

The war saw the use of new weapons, notably rockets and jet aircraft by the Germans. However, only the American use of atomic weaponry had a capacity to transform the situation. The development reflected the sophistication, scale and resources of the American knowledge economy, and the ability of the American government to direct much wealth in order to support the project.

THE EASTERN FRONT, 1941–3

In June 1941, Hitler's over-confidence and contempt for all other political systems, his belief that Germany had to conquer the Soviet Union in order to fulfil its destiny and obtain *lebensraum* (living room) for German settlers, combined with his concern about Stalin's intentions, led him to mount Operation Barbarossa. This attack on the Soviet Union was based on confidence that the Soviet system would collapse rapidly. Hitler was happy to believe totally misleading intelligence assessments of the size and mobilization potential of the Red Army.

Having conquered much territory and killed or captured millions, notably in Ukraine, stronger Soviet resistance stopped the German advance near Moscow and Leningrad in early December 1941 before a Soviet counterattack drove home the message. The impetus of German success was totally broken.

Attacking again in June 1942, although, unlike in 1941, only with sufficient resources to attack in the south, the Germans made fresh gains,

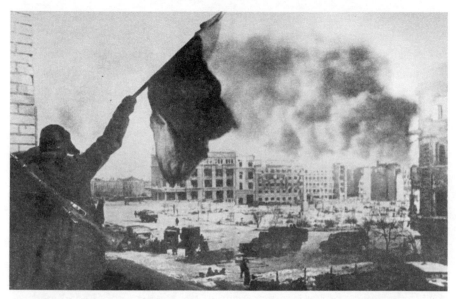

At Stalingrad in later 1942, the Germans were drawn into an intractable struggle in which heavy bombardment created a terrain helpful to the defence. A Soviet counterattack enveloped and destroyed the German force.

notably advancing into the Caucasus mountains in a quest to take control of the oil fields in the region. However, further north, the Germans were drawn that autumn into attritional conflict in the city of Stalingrad on the River Volga, before their forces there were destroyed, in the winter of 1942–3, in a surprise envelopment attack. Surrounded, the Sixth Army was wiped out. The fate of the war on the Eastern Front remained unclear in early 1943, with the Germans eventually shoring up a new front. Nevertheless, the Germans, while still in occupation of much of the Soviet Union, were clearly doing badly. After the Battle of Kursk, in the summer of 1943, the Germans did not mount any more offensives on the Eastern Front. The Soviets took advantage and soon drove the Germans out of eastern Ukraine. Operation Bagration began in the summer of 1944 and pushed the Axis forces back to Warsaw, while other campaigns saw Russian troops reaching the Balkans.

THE WAR AT SEA

The Germans' attempt to blockade Britain, and thus force it to surrender, was more serious than in World War I, as the conquest of Norway and France in 1940 provided them with bases for submarines and surface

shipping from which to enter the Atlantic. The British took heavy losses to submarine attack, but convoying was adopted more swiftly than in the previous world war and ensured that supplies continued to cross the Atlantic. German surface raiders, most notably the battleship *Bismarck* in 1941, were sunk. Submarines turned out to have operational and tactical impact, but not, crucially, a strategic counterpart.

AMERICA JOINS THE WAR

Japan's determination to cut supply routes to the *Guomindang* and to seize resources such as oil was encouraged by the weakness of the Western empires as a result of Hitler's victories. British, Dutch and French colonies were now vulnerable. The decision was also taken to attack the United States in order to prevent it from interfering with this expansionism, notably from its colony of the Philippines and its naval base at Pearl Harbor in Hawaii. Attacking without warning in December 1941, the Japanese launched the war in the Pacific. This broadened out because Hitler, coming to the assistance of his ally Japan, then declared war on the United States.

JAPANESE ADVANCES

Europe's South-East Asian colonies proved particularly attractive. Japan's war machine relied on plentiful supplies of oil and rubber, which the region had in abundance. In July 1940, the Japanese government announced the formation of a 'Greater East Asia Co-Prosperity Sphere', an economic and political alliance of East and South-East Asian countries under Japanese leadership. In September, Japan formed the Axis Pact with Germany and Italy and received permission from the Nazi-allied Vichy regime in France to occupy northern French Indochina.

In the winter of 1941–2, the Japanese overran Hong Kong, Malaya, Singapore and Burma from the British, as well as the Dutch East Indies (modern Indonesia), as well as Burma (Myanmar), the Philippines and America's bases in the western Pacific. The loss of Singapore and a large army proved particularly humiliating for Britain. Japan's rapid series of victories shocked the Allies. In just a few months, Japan had become master of South-East Asia and was now within striking range of Australia and India.

Japanese aircraft (briefly) operated over eastern India and northern Australia, and there were hasty preparations, there and elsewhere, to

resist invasion. Following a US bombing raid on Tokyo and other cities in April 1942, the Japanese decided to expand their defensive perimeter to ensure no further attacks could take place. In May, a Japanese fleet was sent to capture the Australian base at Port Moresby on New Guinea, but was intercepted by US warships. The ensuing Battle of the Coral Sea prevented the attack on Port Moresby, ending the immediate threat to Australia. The Japanese opted instead for an invasion of Hawaii. As a first step, they planned to capture the island of Midway. Having recently cracked Japan's naval cipher, the US fleet was prepared and inflicted its first decisive defeat on the Japanese navy at the Battle of Midway in June 1942.

In the event, Japan's advance pressed hard on their resources. The loss of four aircraft carriers at the hands of American dive bombers in the Battle of Midway in June 1942 ended Japanese bold offensive schemes in the Pacific.

In August, the Allies went on the offensive in the islands of the South Pacific, determined to check Japanese expansion there. The battles were hard-fought amid inhospitable jungle conditions. Japanese soldiers equated surrender with disgrace and were rarely captured alive. In New Guinea, Allied forces gradually drove the Japanese westwards, back across the mountains. Fighting continued there until mid-1944. An Allied invasion and naval blockade of Guadalcanal in the Solomon Islands, beginning in August 1942, finally led to a Japanese withdrawal in February 1943. The remaining Solomon Islands fell during 1943. Small Japanese forces clung on tenaciously on each island and required overwhelming force to defeat.

The Allies soon realized that they did not need to capture the strongest Japanese bases, but could progress across the Pacific by targeting the more vulnerable islands, bypassing the Japanese strongholds and thereby save time and lives. Using this 'leapfrogging' strategy, Allied forces captured one island after another across the Central Pacific, with each island used as a base from which to attack the next. After taking Tarawa in the Gilbert Islands (November 1943), they took two of the Marshall Islands (February 1944). During the fight for the Mariana Islands (June 1944), the US routed the Japanese navy in the Battle of the Philippine Sea. The US air force was able to use the Marianas as a base for bombing raids on Japan.

In October 1944, the Allies assembled an enormous force to retake the Philippines. The Battle of Leyte Gulf, the largest naval engagement in

history, saw the first use of Japanese 'kamikaze' suicide pilots, but they could not prevent another crushing defeat for their country. In the early months of 1945, American planes firebombed Japanese cities, including Tokyo, causing huge casualties. Although defeat was inevitable, the Japanese chose to continue fighting, forcing the Allies to commit ever more troops and resources to the struggle. Two more brutal and bloody campaigns secured the islands of Iwo Jima (February–March 1945) and Okinawa (April–June 1945).

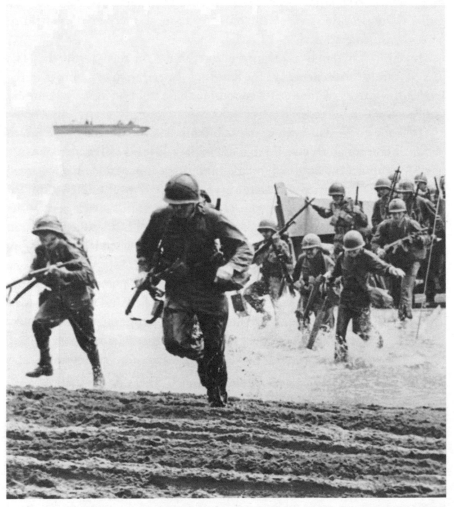

Americans landing on Guadalcanal in the Solomon Islands in 1942, a crucial stage in the early fight-back against the Japanese. After bitter conflict in the hot, humid, disease-infested jungle, the Americans were victorious.

An invasion of the Japanese mainland would undoubtedly have caused hundreds of thousands more Allied casualties. To avoid this, the US government tried to force a Japanese surrender by means of a new invention. On 6 August 1945, an atomic bomb was dropped on the Japanese city of Hiroshima, killing around 100,000. Three days later, another was dropped on Nagasaki, killing 40,000. On 8 August, the Soviet Union declared war on Japan and invaded Manchuria. These events finally persuaded Japan's Emperor Hirohito to urge his government to surrender, which they did on 14 August.

1943: THE ALLIES FIGHT BACK

Checked in 1942 at Midway, El Alamein and Stalingrad, in that order, the Germans and Japanese still controlled wide-ranging territories. In 1943, the Allies fought back on a number of fronts, mounting offensives although much of their effort was devoted to preparing for more major attacks the following year. Production and training were key elements. The Americans pushed in the Pacific perimeters of the Japanese empire, gaining valuable experience of amphibious operations. At the Battle of Kursk, the Soviets defeated the last major German offensive on the Eastern Front. The British and Americans attacked Italy, conquering Sicily and landing on the mainland, leading to the fall of Mussolini's government. They then met with firm resistance when the Germans intervened.

At sea, the Battle of the Atlantic with German submarines was won by May. This provided the basis for the safe build-up of Allied resources in Britain in preparation for the opening of the 'Second Front', by means of an invasion of France. The Soviets were pressing hard for this. The Allies committed themselves to the unconditional surrender of Axis forces, which was designed to prevent any separate peace between the combatants.

1944: REPEATED ALLIED SUCCESSES

The pressure on Germany and Japan greatly increased as a result of repeated Allied victories. The most significant were the Soviet advances into and across Poland and much of the Balkans, which reshaped control of most of Eastern Europe. Devastated by these defeats, and in particular Operation Bagration in which Germany's Army Group Centre was routed with very heavy casualties by the Soviets in June–August, the German army was not in a good position to respond to the Anglo-American

success in invading Normandy on 6 June, D-Day. The Germans were defeated in the subsequent Battle for Normandy and the Allies liberated France and Belgium. But the Allied advance was stopped by the Germans near the German border and in the Netherlands where an airborne British force was defeated at Arnhem. That the Germans fought on reflected the ferocity and fanaticism of the regime and the support for it among most of the army. In December, the Germans launched a counterattack in the Battle of the Bulge. This was designed to inflict such losses on the Americans and British as to drive them to a separate peace, but totally failed to do so. Attacking, as in 1940 in the Ardennes, the Germans achieved initial success thanks to surprise and numbers, but were swiftly stopped and outfought.

American and British aircraft stepped up their bombing of Germany which inflicted serious damage on the war economy. The number of civilians killed in the bombing was subsequently to become a subject of criticism, but the bombing also helped damage German morale and was an understandable response to German bombing including the V-1 and deadly V-2 rocket attacks from 1944.

THE HOLOCAUST

Between 1941 and 1945, the Nazis attempted the systematic extermination of the Jewish population of Europe, an event later termed the Holocaust. Germany's conquests in Europe after 1939 brought millions more Jews under Nazi control. Many were confined in run-down areas called ghettos. Around the middle of 1941, Nazi policy towards Jews changed. Instead of imprisoning them or placing them in ghettos, they started killing them – a policy they called the Final Solution of the Jewish Question. Special squads of SS (*Schutzstaffel*) troops followed the advancing German army into the Soviet Union. When they reached a village, they would round up the Jewish residents, march them into the countryside and shoot them. Nazi leaders soon sought a more efficient method of mass slaughter, and a method less disturbing for the killers. They began locking captured Jews inside sealed vans and suffocating them on the exhaust fumes as the van was driven to the burial site. By spring 1942, over a million Jews had been killed.

'This war is not the Second World War, this war is the great racial war,' declared Hermann Göring, a key Nazi leader, in October 1942. Hitler's paranoid and murderous hatred of Jews led to a policy of genocide

designed to kill all Jews and to end Judaism. In April 1943, Hitler bullied Admiral Horthy to send Jews to the extermination camps, stating that they were to be 'treated like tuberculosis bacilli'. A perverted sense of public health played a major role in Hitler's hysterical hatred.

There was no secret in Germany about the war on Jews. Jews were presented as dangerous aliens who had to be exterminated, which was a total travesty. Alongside the slaughter by Germans, there was active collaboration by many, including allied states, such as Croatia, Romania, Slovakia and Vichy France, as well as by civil authorities in occupied areas. Particular efforts were made to ensure that there was no Jewish future and therefore no children. Nearly 1.5 million Jews under the age of 14 were killed in the Holocaust.

From 1942, the Nazi authorities intensified their assault on the Jewish population of Europe. A series of death camps were built in German-occupied Poland at Belzec, Sobibor, Majdanek, Chelmno, Auschwitz and Treblinka. Here they installed gas chambers disguised as showers. Each camp was capable of killing 15,000 to 25,000 people per day. At Auschwitz alone, poison gas was used to kill as many as 1.5 million. Throughout occupied Europe, Jews were taken from the ghettos on freight trains to the camps. On arrival, they were examined by an SS doctor, who singled out the able-bodied. The others – some 80 per cent – were stripped of their personal belongings and sent immediately to the gas chambers. Once the prisoners were dead, guards removed any gold teeth from their mouths, then burned their bodies in crematoria. The able-bodied had their heads shaved and belongings confiscated. They were known thereafter by a number tattooed on their arm and were forced to work until too weak to continue, whereupon they were killed or left to die.

Towards the end of the war, as Allied forces advanced through Europe, the Nazis hurriedly closed many of the camps to remove evidence of their crimes. Vast numbers of malnourished prisoners were forced to walk hundreds of kilometres to camps inside German territory. Thousands died on these 'death marches'.

By the end of the war, more than 6 million Jews were slaughtered, including 3 million Polish Jews – more than two-thirds of the Jewish population of Europe. Japanese massacres in China were appalling, but there was nothing on the scale of the Holocaust nor with the same intention. Another genocide was directed at the Roma (gypsies).

Survival and Resistance

Jews found different ways of evading capture or fighting back against the Nazis. Some joined resistance movements in France, Poland and the Soviet Union. Others tried to flee, although this became increasingly difficult as the Nazi reach extended across Europe. A great number went into hiding, and there were many examples of non-Jews risking their lives by offering shelter to Jewish families. Individuals such as Oskar Schindler, a German businessman, and Raoul Wallenberg, a Swedish diplomat, were able to save thousands of Jewish lives by bribing or deceiving Nazi officials. Some Jewish partisan groups, such as Bielski Otriad in Belarus, rescued many Jews from the ghettos.

There were rebellions in several Polish ghettos, including Tuczyn and Marcinkonis. The most significant uprising took place at Warsaw in April–May 1943. There were also uprisings at Treblinka and Sobibor death camps in 1943; and in 1944 prisoners rioted at Auschwitz and set fire to the crematorium. These were mostly desperate acts by people who knew they were doomed. Although some managed to escape, the great majority of those who took part were killed.

Other Victims

Besides the death camps, the Nazis operated hundreds of prison camps in Germany and the occupied territories. Conditions in all of them were uniformly harsh and many hundreds of thousands of inmates died of starvation, disease or overwork. In some camps, prisoners died after undergoing cruel medical experiments carried out by Nazi doctors. The Jews were not the only victims of the Holocaust. The Nazis were determined to kill or enslave any they regarded as racially inferior or politically dangerous, including gypsies, Slavs (especially Poles and Soviet prisoners of war), Communists and homosexuals.

HOME FRONTS

The pressure on Home Fronts was again acute, but the experience of World War I, plus the totalitarian ideologies of Germany and the Soviet Union, meant that wartime mobilization was much more rapid. Thus, in Britain and the United States, conscription was introduced at the outset. The British and Soviets proved particularly successful at getting much of the female population into the labour force, whereas in Germany and Japan there was a degree of reluctance to do so. Their reliance,

instead, on coerced labour was harsh and not always successful. Almost 6 million foreign workers were registered in the Greater German Reich in August 1944; combined with the prisoners of war, they provided half the workforce in agriculture and in the manufacture of munitions. Japan also used large-scale forced labour, notably from Korea, China, the Dutch East Indies and Burma, and in a very harsh fashion. Most of this labour was for construction and economic activity, although sexual slavery was also a major issue. Aside from the deliberate slaughter of civilians, harsh occupation policies, notably the seizure of food, could cause heavy casualties, as in the Netherlands in the winter of 1944–5 when tens of thousands of Dutch civilians died due to the Germans seizing food supplies. Germany applied the same policy in northern Norway.

The Soviet Union treated its population in a harsh fashion. Control was total. The entire population of Crimean Tatars – an estimated 191,000 – was deported to Soviet Central Asia in May 1944 as punishment for alleged collaboration with the German occupiers of Crimea in 1942–4. They were loaded on to train wagons and kept there in crowded and diseased circumstances. Many died on the month-long journey. About 108,000 of the Crimean Tatars are estimated to have died of hunger, cold and disease during their exile. Many were used as forced labour in the cotton fields and beaten by overseers when their quotas fell short.

The Home Front was made more immediate for many states due to heavy bombing which caused large numbers of casualties, although this only led to a decisive result in the case of the atomic bombing of Japan. This reflected the sense, even among the totalitarian powers, that popular support had to be wooed, but was also an aspect of a re-education of the public that ranged from eating habits to political goals. Posters, films, radio, newspapers and photography were used for recruitment, to boost production, to motivate and to assist rationing and the conservation of resources; and they linked the Home Front to the front line.

Concern about civilian morale meant that there was a major focus on propaganda. This ensured a major emphasis on governing ideologies and also on national myths about the past. Thus, Stalin stressed Mother Russia, as much as Communism, and looked in films to historical examples of valiant nationhood, an approach also taken in Britain and Germany as with *Kolberg* (1945), a German epic focused on an heroic episode in 1807. Confidence in popular responses, however, was less pronounced than might be suggested by a focus on the wartime

propaganda of togetherness. The Nazis, for example, had to confront the lack of popular celebrations when war broke out. In Britain, there were strikes by trade unionists, and notably so in the period when the Soviet Union was allied with Germany. In Italy, public discontent played a role in the crisis leading up to the overthrow of Mussolini in 1943.

India

The war revealed the tensions in British control of India. The army was loyal, and was indeed the largest volunteer army in history. Against Japan, the army became increasingly professional and highly effective between 1943 and 1945. Wartime Indianization, notably in command positions, was an aspect of the impressive potential of British India.

Yet, in 1942, the Congress Party, in part due to anger at the Viceroy's commitment of India to war against the Axis in 1939 without consulting nationalist leaders, launched the 'Quit India' campaign against British rule. Railway tracks were uprooted and communications with the front line against Japanese forces in Burma disintegrated in the face of a large-scale campaign of all-out civil disobedience. Most of the Indian police and civil administration remained passive, and the government had to deploy troops, arresting over 100,000 people.

The Resistance and its After-Image

The Home Front was very different in territories occupied by hostile foreign conquerors. Racial prejudice meant that this was particularly vicious in the case of the Germans in Eastern Europe and the Japanese in China. Resistance was particularly strong in Poland, Yugoslavia and occupied Russia. Despite great harshness, the Germans failed to crush resistance in Yugoslavia, but they brutally suppressed the Warsaw ghetto rising in 1943 and the Warsaw rising in 1944.

But viciousness was not only found there. The German practice of shooting large numbers of civilians when German troops were killed was also the case in Western Europe. The numbers involved in violent resistance as opposed to other forms varied, not least with reference to local politics, society, terrain and natural cover, and to German demands. Resistance could take time to organize and arm, but, as in France from 1942, it undermined attempts at collaboration and, indeed, co-existence.

After the war, accounts of resistance were important to debates over politics and identity. Thus, in France, the Communists focused on

praising the Resistance, while Charles de Gaulle directed attention to the regular army and the state.

1945: VICTORY

The invasion of Germany by Allied forces brought an unconditional surrender after the Soviets had captured Berlin and Hitler had committed suicide. Meanwhile, British and American forces fought their way across the Rhine and overran western Germany.

Australia in World War II

The 1931 Statute of Westminster granted Australia and the other dominions of the British Empire legislative independence, yet Australia continued to be directed by Britain in matters of foreign affairs, and therefore entered World War II on the Allied side. But with Britain preoccupied with the fight against Germany, Australia became dependent on the USA for security. Japanese planes bombed Darwin a few times and a Japanese submarine entered Sydney Harbour, prompting fears of an invasion, but the USA was able to provide effective naval protection. During the war, many thousands of Australian soldiers suffered harsh conditions in Japanese prisoner of war camps.

The Atom Bombs

There was no comparable invasion of Japan. Instead, the combination of American industrial capability with new weaponry in the form of the atom bombs ensured that Japan surrendered unconditionally. At the Potsdam Conference outside Berlin, the Allied leaders, having defeated Germany, issued the Potsdam Declaration of 26 July 1945, demanding unconditional surrender, the occupation of Japan, the loss of Japan's overseas possessions and the establishment of democracy. The threatened alternative was 'prompt and utter destruction'. The Japanese government decided to ignore the declaration, which they saw as a political ultimatum.

The heavy American losses in capturing the islands of Iwo Jima and Okinawa earlier in the year suggested that the use of atom bombs was

necessary in order both to overcome a suicidal determination to fight on, and to obtain unconditional surrender.

The dropping of atomic bombs on 6 and 9 August led to the deaths of perhaps 280,000 people or more, either at once or eventually through radiation poisoning. On 14 August, Japan agreed to surrender unconditionally. Had the war continued, the bombing and invasion would have killed many more.

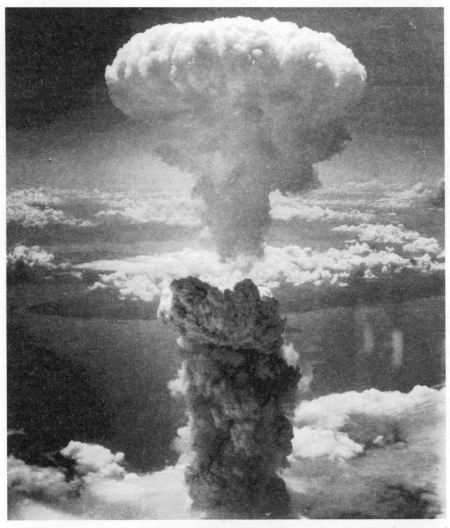

The mushroom cloud over Nagasaki. The American use of nuclear bombs, crucial to persuading Japan to surrender and thus saving many lives, both American and Japanese, marked an unprecedented new capability for the American war machine.

Japan was also under pressure from advancing American, British and Soviet forces. The last had conquered Manchuria and advanced into Korea. British forces were planning to invade Malaya.

Defeated, both Germany (including Austria) and Japan were placed under military occupation. German and Japanese leaders were put on trial, the Germans at Nuremberg. A number were executed. Subsequently, there were to be ridiculous complaints about the 'victors' justice' imposed on these mass murderers who had launched this most destructive of wars.

1939–45: The Key Economy and American Mobilization

The key war economy, the 'Arsenal of Democracy', in Roosevelt's words, was the United States. During the war, American industry developed rapidly in one of the most dramatic economic leaps of the century, with the Americans mobilizing their resources far more speedily and extensively than they had done in World War I. Recovering from the Great Depression to a far greater degree than hitherto, the country's overall productive capacity increased by about 50 per cent between 1939 and 1944. This major growth was of lasting importance to the American economy, one that indicated the close relationship between international and domestic circumstances.

The dynamic of American resource build-up in part relied on lightly regulated capitalism, rather than the coercion employed in totalitarian societies. Having had cool relations with much of business during the 1930s, Roosevelt now turned to it to create a war machine. The War Resources Board was established in 1939, in order to ready industry for a war footing. The Office of Production Management under William Knudsen, head of the leading car manufacturer General Motors, followed in 1941. The attitudes and techniques of the production line were focused on war and this process worked. Indeed, $186 billion worth of munitions were produced, as well as an infrastructure to move them. As a result, by 1943–4,

the USA was making about 40 per cent of the world's total output of munitions, and, alone, was out-producing the Axis powers, as well as providing tanks, aircraft and other weapons to its Allies, in part through loan systems such as lend-lease to Britain. In 1939–45, the United States produced more than 300,000 aircraft, compared to 125,000 each for Britain and Germany, 99,000 for the Soviet Union, 65,000 for Japan, and 13,500 for Italy.

America's output of munitions rested on a broader industrial revolution. In 1944, it produced 90 million tonnes of steel, about half of the world's total production. Of the 42 million tonnes of shipping built by the Allies during the war, most were American-built. Many were Liberty Ships, often constructed in ten days using prefabricated components on production lines. The organizational ability to manage large-scale projects and to introduce new production processes was important: for example, all-welded ships were quicker to make than riveted ones. Despite losing 1,443,802 tonnes of oil tankers, mostly to German submarines, the tonnage of the American oil-tanker fleet rose from 4,336,000 tons in 1942 to 13,100,000 in 1945.

The flexibility of American society was a direct help. This included a positive attitude toward women entering the labour force. Thus, by late 1944, over 15 per cent of the workers in the shipbuilding industry were women. Major changes in the geography of America's people and economy flowed from the development of war production, especially of aircraft and ships. The populations of Washington, Oregon and, in particular, California, where many of the industrial plants were located, rose greatly: by the end of the war, 8 million people had moved permanently to different states, including African Americans from the South to find industrial jobs, notably in the Midwest and on the Pacific coast. As a result of the war, the United States became more of a Pacific society, although the Atlantic-Midwest core of the American economy remained crucial.

The United States benefited from its already sophisticated economic infrastructure. It surmounted the domestic divisions of the 1930s, in order to create a productivity-oriented political consensus that brought great international strength. The resources, commitments and role of the federal government all grew greatly, and taxes and government expenditure rose substantially, the latter totalling $317 billion, nearly 90 per cent of which was spent on the war. With much of the rest of the world in ruins or debt, the Americans were in a dominant position in 1950, with over 50 per cent of the world's wealth and 60 per cent of its gold reserves while comprising just 6 per cent of the world's population.

Full employment and good wartime wages helped encourage an optimism in American society which, indeed, suffered far less than any other major society, not least as foreign occupation and bombing were limited to Pacific possessions. Unlike the other leading economies, American industry benefited greatly from being outside the range of air attack. The legacy of the war included a view that America was the greatest power, and should remain so. This view had major consequences in terms of the assumptions that helped to frame the American role in the Cold War and the willingness of Americans to sustain that struggle.

CHAPTER 6

The Birth of the Post-War World, 1945–56

That World War II would be followed by a struggle for dominance between American- and Soviet-led alliance systems was no more inevitable than the rapid realization that the European colonial systems faced major, possibly terminal, problems. The context was a major recovery of the world economy after the war. Another key element was a 'baby boom' that was eventually to provide much labour to sustain economic growth and to help engender pressures for social change, but also to pose environmental challenges. Modernism was a theme. It spanned new institutions, notably the United Nations, and the arts, including dissonance in music and the concrete and glass architecture of Le Corbusier and Mies van der Rohe.

PLANNING THE POST-WAR WORLD

All the powers fought the war, while also planning for the post-war situation. This entailed a range of planning and projects from international relations to domestic policies. Hitler saw Germany as the centre of a world power able to dominate much of the globe. To that end, he demolished parts of Berlin in order to create a *Hauptstadt Germania* that would be an appropriate capital for such a state. In practice, the grandiloquence of his schemes reflected the lack of humanity that was central to Nazi policy.

In turn, Stalin was convinced that capitalism was doomed. His assumption that the wartime Grand Alliance could not be sustained after the war, itself almost the definition of a self-fulfilling prophecy, left him determined to extend the Soviet sphere of influence, as well as to obtain direct territorial control through annexations that would limit the risks from any sudden attack comparable to that by Germany in 1941.

In response, the British wished to limit Soviet gains in Eastern Europe, notably those made at the expense of Poland, but Soviet control on the ground proved decisive, in this and other instances. At the same time, the British wanted to keep the Soviet Union in the war and to ensure that the

United States sustained the peace settlement, unlike after World War I. Suspicious of Churchill's warnings, Roosevelt was naïve about Stalin's intentions. However, Britain's role in the formulation of Allied policy was eroded from 1942 and, even more, 1944, by the greater economic strength and military power and successes of its allies.

Yalta Conference

The claim that Roosevelt and Churchill sold out Eastern Europe, especially Poland, to Stalin at the Yalta Conference in February 1945 ignores the extent to which Eastern Europe was already being occupied by Soviet forces. Nevertheless, this claim captures the later contentiousness of the peace settlement, and notably so once Communist rule in Eastern Europe collapsed in 1989. Then the war was to be seen, particularly in Eastern Europe, as far more negative in its results than had hitherto been argued.

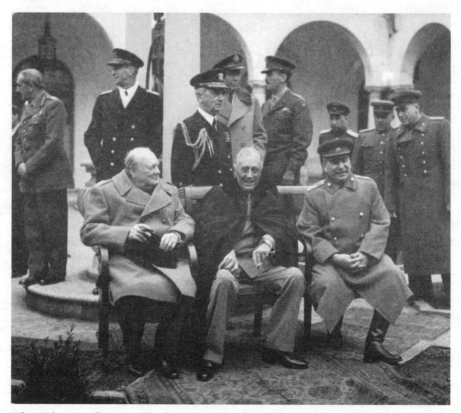

The Yalta Conference. The last meeting of the three major Allied figures saw a grudging acceptance of the Soviet dominance of most Eastern Europe.

CREATION OF GLOBALIZED INSTITUTIONS

As had been planned for by the Americans, the war led to a new international infrastructure. The most famous was to be the United Nations (UN) which was intended as a more viable replacement to the League of Nations, not least because the United States was to be a member. In 1943, the United States, the Soviet Union, Britain and (Nationalist, *Guomindang*) China, had agreed the Moscow Declaration on General Security including the establishment of 'a general international organization, based on the principle of sovereign equality'. The resulting United Nations was established in 1945. The victors in the world war provided a Security Council for the United Nations: the United States, the Soviet Union, Britain, France and China. In 1948, the UN General Assembly passed a Declaration of Human Rights.

There was also an international economic infrastructure that was designed to avoid another Depression. Under the Bretton Woods Agreements of 1944, American-supported monetary agencies, the International Monetary Fund and the World Bank (both of which had American headquarters, as did the UN), were established in order to play an active role in strengthening the global financial system. Free trade was actively supported as part of a liberal economic order, and this was furthered as America backed decolonization by the European empires and the creation of independent capitalist states which were seen as likely to look to the United States for leadership. The General Agreement on Tariffs and Trade (GATT), signed in 1947, began a major cut in tariffs that slowly re-established free trade and helped it to boom. This was also seen as a way to isolate the Communist powers.

THE COLD WAR IN EUROPE

Meanwhile, with much of Europe left in ruins by the war, the Soviet Union had exploited the military dominance of Eastern Europe it had won in 1944–5 to enforce its control there. There was to be no resumption of independence for Estonia, Latvia and Lithuania; while about 48 per cent of pre-war Poland was lost to the Soviet Union, as was northern East Prussia and territory from Czechoslovakia and Romania. In addition, Communist regimes were established across Eastern Europe. Anti-Communist guerrilla forces were defeated and brutally suppressed, notably in the Baltic provinces, Ukraine and Poland. Mass imprisonment and torture were widely used by the Communist authorities, and Nazi

concentration camps were re-opened to receive the victims of Communist rule. These moves vindicated Churchill's claim on 5 March 1946, in Fulton, Missouri, in the USA that an 'Iron Curtain' was descending from the Baltic to the Adriatic.

The exceptions were Finland, which was forced by the Soviet Union into neutralism, and Greece, where the Communist attempt to seize power was defeated in 1949. The Royalists there enjoyed British support which, from 1947, under the Truman Doctrine of that March to stop the spread of Communism, was replaced by that from the United States. The Americans provided weaponry and advisors.

The Coming of the Cold War

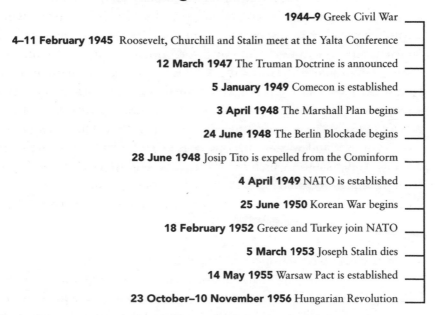

1944–9 Greek Civil War

4–11 February 1945 Roosevelt, Churchill and Stalin meet at the Yalta Conference

12 March 1947 The Truman Doctrine is announced

5 January 1949 Comecon is established

3 April 1948 The Marshall Plan begins

24 June 1948 The Berlin Blockade begins

28 June 1948 Josip Tito is expelled from the Cominform

4 April 1949 NATO is established

25 June 1950 Korean War begins

18 February 1952 Greece and Turkey join NATO

5 March 1953 Joseph Stalin dies

14 May 1955 Warsaw Pact is established

23 October–10 November 1956 Hungarian Revolution

More generally, the American role was to be completely different to that after World War I and there was to be prominent interventionism. American forces were present as part of the occupation of Germany and Austria. There was also a concern to prevent Communist support growing in Western Europe. The awareness, already shown with the establishment of the IMF, the World Bank and GATT, that economic failure, as with

131

the Great Depression, was the principal cause of political extremism led the Americans, in the Marshall Plan of 1947, to offer $13 billion of help with economic reconstruction, which also made it possible to cope with the major trade deficit in European–American trade. Seeing this plan as a means of American influence, as it indeed was, the Communists rejected the aid which, however, was accepted in Western Europe. The result was a division of Europe in terms of economic and financial linkage to go with the geopolitical and military schism there.

In 1948–9, the front line was solidified. A blockade of West Berlin designed to bring it under Communist control was thwarted by a successful large-scale Anglo-American airlift of supplies. However, a coup brought the Communists control of Czechoslovakia in 1948, taking further west the Communist presence, and threatening the security of the American occupation zone in neighbouring southern Germany.

In turn, American concern led to the United States in 1949 becoming a founder member of the North Atlantic Treaty Organization (NATO), which created a security framework for Western Europe by linking the United States and Canada to the Western European states, bar Fascist Spain. The basing in Britain of American aircraft carrying nuclear bombs strengthened the military bite of NATO as these planes were able to reach targets in the Soviet Union. In 1952, the NATO alliance, hitherto North Atlantic and Western Europe, was extended to include Greece and Turkey. This alliance, which helped deter Soviet attacks, provided a key background to the political stabilization of Western Europe and thus to its economic growth.

Germany

The war ended with occupation zones for American, British, French and Soviet forces, although French plans for undoing Germany's unification in 1866–71 by the transformation of Germany into autonomous states were rejected. Stalin sought greater control: reparations (compensation for war damage) proved a key element, with the Soviets demanding them from the occupation zones of the Western powers, as well as a four-power supervision of the key industrial region of the Ruhr in the British zone. Such demands, which were turned down, crystallized a growing concern to limit the westward penetration of Soviet power and influence. The Soviet zone became the German Democratic Republic, or East Germany; the others were joined together as the Federal Republic of Germany,

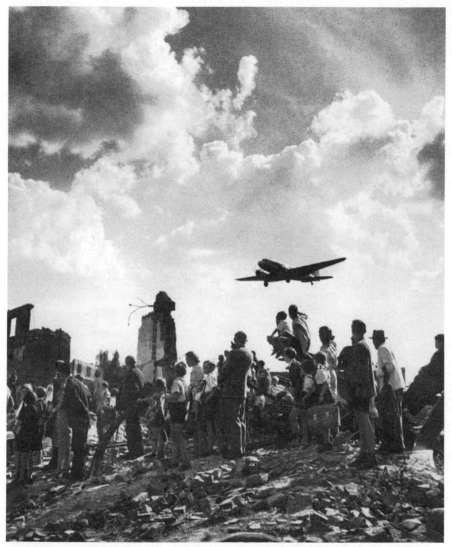

Berlin Airlift, 1948–9. Anglo-American airpower enabled Berlin to survive Soviet blockade, serving as a limit to the westward advance of Soviet power.

or West Germany. These were two very different states. The first was a Communist dictatorship, the second democratic, market economy-based and Western. Similarly, there were to be differences in Korea and Vietnam. East Germany sought to control opinion and seal off its state, both by brutally suppressing dissent and by blocking American radio broadcasts. In contrast, opinion was much freer in West Germany.

Culture and heritage were a key element of difference. Thus, in East Germany, some palaces were destroyed, notably the royal palace in Berlin in 1950 and that in Potsdam in 1960. There was also a destruction of aristocratic houses or, more generally, a destruction by neglect that was to last until after the fall of Communism.

Population Moves

Alongside territory transfer, population moves were an important aspect in cementing the peace settlement. Japanese settlers were expelled from China and Korea, or imprisoned by the Soviets for use as forced labour. In 1945–6, well over 9 million Germans fled or were driven west from Eastern Europe, including nearly 3 million from Czechoslovakia. This was an aspect of the widespread displacement, or 'ethnic cleansing', that the war had brought and that continued after its end. Thus, Poles were moved out of the territories gained by the Soviet Union in western Ukraine and were resettled in lands cleared of Germans. Following on the German slaughter of Jews, this made cities such as Lvov Soviet. In turn, the Poles moved Germans out of the areas gained by Poland – Eastern Pomerania, Silesia, Danzig and part of East Prussia, replacing them with Poles moved from territory seized by the Soviet Union. The cities were Polonized, Breslau becoming Wroclaw and Danzig was renamed Gdansk. The same process was seen more generally. For example, Italians were moved out of former territories in Yugoslavia, notably Istria, as well as Greece and Africa. The short-term effect was misery and often long detention in insanitary camps. The long-term consequence was bitterness, although in Germany and Italy the political consequences were limited.

Eastern Europe

By 1948, Europe was a completely divided continent. The Soviet Union banned all communications, travel and trade between the Communist east and the democratic west. Germany was split into Communist East Germany and democratic West Germany. Eastern Europeans were not allowed to accept Marshall Plan aid. Instead the USSR set up an economic organization called Comecon to promote trade and economic cooperation within the Eastern Bloc.

The overthrow of earlier political structures in World War II, the 'Liberation' by the Red (Soviet) Army in 1944–5 and the subsequent establishment of Soviet hegemony and Communist rule cleared the way for the economic bloc of Comecon (1949) and the security bloc of the Warsaw Pact (1955). Although they were far from similar to the European Economic Community (EEC, 1957) and NATO (1949) in Western Europe, there were instructive parallels. At the same time, the degree to which American hegemony in its bloc was far less comprehensive and direct was readily apparent.

The Soviet Union not only sought political uniformity, but also tried to integrate the Eastern European economies. However, it was handicapped by the inherent flaws of Communist economic management, and was also resisted by attempts by national governments, conspicuously those of Yugoslavia, Albania and Romania, to retain and assert control. Yugoslavia under Josip Tito and Albania under Enver Hoxha broke from the Soviet bloc in 1948 and 1960–1 respectively. Romania became autonomous later in the decade. In 1953, there were uprisings in East Germany, and in 1956 the Hungarians took a stand for greater freedom, soon crushed by Soviet military force. In 1968, the Czech government attempted liberal reforms, but again the Soviets and their allies ruthlessly ended this experiment.

DECOLONIZATION

The war had left the European colonial powers exhausted, while the experience of colonial troops fighting in it had helped shape the more powerful anti-colonial nationalist movements that followed the war.

Italy, as one of the defeated states, lost its empire, as Germany had done after the previous world war. The end of Italy's empire does not tend to attract attention, but it was important to a number of states. Italy's African territories were put under British or French administration, but Libya eventually became independent, while Eritrea was gained by Ethiopia, and Italian Somaliland was joined to British Somaliland to become Somalia. In Europe, Albania became independent from Italy, the Dodecanese Islands (most prominently Rhodes) were acquired by Greece (Turkey losing out due to its neutrality) and there were Italian territorial losses to Yugoslavia.

Creating New National Histories

Newly independent countries had to have new official histories. Many have lasted to the present. In Hanoi, on National Day, Ho Chi Minh's Declaration of Independence from French colonial rule in 1945 is celebrated, while his embalmed body can be revered at his mausoleum. It is also possible to visit his house as well as a museum devoted to him. Hanoi's Hoa Lo prison contains the guillotine used by the French when they were Vietnam's colonial power, as well as mock-ups of the harsh conditions, including prisoners shackled to the ground. In contrast, the use of Hoa Lo as a prison by North Vietnam, once it became independent in 1954, is not stressed. Similarly, the Communists in East Germany made use of the Sachsenhausen concentration camp earlier used by the Nazis.

Britain and France had to respond to the new international situation. The particular nature of the wartime developments led France to grant independence to Lebanon and Syria. The post-war Labour government in Britain was less committed to empire than its Conservative-dominated predecessor and, in particular, supported independence for India. This came in 1947, with India divided between a Muslim-majority Pakistan, led by Muhammad Jinnah, and a Hindu-majority India, a partition accompanied by much communal bloodshed, and by India brutally crushing Muslim opposition in Hyderabad and in part of Kashmir. The following year, Burma and Ceylon, now Myanmar and Sri Lanka, gained independence.

Israel and Palestine

Anti-Semitism in Europe and Russia during the late 19th century drove many Jews, known as Zionists, to seek sanctuary in Palestine, where they hoped to build an independent Jewish state. Under the British Mandate (1920–1948), clashes between Jewish settlers and Arabs became increasingly violent. Jewish emigration to Palestine accelerated during the 1930s, particularly following the Nazi takeover of Germany. After the Holocaust the international community found it harder to

ignore Jewish demands for an independent homeland. By 1947, the British wished to end their mandate and requested help from the UN. In November 1947, the UN devised a plan to divide Palestine into two states, one Jewish, one Arab. The Jews accepted the plan, but the Arabs rejected it.

Britain faced major difficulties also in Palestine, with rising violence between Arabs and Jews accompanied by a sense in Britain that its presence was serving little purpose. The end of British rule in 1948 was followed by the first of a series of Arab–Israeli wars. Six neighbouring Arab countries immediately invaded the new state. Although outnumbered, the well-organized Israeli forces held their own and even advanced into territory beyond that allocated to them by the UN plan. By the war's end a year later, Israel controlled 77 per cent of Palestine, while its Arab foes took over the remaining portions. Transjordan occupied the West Bank (west of the River Jordan) and Egypt occupied Gaza in the south-west. The Palestinian Arab state proposed by the UN was never established. During the war, around 726,000 Palestinians fled Israel to become refugees in the West Bank, Gaza and neighbouring Arab states. Israel refused them re-entry after the war.

Decolonization across Asia

There were also struggles over decolonization elsewhere in the late 1940s. In the Dutch East Indies, Dutch 'police actions' against nationalists became a war that neither side could win. World War II exhaustion, combined with American pressure, led the Dutch to give up the struggle and Indonesia became independent in 1949. The Dutch retained control of western New Guinea until it was seized by Indonesia in 1962, helping to provoke an independence movement there, as also in East Timor when it was seized with the end of Portuguese rule in 1975.

In Indochina (Vietnam, Laos and Cambodia), France from 1945 faced a decolonization struggle that it made a major effort to resist. Vietnam was the key area of conflict. Following Japan's defeat in World War II, the Viet Minh, a Vietnamese nationalist Communist group, led by Ho Chi Minh, occupied northern Vietnam. The Viet Minh founded the independent Democratic Republic of Vietnam (DRV), with its capital at Hanoi. France, determined to regain control of the territory, reoccupied the south. The First Indochina War, between France and the DRV, broke out in 1946.

During the first three years of the war, the better-armed French forces made little progress against the guerilla tactics of the Viet Minh. To gain the support of the local population, the French established an independent Vietnamese government in the south under former president Bao Dai, in 1949. The situation became more difficult in 1949, when the Communists won the Chinese Civil War and were able to supply the nationalists in neighbouring Vietnam with military goods. This helped internationalize the struggle there. The American government, meanwhile, determined to halt the spread of Communism in Asia, supported the French.

In 1954, the Viet Minh captured a French military base at Dien Bien Phu. The French, tiring of the campaign, agreed to withdraw from Vietnam. At a peace conference in Geneva, it was agreed that the country would be reunified following elections in 1956. However, the new leader in South Vietnam, Ngo Dinh Diem, refused to hold elections because, he claimed, a free vote was impossible in the Communist North. The USA supported Diem's stance, preferring an independent non-Communist South Vietnam to the most likely alternative: reunification under Communist rule.

The USA, never a natural imperial power, actually drove the decolonization process in the Philippines, promising in 1935 full independence within ten years – and actually granted it in 1946. In 1948, Burma and Ceylon, now Myanmar and Sri Lanka, gained independence. Withdrawal from Malaya took longer as British and Commonwealth forces became caught up in a prolonged battle with Communist guerrillas. Independence was eventually achieved in 1957 when the colonial regime handed power to anti-Communist nationalists.

American concerns resulted in the provision of financial assistance to the French in Indochina, but there was a refusal to commit ground troops or aircraft, in part because Britain, Australia and New Zealand refused to help. In 1954, after defeat at Dien Bien Phu, France abandoned the struggle. Against the wishes of the Viet Minh, the coalition of groups fighting for independence, Vietnam was partitioned between a Communist north and an anti-Communist south. Neither was democratic.

Decolonization in Africa and Europe

Organized opposition to colonial rule had begun in some African colonies in the early 20th century. However, it was only after World War II that this grew into a mass movement, as an emerging class of educated, urbanized Africans led calls for independence. Britain and France, the dominant

colonial powers, had been severely weakened by the war and found it hard to resist demands for greater self-rule.

In some cases, independence arose relatively peacefully; in others, it only occurred after a struggle. In 1951, the former Italian colony of Libya became the first African nation to achieve independence. Morocco, Sudan and Tunisia followed in 1956. The Gold Coast won its independence as Ghana in 1957, and by 1965 almost every other sub-Saharan colony had followed suit. In the case of French West Africa, the post-independence governments were persuaded by France to maintain a common currency pegged to the French franc, so that France could retain economic influence in the region.

Elsewhere, the early 1950s saw nationalist insurrections win less success. Wishing to keep its empire going, the British defeated insurrections in Malaya and Kenya, and resisted another in Cyprus. The British benefited in each case because the insurrections were weakened by their location in sectional (rather than general) opposition to imperial rule. Thus, in Malaya in 1948–60, opposition was by the Chinese population, rather than by the Malays; in Kenya in 1952–6, it was primarily by the Kikuyu, Embu and Meru tribes; and in Cyprus in 1955–9 it came from EOKA, a Greek Cypriot paramilitary organization. Moreover, the British developed effective counterinsurgency policies, ranging from the use of air power and a forward offensive policy, to the movement of apparently hostile civilians away from areas of operation. There was little evidence of the policy of minimum force that was subsequently to become important in British military doctrine. Concern about the Cold War and the tendency to see Communist planning behind nationalist pressure, a tendency that was generally misplaced, encouraged this reliance on force. The was a sentiment shared by other powers, including Communist ones: there was a marked degree of paranoia in response to opposition.

At the start of 1956, it did not seem impossible that the European empires would continue for many decades. Britain, France, Portugal and Belgium all saw themselves as trustees for peoples who allegedly could not yet be trusted with independence. Empires were regarded as ways to enable states to 'punch above their weight'. They were seen as sources of resources, including raw materials and troops. In strategic terms, empires also provided bases. While they definitely appear backward-looking by later standards, empires were in part regarded as ways to

139

achieve modernization as well as strength. The British saw themselves in this light, particularly in Africa.

THE RESUMPTION OF WAR IN CHINA

The struggle between Communism and its opponents had rapidly become worldwide as a result of the Soviet determination to expand the doctrine, combined with the attempt by foreign powers to overthrow the regime in Russia. This encouraged the latter to try to bring down the Western empires. That struggle began in the 1920s, and China provided a particularly important battlefield.

From 1946, the struggle between the *Guomindang* and the Communists revived, and the latter were greatly assisted by the Soviet Union. In 1948–9, the *Guomindang* forces were outfought and retreated to Formosa (Taiwan), and the Communists followed up in 1950 by conquering Tibet and Hainan. The Communist success was more complete than that of the Nationalists in the late 1920s, not only because it included Manchuria and Tibet, but also because it was not dependent on cooperation with warlords.

The Chinese Civil War was the most important Communist victory in the Cold War. It also marked the centrality of East Asia to the struggle, a centrality that Europeans were apt to ignore but that Americans understood, making the issue politically contentious. In 1950, China and the Soviet Union signed a mutual security agreement, while the Soviet-encouraged invasion of South Korea by Communist North Korea took forward this struggle. Japan had lost Korea in the peace settlement after World War II, as well as Taiwan, South Sakhalin, the Kurile Islands and the Pacific islands it had received after World War I.

In 1949, the USA rejected Mao Zedong's terms for diplomatic recognition, and there was no American representative in mainland China from then until 1973. Instead, the USA recognized the *Guomindang* in Taiwan as the government of China.

Mao saw an anti-Western policy as crucial for legitimizing Communism, arguing it was Western imperialism that had prevented Chinese development. He wrote: 'The history of China's transformation into a semi-colony and colony by imperialism in collusion with Chinese feudalism is at the same time a history of struggle by the Chinese people against imperialism and its lackeys.'

AMERICAN INTERVENTIONS

The Americans took a major role in a number of proxy struggles. In the Philippines, an American colony until 1946, the conservative government failed in 1946–7 to defeat an insurrection by the Communist-led Hukbalahap movement. From 1948, however, the US-run Joint Military Advisory Group began to receive more American military assistance, and from 1950 this gathered pace in response to developments in China and Korea. The Americans financed and equipped the Philippine army so that it was able to take the war to the Huks, and this was powerfully supported by a policy of land reform. The rebellion ended in 1954. As a result, the Philippines, with its military bases, was a key part of the American presence in East Asia. Japan fulfilled the same function as a military and economic support, and this encouraged America to end its post-war occupation there.

The Philippines, like Latin America, was part of what many American policymakers saw as the informal American empire, and this encouraged intervention. In the case of Latin America, a direct or proxy role in domestic conflicts was also longstanding. During the Cold War, this role was accentuated by concern about the alleged Communist leanings of populist regimes. Thus, the government of Jacobo Árbenz in Guatemala, with its commitment to land reform, was seen as pro-Communist. In 1954, this led to opposition, with rebel troops organized, funded, armed and trained by the CIA, culminating in an invasion of these troops from Honduras, eventually supported by American aircraft. Under this pressure, the government was deposed by the army, and a military dictatorship was established. The Americans were to be far less successful in the case of Cuba in 1961.

The Korean War

Again, it was East Asia where conflict came to the fore in the 1950s. The United States led an international coalition under a United Nations mandate to help South Korea, and the invading North Koreans were driven back toward the Chinese frontier in 1950. In turn, the Chinese intervened on behalf of the North Koreans. Mao felt that UN support for Korean unification threatened China and might lead to a *Guomindang* return, saw American support for Taiwan as provocative and was also keen to present China as a major force. Stalin, to whom Mao appealed

for help, wanted to see China committed to the struggle against the USA. This was the price for the Soviets assisting the Chinese with military modernization. Neither side won the resulting war, which continued until 1953, with over 3 million dying, but it drove forward military activity on both sides. In the United States, a military-industrial complex came to play a greater role in the economy and the governmental structure.

The war strongly increased American sensitivity to developments and threats in East Asia. This led to an extension of its containment policy towards the Communist powers, the maintenance of American bases in Japan, a military presence in South Korea and a growing commitment to the Nationalist Chinese in Taiwan, one underlined by the location of American warships nearby. This reflected the Americans' greater presence in Europe.

Iran

As part of the more general process seen in the Cold War, America replaced Britain as the main foreign influence in Iran where the Anglo-Iranian Oil Company had been nationalized in 1951. The crisis point came in the early 1950s, when the nationalist prime minister Mohammad Mosaddegh came to power. In opposition to his nominal boss, the Shah of Iran, Mosaddegh introduced a parliamentary bill to nationalize the country's oil industry. In 1953, a CIA-instigated coup led to the fall of Mosaddegh.

Following the coup, the unpopular pro-Western Shah, Mohammed Reza Pahlavi, returned from exile. He became an increasingly repressive ruler, coming down particularly hard on the growing Islamic fundamentalist movement in his country. One of the religious leaders he drove into exile was the cleric Ayatollah Ruhollah Khomeini, who in 1979 was to return to Iran at the head of a revolutionary movement. Designed to limit populist nationalism, and to control Iranian oil, the coup encouraged Iranian popular hostility to the West and was to be cited at the time of the Iranian Revolution in 1978–9 and subsequently.

NEW ALLIANCES

Although the Cold War was at its height at the end of the age of empires, it was also a time that saw the formation of informal empires, in the form of alliance systems, to reflect the changing international situation. In 1955, two were created to try to limit Communist expansion in Eurasia.

Britain organized the Baghdad Pact with Turkey, Iraq, Pakistan and Iran. This was matched by the South-East Asia Treaty Organization established by Australia, Britain, France, New Zealand, Pakistan, the Philippines, Thailand and the USA. These organizations echoed Mackinder's interest in the 'Periphery' opposing the expansionist 'Heartland', as well as Nicholas Spykman's reconceptualization of this in *The Geography of the Peace* (1944) and its idea of a 'Rimland'. Both of the alliances drew on the idea of 'containment'.

These organizations cut across the anti-Western Afro-Asian internationalism seen in the Bandung Conference held in Indonesia in 1955, which had attracted 29 states, including China, Egypt, India and Indonesia. The Non-Aligned Movement was established at the conference.

THE ATOMIC AGE

The American monopoly of atomic power only lasted until 1949, when it became apparent that the Soviets had also acquired a nuclear capability as a result of enormous efforts as well as espionage directed against the United States and Britain. The Americans, in turn, pressed ahead with a far more powerful hydrogen bomb, which was first tested in 1952, destroying the Pacific island of Elugelab. Such a use of the Pacific was all-too-typical of the Western powers. The Soviets responded rapidly to America's creation of the hydrogen bomb, developing, for example, a long-range bomber capability able to reach the United States.

In response to the Soviet superiority in forces on land, the Americans pushed a willingness to use the atomic weaponry first. In 1953, President Dwight Eisenhower threatened to uses atom bombs to bring the Korean War to an end. Georgy Malenkov, chairman of the Soviet Council of Ministers from 1953 to 1955, warned about the possible end of world civilization that would follow. Eisenhower himself observed in 1955 that, due to the windborne spread of radioactivity, any nuclear war would end life in the northern hemisphere only. In 1961, Andrei Sakharov, a designer of Soviet nuclear weapons, feared that new, improved warheads might set light to the Earth's atmosphere.

This arms race represented a new and unprecedented form of globalization and generated much international effort towards disarmament. This consumed much diplomatic energy and eventually played a major role in the Cold War, but it was beset by continued animosity between the two great powers.

Nuclear capability was enhanced by the development of a range of air, sea and land machinery able to deliver weapons. The deployment of the B-52 Stratofortress heavy bombers in 1955 upgraded American delivery capability. Equipped with eight Pratt and Whitney J57-P-1W turbojets, the B-52 could cruise at 845 kph (525 mph) and had an unrefuelled combat range of 5,800 km (3,600 miles), a payload of 30 tonnes of bombs and a service ceiling of 47,000 ft (14,325 m).

The USS *Nautilus*, the first nuclear submarine, was launched in 1954. The Americans also developed a submarine-based ballistic missile capability.

AMERICA

America moved in a more conservative direction in the 1950s. Roosevelt's successor as president, his vice-president, the Democrat Harry Truman, who had taken office when Roosevelt died in 1945, narrowly won re-election in 1948. However, the 1952 election brought the Democrats' 20-year hold on the presidency to an end.

Anti-Communism contributed to a conservative ethos. Notably as a result of allegedly having 'lost China', by failing to provide assistance to the Nationalists against the Communists, the Democrats were portrayed as soft on Communism. This was a dangerous charge due to the lurid claims about Communist influence made by Senator Joseph McCarthy, Chairman of the Permanent Sub-committee on Investigations of the Senate Committee on Government Operations from 1953 to 1955. In 1950, he announced that he had a list of 'card-carrying Communists' in the State Department and in 1952 referred to '20 years of treason' under the Democratic Party. He gave his name to a process of public legislative inquisition known as McCarthyism which drew on the potential of television. The undoubted role of espionage in the Soviets gaining the ability to produce atom bombs contributed to this sense of crisis.

Elected in 1952, Dwight Eisenhower was re-elected in 1956, beating the Democrat Adlai Stevenson on both occasions, on the latter occasion with a margin of 9 million votes. The result displayed widespread satisfaction with the economic boom and social conservatism of these years. There was an upsurge in religiosity, as church membership and attendance rose, and Eisenhower encouraged the addition of 'under God' to the Pledge of Allegiance and 'In God We Trust' on the currency. At the

same time, the legacy of the Great Depression was such that Eisenhower left the New Deal intact.

The Eisenhower years were to be the background to modern America. In many respects, the new social and political currents of the 1960s were to be a reaction to this conservatism, but many of the shifts of the 1950s had a lasting impact, not least the growing suburbanization and car culture.

American Film and the Cold War

The willingness of Hollywood to confront social problems, as in *The Grapes of Wrath* (1940), the film of the grim 1939 John Steinbeck novel about dispossessed dirt-farmers, slackened after World War II, reflecting political pressure not to criticize America, but, instead, to resist Communist 'subversion'. Orchestrated by the House of Representatives' Committee on Un-American Activities, as part of a battle over national identity and interests, this campaign saw the blacklisting of those in Hollywood with Communist associations. Moreover, anti-Communist films were produced, such as *The Red Menace* (1949) and *I Was a Communist for the FBI* (1951). There was also an anti-Communist dimension to many science fiction films with their hostility to the alien.

Alternative views of a more egalitarian America were presented, instead, as causes and reflections of internal division in the shape of unwelcome class conflict and radicalism. Eric Johnston, president of the Motion Picture Association, a committed anti-Communist, told script writers to act accordingly, and was supported by Ronald Reagan, president of the Screen Actors Guild, who linked radicals and strikers to foreign Communists. Reagan later became America's president.

Transport and Society

In the 1950s the constraints of distance in America were overcome, most significantly with the extensive Interstate Highway System pushed forward by the Eisenhower administration, in part in order to help speed the military response to any major war, and also with the development of civil aviation. The 1956 Federal Aid Highway Act authorized the construction of a 66,000 km (41,000 mile) road network and allocated $26 billion to pay for it from an increased petrol tax. This was a federal (national) response that took influence away from the individual

states which had hitherto controlled roadbuilding, as in the individual turnpikes or toll roads in particular states. Ultimately, more than 74,000 km (46,000 miles) of highway was built, though some of it was locally destructive. For example, building the I-95, the main east coast route, meant flattening city neighbourhoods in parts of Philadelphia.

The highway network helped spread national brands. This was obvious to travellers, since chains selling homogenous products replaced local restaurants and hotels, but was also important to companies seeking to create national markets for products such as cigarettes. The process was aided by television advertising. Television, cinema, popular music and sports teams playing for national audiences all contributed to, if not homogenization, at least a growing awareness of what became national trends.

Civil aviation also became increasingly influential as a way to link America. As an aspect of a free-market state, there was no national airline in the United States, a situation that has continued to the present. In contrast, rail travel, hitherto the key means of long-distance travel, rapidly withered. The replacement of the train by the motor car was very much linked to the move of populations from city centres to suburbia.

SOCIAL MODELS

Very different models of welfare states were offered in the Communist world, Western Europe and the United States. In the last, self-reliance was to the fore, and there was no extension of the New Deal. In the Communist states, notably with the Soviet 4th and 5th Five Year Plans in 1945–55, heavy industry was seen as the route to strength and progress. In contrast, there was scant interest in creating consumer goods for the workers, although there were attempts to provide healthcare, education and housing. The welfare state was also taken to mean the harsh suppression of social and economic practices believed unacceptable, as well as the policing of all opinions. In Western Europe, currents looking to Socialism and to Christian Democracy sought to provide for the working class and to keep them from the temptations of Communism.

Thus, welfare state policies were part of the Cold War. Indeed, they should not be understood separately from that context because it helps explain why political capital was expended to drive through certain policies.

The World Economy, 1945–56

The European and East Asian economies were all hit hard, if not devastated, by World War II, while Britain had crippling debts for which she had to seek American help. The American economy dominated the world even more than at the start of the war. It was America that established the new economic order, and this order reflected the global goals it was seeking. The international free trade and capital markets that had characterized the global economy of the 1900s were slowly re-established in the non-Communist world. The availability of American credit and investment was crucial to this process, since, among the major powers, only the United States enjoyed real liquidity in 1945. The dollar's role as the global reserve currency in a fixed exchange-rate system ensured that much of international trade, foreign-exchange liquidity and financial assets were denominated in US currency.

The American model played a crucial role in the West. Marshall Aid enabled the economies of Western Europe to overcome their dollar shortage, and thus to finance trade and investment, ensuring that American-style technologies could be adopted. Thanks in part to this, 1945–73 marked a period of rapid economic development, later characterized as the Long Boom. In particular, this development was to contrast with the more difficult 1970s and early 1980s. Both the boom and the subsequent hard years, which were taken to full-scale recession by the oil-price shock of 1973, were important to the attitudes of the period. Indeed, the boom can be linked both to the comfortable complacency of the 1950s, and to the hedonistic reaction of the late 1960s. In turn, the difficult years produced a more contentious politics.

During the Long Boom, the American economy produced consumer durables such as cars and fridges in large quantities, that were affordable to many. Linked to this, the United States became a society of mass affluence, which helped to make it

more generally attractive. It was helped in this by Hollywood and TV, with series such as I Love Lucy (1951–7) spreading positive images of American life. The country appeared affluent, happy and based on stable and secure families.

In contrast, the Communist world looked to different models of public effort and communal engagement. Material goods for the individual and the family were downplayed, notably under Stalin and Mao.

CHAPTER 7

Western Predominance in Decline, 1956–74

The combination of American power and the continued resilience of the Western European colonial empires ensured that the decade after the end of World War II was very different to the period that followed. America was buffeted hard by failure in Vietnam, and the American-dominated economic order was much damaged by financial crises, culminating with the 1973 oil-price hike. The European empires went, revolution in Portugal in 1974 prefiguring the end of the last major one, as Angola, Mozambique, Cape Verde and Portuguese Guinea (Guinea-Bissau) gained independence, while East Timor was seized by Indonesia.

THE SPACE RACE

Overarching everything was environmental change, a potent example of which came with the dawning of the Space Age. This can be too readily underplayed and treated as a dead end; but, in practice, it was the greatest drama of the century.

The background was World War II, while the context was the Cold War. In 1945, the Americans and Soviets seized scientists and parts from the rocket programme that had been established by the Germans with great cruelty and used to fire V-2 rockets at targets in Britain and Belgium. The Soviets, who had shown much earlier interest in rockets, developed ballistic missiles and rocket engines. They launched an unmanned satellite, the *Sputnik*, in 1957, beginning a new period of rocketry and one that exposed America to the threat of Soviet nuclear attack. *Sputnik* frequently passed over the United States. The *New York Times* referred to the 'reshaping' of the world. Lyndon Johnson, a prominent Democrat politician, predicted the Soviets 'dropping bombs on us from space like kids dropping rocks onto cars from freeway overpasses'. In 1961, the Soviets put the first man into space, Yuri Gagarin; although he did not complete the orbit they claimed because they provided misleading information on the take-off and landing

sites. The first spacewalk, by Alexei Leonov, followed in 1965, although the mission nearly ended in disaster. These events attracted great world attention, and were seen as a major and prestigious sign of success.

In response, the National Aeronautics and Space Administration (NASA) was established in 1958. John F. Kennedy, president from 1961 to 1963, pledged to make every effort on behalf of an American space drive which was regarded as a way to renew American greatness. Much money was spent. Indeed, in 1966, NASA took 4.4 per cent of the federal budget. The Americans were clearly seen as winning the Space Race when they landed men on the Moon in 1969. This success was broadcast around the world in another triumph of American technology, which thus provided a novel sense of immediacy. The Apollo missions to the Moon also left photographs of Earth as a legacy. If this was a potent image of one world, it was one very much derived from America.

Under great fiscal pressure, President Nixon, however, closed down the manned-flight Apollo missions, the last being sent in 1972, and hit NASA's budget hard. This left the achievement unclear. Much knowledge was gained about the Moon, but there were also doubts about the value of the project, doubts that might seem underlined by the environmental cost.

Neil Armstrong

Neil Armstrong (1930–2012) was born in Wapakoneta, Ohio. A fascination with airplanes from an early age led to his learning to fly even before he got his driving licence. He spent two years at Purdue University studying aeronautical engineering before he was called up to join the US Navy in 1949. By August 1950, he was a fully qualified naval aviator. After serving in the Korean War, his regular commission finished in 1952, but he continued to serve as a reservist until 1960, while also pursuing a career as an experimental research test pilot and beginning work for NASA in 1958. Selected for the US Air Force's Man in Space Soonest programme, Armstrong eventually applied to become an astronaut in 1962. He took part in the Gemini programme, and then the Apollo programme. He was appointed Commander of Apollo 11

on 23 December 1968. On 21 July 1969, it was Armstrong who uttered the words 'The Eagle has landed' as the space module touched down at Tranquility Base on the moon. After his historic moon landing, Armstrong gave up his work with the space programme and worked briefly for ARPA before taking up a teaching position at the University of Cinncinati in 1970. He was also appointed to several commissions and worked as a spokesman for a number of businesses and joined various corporate boards. However, as President Obama said when the news of Armstrong's death was announced, he was 'among the greatest of American heroes – not just of his time, but of all time'.

THE RISE OF CONSUMERISM

Rising population was a key issue, and rise it did: from about 3 billion in 1960 to about 6 billion by 2000, an unprecedented increase and one that attracted insufficient attention. A clear implication can be that environmental damage was all the fault of 'ordinary people' having lots of children, driving cars, consuming goods and resources, and producing waste. That was certainly a very major issue, and the fulcrum of much pressure and pollution were the rapidly growing cities, their population fed by the movement of people from the land as agriculture became less labour-intensive. But, it was, and remains, also necessary to look at how resources are used. Here the pattern was very skewed. The more affluent used their affluence in order to consume a greatly disproportionate share of domestic and international resources, and their affluence was, in part, measured by this consumption and displayed and enjoyed through it.

The propaganda dimension of the Cold War increasingly focused in the late 1950s on the living standards of consumers, with Nikita Khrushchev, the Soviet leader, and Richard Nixon (then Eisenhower's vice-president) publicly debating the virtues of the two systems in 1959. If the Soviet system could provide better outcomes, then it was believed/feared that workers around the world would opt for it, as would newly independent Third World states. This approach was a challenge not only to capitalism, but also to the Socialist parties, such as those in France and Italy, Britain's Labour Party and the German Social Democrats.

The Communists presented them all as tarnished by their willingness to compromise with capitalism. As an aspect of the attempt to appeal to the workers, East Germany produced the Trabant motor car from 1957.

However, the lack of capacity in the economy was such that it generally took 12 years to meet orders for Trabants. More generally, East Germany, like other Communist states, was drab and grey. This was the case with clothes, buildings and street lighting. There was also a lack of flowers, in contrast to Western European homes.

Khrushchev on Consumerism and the Cold War

'a race to see who could do the best job at supplying the ordinary fellow on the beach with his cold drink ... The Americans got it. They understood that if ordinary people were to live the way the kings and merchants of old had lived, what would be required was a new kind of luxury, an ordinary luxury built up from goods turned out by the million so that everybody could have one.'

Suburbanization

A rejection of the inner city as crowded, dirty and dangerous played a role in suburbanization, but the key driver in the 1950s in the West was the rise in motor-car culture, the cheapness of land, the mass production of housing, rising wealth and the ready availability of low-priced loans for the purchase of new houses.

In Socialist and Communist societies, which were very much planned, and planned for public policy goals, the movement of new housing to the edge of cities owed more to a belief in the value of such housing and sites. In particular, there was a wish to separate housing from industry. In these societies, new housing was higher density than in the West, particularly the USA, and usually took the form of blocks of flats.

The cultural consequences of suburban expansion included an important measure of homogenization, seen, for example, in the use of national patterns of urban layouts and housing types, as well as in

shopping and leisure facilities, most of which were provided by national chains. Supermarkets became an adjunct of new housing.

In the United States, private demand was the crucial element in housing, and not public provision; and this demand responded to the major growth of GDP from the 1940s, and to the extent to which the lifestyle of the rich became that of the middle class, a key element in the politics of the 1950s. The kitchens and bathrooms of standard houses reflected this shift. The average house purchaser came closer to realizing the standard dream of a detached house in a low-density area. This was crucial to the 'pull', in the shape of aspirations for a particular lifestyle, as opposed to a 'push', in the shape of fear of the city, notably of crime. Racial tension played a role as 'inner cities', itself a concept with new and negative meanings, were increasingly associated in America with black inhabitants.

DECOLONIZATION

The Cold War was pushed to the fore because of a marked acceleration in the pace of decolonization. Britain, France and Portugal all made major efforts to sustain their imperial position, but these ultimately failed. Although nationalism was crucial to anti-colonial 'liberation struggles', these struggles were also characterized by Communist exploitation, as the Soviet Union and China sought to challenge the United States indirectly, by encouraging supporters to attack America's allies. These attacks brought together notions of popular warfare, nationalism and revolutionary Communism. To this end, the Soviet Union supplied training and weaponry.

In practice, the attempt to shape world politics in terms of a geopolitical and ideological competition directed by the great powers was challenged by independent initiatives. Some were really, or ostensibly, linked to the ideological dynamic of the Cold War, but many were not, or not in the way that the USA and the Soviet Union sought. The cross-currents of other views and interests played a role, from the anti-imperial Non-Aligned Movement, to more nationally specific elements. Allies also proved reluctant to accept guidance, let alone leadership. This was to be a major problem for the United States in its dealings with France and Israel; but also proved an issue with Britain, which recognized Communist China, attacked Egypt in 1956, and refused, despite considerable pressure, to commit troops to the Vietnam War.

Egypt and the Realities of Power

The focus is often the iniquities of Western imperial powers, but this is a very partial account, albeit one that is characteristic of much writing. Imperialism, in fact, was also seen with non-Western states such as Egypt, which resumed earlier attempts to dominate Libya, Sudan and, in particular, Yemen, where, with Soviet support, it intervened in the civil war that began in 1962. It also sought to overthrow the British position in Aden.

In addition, the coup in Egypt in 1952 was followed in 1953 by an abolition of democracy, in the shape of the 1923 liberal constitution, and of political parties, notably the Wafd, a liberal, nationalist party. Under the Treason Law of December 1952, opponents of the new regime were subject to harsh treatment by special tribunals acting in a very biased fashion. Moreover, the Muslim Brotherhood, accused of instigating civil war, was outlawed in 1954 and persecuted. The military had seized total control, which they used to their own profit. Colonel Nasser became a dictator. Thereafter, the state Socialism followed by the Egyptian government could not produce significant economic improvement.

The Suez Crisis, 1956

The major British effort to resist the collapse of the empire occurred in 1956 in Egypt, when Colonel Nasser nationalized the Suez Canal, a key axis of British imperial power. Nasser also challenged British and French interests in the Arab world, notably the French attempt to retain Algeria and Britain's support for friendly monarchies, particularly in Iraq and Jordan. In response, Britain and France sought to overthrow Nasser. However, their invasion of the Suez Canal Zone in October 1956, while initially successful on the ground, met with international condemnation, notably active opposition by the United States which had not been consulted and felt that British policy risked driving the Third World into Soviet hands. Moreover, Britain found much of the former empire unwilling to provide diplomatic backing, notably Canada, but also, for example, Ceylon.

The American government refused to extend any credits to support Sterling, blocked British access to the International Monetary Fund until she withdrew from Suez, and was unwilling to provide oil to compensate for interrupted supplies from the Middle East. Under this pressure, Britain and France withdrew their forces.

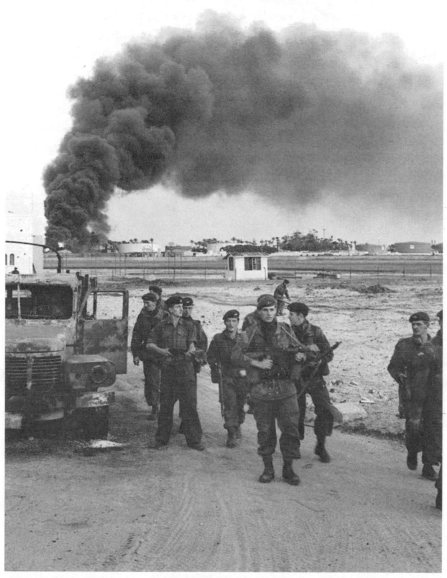

The Suez Crisis 1956. Anglo-French military intervention to thwart the Egyptian nationalization of the Suez Canal was militarily successful in the short-term, with British paratroopers here seizing El Gamil airfield, but international political hostility thwarted it.

The End of Empire

The humiliating climb-down led to the fall of the British government, and the new administration of Harold Macmillan, Conservative prime minister from 1957 to 1963, decided to part with empire. Beginning with the independence of the Gold Coast in 1957, it was a policy that was followed with increasing rapidity – even for some colonies, such as Cyprus in 1960, that Britain had argued were unsuitable for independence. The process was to be continued by subsequent British governments.

Allied regimes also suffered, with Iraq's pro-Western monarchy falling victim to a left-wing military coup in 1958, although the British successfully intervened in support of Jordan that year and in Kuwait in 1961. In 1960, Belgium abandoned the Belgian Congo, and France left all its sub-Saharan colonies bar French Somaliland (Djibouti), which finally went in 1977. It had already granted independence to Morocco and Tunisia in 1956, and Guinea in 1958.

France, however, sought to hold on to Algeria, which it treated not as a colony but as part of France itself. This was easier said than done, and the burden of the Algerians' war for independence pressed hard. France's new government under Charles de Gaulle abandoned its commitment to retain Algeria in 1962, despite the demands of the numerous white settlers there. Instead, de Gaulle was concentrating on a European identity for France, while France's development of the atomic bomb meant that it had less need for soldiers from North Africa.

Portugal went on in the face of a major insurgency in its African colonies which began in Angola in 1961 and spread to Mozambique and Portuguese Guinea. This insurgency was supported by the Soviet Union and China. As with France in Algeria, there was military impasse, but also heavy burdens on Portugal, notably conscription – also an issue for France in Algeria and for the United States with Vietnam. The overthrow of the right-wing authoritarian system in Portugal in 1974 was followed by a rapid abandonment of empire. The death of Franco in 1976 led Spain to abandon the Spanish Sahara.

Differing Images

'This time the slaves did not cower. They massacred everything.' Holden Roberto, leader of the National Liberation Front of Angola when it launched its first guerrilla invasion of the Portuguese colony by slaughtering colonists in 1961.

In 1962, a large wall mosaic was unveiled in the bank in Lisbon handling the currencies of Portugal's colonies. It depicted Portugal's colonization of Africa in benign terms of ethnic harmony, progress and Christian proselytization. It was attractive, convenient and misleading.

Ethnic Identity

One of the less attractive aspects of decolonization was the extent to which former colonies frequently sought to destroy ethnic and religious heterogeneity. Imperial states had tended to support such variety, offering equal rights to all, but that was less true of many of their successors who tended to treat nation and race as synonymous. Thus, Christians and, in particular, Jews were harshly treated across the Arab Middle East, while those of Indian descent faced discrimination, for example in Fiji and Uganda, as did their Chinese counterparts in Indonesia and Malaysia. In 1962, Christians and Jews fled Algeria. In 1967, newly independent Kenya passed Africanization legislation which hit the economic interests of its Indian population, leading 33,000 to emigrate to Britain, although a larger number stayed. At times, as in Indonesia, discrimination proved murderous. Moreover, there was ethnic cleansing when 60,000 Ugandans of Asian descent were expelled in 1972.

More generally, racial tension was widespread, that between those of African and Indian descent being seen elsewhere also, for example in Trinidad. The defence of white minority interests in Africa was not separate to this widespread racial tension, but an important aspect of it. Indeed, talk of globalization should take note of this prejudice across much of the world. As an aspect of racial tension, there was a widespread tendency to neglect the extent and role of those of mixed-race descent, for example in South Africa.

Imperial Identity

British settler communities in much of the empire had been relatively small-scale, and they became less important after independence, notably so in India. However, settler communities continued to be a presence in some former colonies, such as Kenya. The Dominions continued to have a strong sense of British identity. Close to 1.5 million Britons emigrated to Australia from 1947 to 1981 and Australian-born Robert Menzies, prime minister from 1939 to 1941 and 1949 to 1966, claimed: 'A migrant from Britain to Australia is not lost to Britain; he merely serves the true interest of Britain in another part of the British empire.' From the 1980s, emigration to Australia was no longer dominated by Britons, but, increasingly, by Asians.

New Identities

The creation of new states ensured that unifying ideologies were required. In part, this involved an emphasis on the national scale and not the regional one. Thus, in Indonesia, which in part was/is a greater Java that adopted a convenient identity, there was a downplaying of the perspectives of Sumatra, Sulawesi, Indonesian Borneo and West Irian. This was also the case with Malaysia for Sarawak and North Borneo. In both countries, there was a concern about the potential consequences of the multi-ethnic and multi-religious character of these far-reaching states, and this entailed de-emphasizing other links, notably between the Indonesian and Malaysian sections of Borneo, and between northern Malaya and Thailand.

Renamings

On independence in 1964, Nyasaland was renamed Malawi and Northern Rhodesia became Zambia, with Southern Rhodesia eventually becoming Zimbabwe in 1980. Its capital, Salisbury, named after a British statesman and prime minister of the imperial apex, Robert, 3rd Marquess of Salisbury, became Harare. Some changes came later than independence, Ceylon becoming Sri Lanka in 1972, Burma Myanmar in 1989 and Bombay Mumbai in 1995. This was also the case in other

empires. The French colony of Upper Volta became Burkina Faso in 1983. Saigon, capital of South Vietnam, became Ho Chi Minh City in 1975.

Africa in Independence

In 1960, when Congo became independent from Belgium, the rising pace of imperial collapse provided new fuel for Cold War rivalries. Regarding him as pro-Soviet, the USA unsuccessfully sought to prevent the election of Patrice Lumumba, the head of the Congolese National Movement. Comprising many ethnic groups, and lacking a practice of united central government under African control, Congo fragmented. Lumumba sought UN support, but a fear that he might turn to the Soviets led the USA to back the seizure of power by the Congolese military under General Joseph

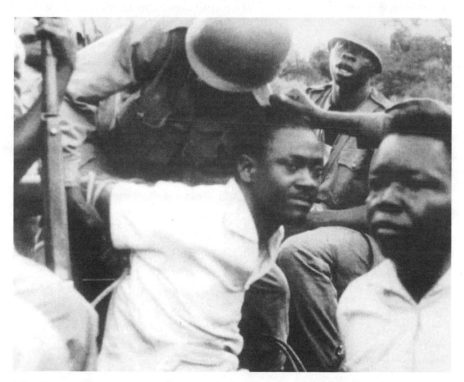

The arrest of Patrice Lumumba, the leader of the Congolese National Movement, by Mobutu's forces after his coup, December 1960. Lumumba was executed by a Katangan firing squad with Belgian connivance the following month.

159

Mobutu in September 1960. Lumumba was assassinated in January 1961, and the CIA helped finance Mobutu to gain control over the country at the expense of opponents and separatists.

Elsewhere, the euphoria that greeted independence was all-too-quickly dispelled. Few states were able to offer their citizens security or prosperity. The colonial borders they inherited bore little or no relation to the realities of ethnic settlement. Consequently, once the common colonial enemy was removed, there was little sense of national cohesion. Ethnic violence was the frequent outcome.

This was also the case in Nigeria (independent from Britain in 1960), where, in a bitter conflict in which mass starvation played a role, the Ibo-majority region failed in 1967–70 to sustain an independent state called Biafra in the face of a major effort by the far larger Nigerian military.

There was a similar story with the longstanding, but eventually successful, attempts of Eritrea and South Sudan to win independence from Ethiopia and Sudan, in 1991 and 2011 respectively. To a degree, a related process occurred in Czechoslovakia, Yugoslavia and the Soviet Union in the 1990s. Many states had been the creations of Western imperialism, including Indonesia, Sri Lanka, India, Pakistan, Malaysia, Nigeria, Kenya, South Africa and Congo. In each case, their territorial extent reflects this imperialism.

With elected governments often ill-prepared for such challenges and democratic traditions still weak, many states fell prey to military coups. Among the more brutal and corrupt regimes were those of Jean-Bédel Bokassa in the Central African Republic and Idi Amin in Uganda. During the Cold War, African nations often became battlegrounds for rival interests, with brutal dictators kept in power with Communist or Western support. Rebel armies, assisted by South Africa and the USA, fought against regimes in Mozambique and Angola. A pro-Soviet Communist regime won control of Ethiopia in 1974.

Africa suffered economically in the 1970s from a rise in oil prices and a drop in prices for commodities such as coffee and cocoa. National debt rose in most African countries, causing economic stagnation and extreme poverty in many areas.

African Independence

1949 Mau Mau movement founded in Kenya

1954 Gold Coast National Liberation Movement begins

1958 French colonies hold referenda on independence

1961 Wars of liberation begin in Portuguese colonies

1962 Algeria wins independence from French rule

1963 Kenya wins independence from Britain

1965 Rhodesia's white minority declares UDI (unilateral declaration of independence)

1967–70 Biafran War

1974 Marxists oust emperor Haile Selassie in Ethiopia

1975 Civil war breaks out in Angola following independence.

THE COLD WAR

Environmental pressures were involved in the Cold War, but were scarcely to the fore. Instead, it was resources to be used, rather than conserved, that were at issue – particularly oil, a major theme in the struggle over the Middle East. To the United States, it was important to keep Saudi Arabia out of Communist hands because of its massive oil reserves.

Yet, underlying all was the determination to control people and territory. Neither the United States nor the Soviet Union saw their ideologies as appropriate only for themselves or in their nearby regions. Instead, these rival ideologies were regarded as of worldwide validity. This helped make the Cold War particularly destabilizing.

Totally incompatible ideologies and views about the necessary future for humanity both underlay the Cold War and gave it great energy. Communist commentators presented an image of Soviet-led equality as the means for, and guarantee of, progress, while anti-Communist counterparts argued that Communism was inherently totalitarian and destructive to freedom. Modernization was presented from a variety of perspectives. It was regarded by the Americans as a form of global New Deal: an attempt to create independent, capitalist, democratic and liberal states. There was an inherent preference for democracy, but, across much of the world, American distrust of populism and of left-wing politicians led, instead, to alliance with authoritarian élites. Thus, containment in

Iran, Portuguese Africa, South Vietnam, South Africa and Latin America, meant supporting these regimes' resistance to liberal tendencies, although the opposition to these regimes in each case included markedly anti-liberal movements.

The Cold War in Latin America

Wealthier and more determined than the European empires, the United States generally proved a more successful imperial power. This was particularly so in Latin America where its economic and military dominance was exercised through local allies, many of them military, as in Brazil and Chile. In Argentina, Juan Péron, president from 1946 to 1955 and 1973 to 1974, was a populist dictator and military figure who the Americans were generally able to accept. In Paraguay, Alfredo Stroessner seized power in a coup in 1954 and remained president until 1989, his dictatorship supported by the USA. In Brazil, concern about Communism and instability led the army, eager to impose order and progress, to take power in 1964, a step supported by the United States.

Latin America During the Cold War

4 June 1946 Juan Peron begins first term as president of Argentina

4–7 May 1954 Alfredo Stroessner seizes control of Paraguay in a coup

1 January 1959 Batista's government in Cuba falls

17–20 April 1961 Cuban exiles lead the unsuccessful Bay of Pigs invasion backed by the CIA

31 March – 1 April 1964 Army takes power in Brazil

28 April 1965 American troops invade the Dominican Republic to put Joaquín Balaguer in power

9 October 1967 Che Guevara is executed in Bolivia

13 June 1968 Uruguay declares a state of emergency

11 September 1973 Salvador Allende is overthrown in a military coup led by General Pinochet

17 July 1979 Sandinistas come to power in Nicaragua

14 October 1983 America intervenes in Grenada

27 June 1985 International Court of Justice condemns US support for the Nicaraguan Contras

The coup produced a dictatorship that lasted until 1985 and that initially brought, alongside the killing of dissidents, economic growth in the 1970s, only to end up in the 1980s facing serious economic problems and major unpopularity. In Chile in 1973, the left-wing government of Salvador Allende was overthrown in a right-wing military coup which resulted in a brutal American-backed military dictatorship under General Augusto Pinochet that lasted until 1990.

In Uruguay, where a state of emergency had been declared in 1968 in response to unrest and, notably, the Tupamoros guerrillas, the military gained power in 1973 and held it until 1985. Again, human rights were violated, notably with torture and murder. Opponents 'disappeared'.

The relationship between the United States and Latin American militaries broke down in Cuba where the regime of Fulgencio Batista, a reactionary military dictatorship, was overthrown in 1959 by left-wing radicals under Fidel Castro, who turned for support to the Soviet Union. This led to a totally unsuccessful CIA-backed invasion by Cuban émigrés in 1961, the Bay of Pigs episode.

In turn, the Soviet Union attempted to transport nuclear missiles to Cuba. Their deployment, which threatened the United States, brought the world close to nuclear war in 1962 (although, in practice, that very prospect may have helped to prevent conventional military operations which would have begun with an air attack on the Soviet bases on Cuba). In the event, using the argument that the 1930s' appeasement of Germany must not be repeated, an American air and naval blockade was imposed in order to prevent the shipping of further Soviet supplies.

The Soviet Union agreed to remove the missiles, while the United States undertook not to invade Cuba and to withdraw missiles from Turkey. Today, an American economic blockade against Cuba remains in force, and this is used by Cuba to justify its authoritarian regime and excuse its serious economic failures. Khrushchev, meanwhile, was compromised by the crisis, being perceived as erratic by his colleagues, while Castro and Mao saw him as weak for having blinked first. Khrushchev's handling of the crisis was given as a reason for his dismissal in 1964.

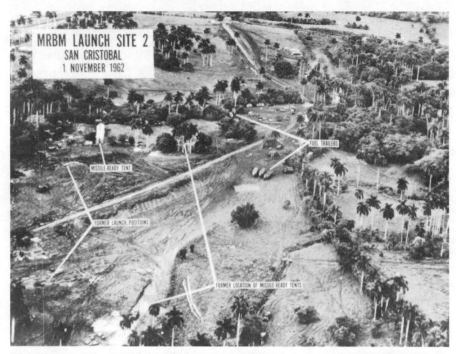

The Cuban Missile Crisis, 1962. American aerial surveillance indicating the development of Soviet-rocket bases led to an American blockade, but war was avoided.

A Revolutionary History

In Cuba, the *Museo de la Revolución*, housed in the presidential palace used by Batista, provides detail on the Cuban revolution. The story is then taken forward with exhibits on the 'construction of Socialism'. Alongside the museum is the boat that took Castro to Cuba in 1956 to begin the revolution, military vehicles from the 1961 Bay of Pigs invasion, and a monument to those who died in the revolutionary struggle. The museum of the Ministry of the Interior displays exhibits relating to the numerous assassination attempts made on Castro, as well as details of other CIA and Cuban exile operations.

Despite persistent American fears, Cuba was not a forerunner for the remainder of Latin America. Castro's lieutenant Che Guevara unsuccessfully sought to launch social revolution in South America and was killed in Bolivia in 1967. In 1965, the Americans sent troops into the Dominican Republic to thwart a left-wing movement from seizing power to reverse a coup of two years earlier. They did the same in Grenada in 1983. However, the Americans found the situation less favourable in Nicaragua in the 1980s when they sought to coerce the left-wing Sandinista regime.

The Cold War in Europe

The nuclear shadow contributed to a stabilization of Cold War boundaries in Europe. It became too risky for the United States to sponsor the roll-back of the Soviet sphere. This stabilization encouraged the pursuit of advantage instead in the Third World.

With American military support, West Berlin was kept out of the Soviet bloc in the Berlin Crisis of 1961, but the West's policy was one of containment rather than any attempt to reduce Soviet power in Eastern Europe. Indeed, the Berlin Wall, constructed by the East Germans in 1961, left the city a powerful testimony to hostility, one that lasted until 1989. Presented as a defensive structure, an 'Anti-Fascist Protection Wall', the Berlin Wall was in fact erected to stop the exodus of East Germany's population.

The open border between East and West Berlin had offered an easy means for fleeing from East Germany, and by building the wall the Communists abandoned any suggestion that their system was more popular. Their division of the city was initially with barbed wire, but later with a concrete wall supported by frontier troops trained to shoot would-be escapees, and ready to do so. The wall was supported by underground corridors, which allowed border guards to move rapidly. It was lined by watchtowers and minefields, and many were shot dead as they sought to breach it. This division was a breach of the agreements between the citizens of Berlin to move freely through the whole city.

In response the crisis escalated at the international level and there was a stand-off in Germany between American and Soviet tanks in October. The end result was a Berlin Wall that left the divided city as a powerful testimony to hostility. The wall was also a declaration that East Berlin was in the Soviet zone and that German reunification was highly unlikely to occur. The Berlin Wall became a powerful and repeated subject and motif in fiction and film.

Albania: A Maverick State

The ruthless Communist leader, Enver Hoxha, ruled as dictator from 1944 until his death in 1985, becoming an ally of China from 1961. Due to Hoxha's paranoia, the established Communist model of totalitarian state control, personality cult, collectivization and state atheism remained insulated from reformist pressures elsewhere in Eastern Europe, which was kept at a distance for fear of ideological contamination.

Cold War in the Middle East

The Americans had sought to limit the Soviet advance by means of 'containment', a system of alliances among bordering states. As a result, they established a series of alliances – NATO, CENTO and SEATO – as well as bilateral agreements. In turn, the Soviets tried to leapfrog containment by finding more distant allies, such as Cuba, Ethiopia and Angola, and exploiting rivalries in the newly decolonized world, for example between India and Pakistan. This was done most successfully in the Middle East, where Egypt, Syria and Iraq all became Soviet allies and were armed accordingly.

By the 1950s, the Middle East was free from direct colonial rule, yet because of the increasing importance of the oil industry, the West, particularly the USA, continued to exert political and economic influence on governments in the region. This caused anger among many Arabs, who saw it as a new form of imperialism. Riding this wave of resentment, military officers seized power in Egypt (1954), Syria (1963), Iraq (1968) and Libya (1969). The new rulers were anti-Western Arab nationalists, seeking to end Western interference in Middle Eastern affairs and forge closer ties between the nations of the Arab world. Some, called pan-Arabists, even wished to unite the Arabs into one nation – Egypt and Syria briefly joined to form the United Arab Republic (1958–1961).

The new regimes favoured socialist reforms – including the national-ization of Western-dominated industries and the redistribution of land

owned by foreign settlers – as the most effective way of overcoming the legacy of colonialism and securing political independence. In this Cold War era, this naturally placed the new regimes in the Soviet camp, while the conservative monarchies of Saudi Arabia, Jordan, Iran and the Persian Gulf emirates remained staunch US allies.

Whether or not seen in terms of the Cold War, Egypt was the most expansionist of the states. Nasser pursued a pan-Arabist idea of unity, notably exploring federal union with Syria, Sudan and Libya, in the last of which a radical military group under Colonel Qaddafi overthrew the monarchy in 1969 and held power until 2011. Egypt also competed with the conservative Saudi monarchy and, in 1962, intervened on the anti-royalist side in a civil war in Yemen. In turn, the Saudis backed the other side. This was also the case with a civil war in Oman's western province of Dhofar.

However, Egypt's particular ire focused on Israel, by which it had been defeated in 1948–9 and 1956. Opposing Israel offered Nasser an opportunity to claim leadership of the Arab world. None of the Arab states recognized Israel's right to exist, and the following years were marked by frequent border skirmishes.

In June 1967, in the Six Days' War, Nasser's belligerence was countered by a successful Israeli surprise attack, and the Israelis pressed on to defeat Jordan and Syria, which came to Egypt's assistance. In just six days, the Israelis captured Gaza and the Sinai from Egypt, the Golan Heights from Syria, and the West Bank from Jordan, more than trebling its territory. Over 750,000 Palestinian Arabs suddenly found themselves under the control of the Jewish state. Many turned their support to the Palestine Liberation Organization (PLO), a coalition of Palestinian groups that began engaging in terrorist actions against Israel.

Nevertheless, the Soviets fully rearmed Egypt and Syria which, in turn, launched a surprise attack on Israel in 1973. Variously known as the October, Yom Kippur or Ramadan War, which reminds us how wars, and indeed world history, can be differently seen and described, this conflict saw the Israelis take heavy casualties before finally triumphing over both assailants. There was a risk of both the Soviet Union and the United States coming in on the side of their respective allies, but, in the end, that danger helped to contain the struggle. The United States leaned on Israel to stop fighting its eventually defeated opponents.

THE SOVIET UNION

Meanwhile, the Sino-Soviet split was a challenge to the Soviet dominance of the Communist bloc that was far more serious than the defection of Yugoslavia in 1948. The differing origins of the Soviet and Chinese Communist Parties were an issue, as were ideological factors, cultural differences, the temperaments of leaders, military competition and concerns about status. More generally, the Soviets found it difficult to influence, let alone direct, non-Western states over a long timescale: alongside ideological rifts, nationalism repeatedly trumped ideology.

The Chinese rejected both what they correctly saw as Soviet patronizing and also the Soviet ideological leadership that had become, from the mid-1950s under Nikita Khrushchev, a rejection of the legacy of Joseph Stalin and, instead, a move to a degree of liberalization. In contrast, the China of Mao Zedong opposed any compromise, and, in the 'Great Leap Forward' of 1958–62, a typical misuse of language that consistently needs guarding against, sought a radical forcing forward of its economy. The Soviet Union under Khrushchev lacked this brutality. Neither country found that state control brought the economic transformation they sought, but Communism made it impossible to abandon such control and the bold aspirations that accompanied it.

AMERICA

The world power, America, had a dynamic economy and maintained its democratic system. At the same time, America was changing with the increased prominence of Texas and California, and with moves against racial segregation in the South. The 1960s and early 1970s proved roller-coaster years for the country. The confidence of the 1950s, a decade of economic growth and prosperity, was followed in the early 1960s by the optimism of the Kennedy presidency. That optimism was soon shattered. Kennedy was assassinated in 1963, the Great Society programme and the enactment of Civil Rights legislation failed to end discrimination, while attempts to contain Communism abroad resulted in the disastrous failure of the Vietnam War. A lack of unity among the Democrats resulted in the election of the Republican Richard Nixon in 1968, who followed a path of *Realpolitik*, urged on by his National Security Advisor, Henry Kissinger. Nixon's subsequent attempt to subvert domestic opponents fell foul of the law in the Watergate Affair, resulting in a crisis of legitimacy for his regime and ultimately his resignation.

Rosa Parks (1913–2005)

When Rosa Parks refused to give up her seat to a white man on a bus in Montgomery, Alabama, in 1955, it was a catalyst to the civil rights movement in the USA.

The frustrations felt by Rosa, a seamstress, her husband Raymond and members of their community were manifest. The segregation laws meant Black people could attend only certain schools, drink only from designated water fountains and borrow books only from the 'Black' library, among other restrictions.

In December 1943, she joined the Montgomery chapter of the National Association for the Advancement of Colored People (NAACP) and became chapter secretary. Her refusal to move from her bus seat on 1 December 1955 led to her arrest, and initiated the year-long Montgomery Bus Boycott by Black residents of the city. The boycott enraged many white residents and led to violence against the leaders, but ended only when the US Supreme Court ruled that bus segregation was unconstitutional.

Parks – who lost her job and endured harassment all year – became known as the mother of the civil rights movement. She continued to be active in US civil rights throughout her life and was awarded a Congressional Gold Medal in 1999. On her death in 2005 she was the first woman to lie in honour in the Capitol.

The Kennedy Assassination

Several American presidents were assassinated in the 19th century, but only one, John F. Kennedy, in the 20th, although there were unsuccessful attacks on Harry Truman and Ronald Reagan. The Warren Commission concluded that the assassination, in Dallas on 22 November 1963, was the work of a single individual, but the number of conspiracy theories that circulated from the moment of Kennedy's death testified not only to the strength of paranoia, but also to a sense that the barrier to an alternative world, in which violence played a major role, had been surmounted. This

was partly a matter of bridging the division between international conflict and domestic politics, most obviously with reports that the KGB or the Cuban government or anti-Castro Cuban exiles, disillusioned by a lack of support, had been responsible. There were also reports that Kennedy was the victim either of organized crime, or of political elements wanting a tougher anti-Communist stance.

In practice, it is far harder to organize conspiracies than to allege their existence. However, the murder began a decade in which assassinations or attempted assassinations (Malcolm X, 1965; Martin Luther King and Robert Kennedy, 1968; George Wallace, 1972) played a role, often major, in politics. Partly as a result, it became easier to think in terms of conspiracies. The assassinations certainly indicated the significance of the prevalence of guns in the United States.

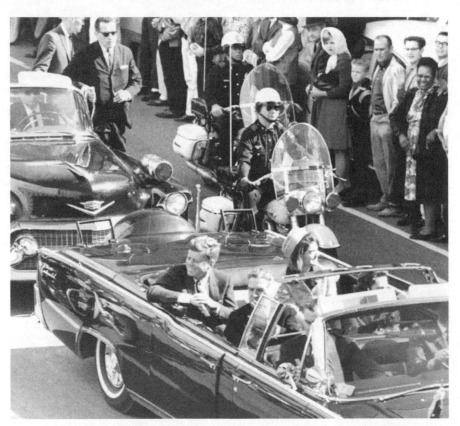

Dallas, 1963. The assassination of President Kennedy was a traumatic moment for America but also showed the resilience of its political system.

The Great Society and Civil Rights

Kennedy's successor, the vice-president Lyndon Johnson, a Texan politician who was an experienced leader in Congress, won a resounding victory over the strident Republican Barry Goldwater in the 1964 presidential election. Johnson's subsequent reputation was harmed by the Vietnam War, but, in domestic politics, the Democrat Johnson was willing, and able, to engage with profound inequalities about which Kennedy had only talked. Tapping into powerful iconic language with his message of frontiers and society, and affirming a possibility of national greatness, Johnson, who had been an agent of the New Deal under Franklin Delano Roosevelt, expanded expensive social programmes as well as backing desegregation. He declared: 'I have called for a national war on poverty. Our objective: total victory.' The Civil Rights Act, passed in 1964, with Johnson's eager support, banned employment discrimination on the basis of race, religion and gender. The desegregation of schools was stepped up. The Voting Rights Act followed in 1965. These measures were important to the extension of civil rights and opportunities to black people, although they tended to be underplayed due to an understandable focus on brave action by black activists themselves, notably Martin Luther King. Building on Truman's desegregation of the military, and Eisenhower's moves against discrimination, Civil Rights affected education and federal employment, but had less of an impact on public health and private housing.

Most black leaders pursued community interests through mainstream politics. In contrast, black separatism and radicalism, as advocated by Malcolm X, failed to develop as mass movements. He declared in 1965: 'One of the things that made the Black Muslim movement grow was its emphasis upon things African. This was the secret to the growth of the Black Muslim movement. African blood, African origin, African culture, African ties... we discovered that deep within the subconscious of the black man in this country, he is still more African than he is American.'

'I Have a Dream'

In a powerful speech for Civil Rights, symbolically delivered on the steps of the Lincoln Memorial in Washington on 28 August 1963, Martin Luther King Jr. declared that, despite

the Emancipation Proclamation, 'One hundred years later, the life of the Negro is still sadly crippled by the manacles of segregation and the chains of discrimination.'

The Vietnam War

Kennedy's success in brinkmanship in the Cuba crisis in 1962 encouraged a firm American response in other circumstances, with a mistaken belief that similar pressure could be brought to bear to force the Communist powers to back down. The crisis also accentuated a sense of the USA confronting an advancing Communism around the world.

This sense was to focus on South Vietnam, a country that most Americans, and many politicians, could not have found on a map in 1960. The creation of North and South Vietnam as two states in 1954 had not produced stability. The American government was concerned that a failure to support the government of Ngo Dinh Diem in South Vietnam against active Communist subversion from North Vietnam would lead to the further spread of Communism in South-East Asia, a view described as the domino theory. Diem was an autocrat, but his anti-Communism made him acceptable to the Americans, and Kennedy favoured his Catholicism.

Diem's government, based in Saigon, lacked popular support, and was opposed by many, especially in the countryside, who saw it as a puppet of the USA. An organized rural opposition emerged, called the Viet Cong, supported by the DRV. Open warfare between the Viet Cong and the South Vietnamese army (ARVN) broke out in 1959. The US government offered military advisors and financial support to sustain the Diem regime, but it grew increasingly vulnerable, especially after Ngo Dinh Diem himself was assassinated in a military coup in 1963.

Moreover, a generally racist American attitude to the South Vietnamese ensured that a lack of democracy there seemed reasonable and also led to less concern about Vietnamese casualties. President Kennedy initially committed only to providing American 'advisors' to South Vietnam.

In 1964, the new President Lyndon Johnson used an attack on US ships in the Gulf of Tonkin as an excuse to become directly involved in the conflict. US planes began bombing North Vietnam and, in 1965, the first American combat troops were deployed to attack Viet Cong forces in

the South. The DRV and Viet Cong avoided major battles where superior American firepower could be decisive, opting instead for guerrilla tactics, including ambushes and bomb attacks. Prolonged and intensive US aerial bombing failed to demoralize the North, and despite suffering high casualty rates, the DRV and Viet Cong always managed to replace their losses. As the war dragged on with no sign of victory, it began to attract strong opposition from many in the USA, especially college students. By 1969, Johnson's escalation had led to over half a million American troops being deployed in Vietnam.

The Tet Offensive

In early 1968, on the day before the Vietnamese celebration of Tet, the DRV and Viet Cong launched a major offensive, attacking military bases and the major cities in the South. The invaders were driven back, but the Johnson administration in the US, stunned by the offensive, did agree to begin peace negotiations. The talks, in Paris, came to nothing. In 1969, faced with growing domestic opposition to the war, the new president, Richard Nixon, ordered a gradual troop withdrawal.

This war, however, proved intractable, with American strategy wrongly assuming that the North Vietnamese would capitulate as losses mounted. In practice, American losses soon proved unacceptable to the population at home. Disillusionment at continued signs of North Vietnamese vitality, notably the unexpected Tet Offensive in January 1968, combined with domestic economic problems, as well as political opposition, led Johnson, in March, to reject the request for another 206,000 troops and to decide not to stand again for president.

Once elected in 1968, his Republican successor, Richard Nixon, who had promised to end the war, initially stuck with it. Indeed, in 1970, he widened its scope, invading neighbouring Cambodia in order to destroy Communist bases there. Successful on the ground in the short term, this destructive 'incursion', which was of dubious legality, further lessened support for the war in the United States and helped to create a feeling of a government not willing to limit its goals and methods. At the same time,

the Americans withdrew troops from South Vietnam, taking advantage of poor relations between China and the Soviet Union.

Anti-war protests intensified as news emerged in 1971 of a massacre of innocent Vietnamese by a US army unit at My Lai, and the American use of the highly toxic defoliant, Agent Orange, against the jungle bases of the Viet Cong.

An American-Chinese *rapprochement* in 1972, with Nixon visiting Beijing that year, made it less serious for America to abandon South Vietnam, just as in Indonesia the CIA-backed defeat of Communism and the overthrow of the Sukarno government by the Indonesian military in 1965–6 had made the fate of Vietnam less significant geopolitically.

Exhausted, both sides agreed to further talks, leading to a ceasefire in 1973 and US agreement to withdraw its forces. After US troops had gone, the conflict resumed, with the North now at a decided advantage. The war ended in April 1975 when North Vietnamese forces captured Saigon, which was subsequently renamed Ho Chi Minh City. In 1976, Vietnam was reunited as the Socialist Republic of Vietnam. The war had left much of South Vietnam in ruins. The new government imprisoned thousands of South Vietnamese, and private businesses were forced to close, precipitating an exodus of around a million Vietnamese between 1975 and the early 1990s.

The Vietnam War had demonstrated that being the foremost world power did not necessarily mean that less powerful states could be defeated. It also showed that Communism was determined to regiment society and ready to establish a control state accordingly.

The Khmer Rouge

In 1975, a Cambodian Communist organization, the Khmer Rouge, under their leader Pol Pot, seized power and renamed the country Democratic Kampuchea. The Khmer Rouge had a vision of Cambodia as a peasant-run agrarian state. They marched all city dwellers into the countryside and forced them to take up farm labour. Intellectuals, merchants, bureaucrats, clergy and any ethnic Chinese or Vietnamese were slaughtered en masse. Millions more were forcibly relocated, deprived of food and tortured. During the four years that the Khmer Rouge were in power, some 1.7 million Cambodians were killed, which was more than a fifth of the population. The regime was overthrown by Vietnamese forces during an invasion in 1979.

Henry Kissinger and *Realpolitik*

Appointed National Security Advisor by Nixon in 1969, Henry Kissinger, a Harvard International Relations specialist, saw himself as a realist determined to limit chaos. Reaching out to China to counter the Soviet Union was regarded as a way to put pressure on the Soviets to persuade North Vietnam to reach an accommodation with South Vietnam. In pursuit of 'realism', this put geopolitics before ideology, and Kissinger was keen to do so. Thus, the Republicans ended the Vietnam War. However, opposition to this policy led to the birth of what later became neo-conservatism.

Realpolitik was also seen from the Soviet Union. Stability in Europe was regarded by the Soviet government as helping ensure a stronger position from which to confront China, while there was interest in cutting defence costs and importing Western technology. Interest in stability was shown in 1971 in Leonid Brezhnev's speech to the Party Congress when he called for international security and devoted scant space to the cause of 'national liberation', the argument generally used to justify support for anti-Western struggles in the Third World. There was therefore a rejection of the adventurism associated with Khrushchev, and this was important in the background to *détente*. The latter also owed much to American caution as a result of failure in Vietnam and to the ability to contain the 1973 conflict in the Middle East.

The Watergate Affair

The discovery of the break-in on 17 June 1972 at the headquarters of the Democratic National Committee in the Watergate Building in Washington brought the edifice of Nixon's illegal acts into the public eye. The action was ironic as Nixon's supporters were seeking information that would be useful to his re-election as president in 1972, but, in practice, he had no difficulty in winning the election against a very weak Democratic opponent.

Nixon's scorched-earth policy towards the subsequent investigation, first by the press and then by the Senate investigating committee, took the form of repeated political and legal obstruction, but, in the end, with multiple infractions of the law apparent, he was forced on 9 August 1974 to resign for his conspiracy to obstruct justice. The scandal led to a crisis of confidence in national leadership, one that left a powerful and lasting legacy in terms of the role of conspiracy theories in fiction

and on the screen. There was a parallel here to the disillusionment seen with failure in Vietnam.

POST-WAR AUSTRALIA

From 1949 to 1972, the conservative Liberal Party ruled Australia, much of it under the premiership of Robert Menzies. The country retained close links with Britain, but also forged a strong defensive alliance with the USA, committing troops to the Korean and Vietnam Wars, as well as hosting several US naval communications stations. The economy grew, thanks to the government's pro-market economic policies and foreign investment, especially from the USA, in the manufacturing sector. Urbanization increased, and the major cities sprouted sprawling suburbs. Mass immigration from southern Europe and the Middle East began to change the face of Australian society, with diverse ethnic communities creating their own enclaves in the inner suburbs.

From the mid-1960s, a new nationalism emerged, with Australians taking a greater pride in their natural, cultural and historic heritage. Australian TV made locally based dramas, the Australian film industry flourished, and the iconic Sydney Opera House opened in 1973. The early 1970s was a time of political activism, with demands for women's liberation, aboriginal rights and an end to the Vietnam War. A desire for change swept the country, propelling the Labour Party to power. Australian troops were withdrawn from Vietnam and social reforms were introduced. The government lasted just two years, but its Liberal successor continued its progressive domestic programme.

New Zealand

After the war, the USA gradually replaced Britain as New Zealand's major economic and military ally, although economic links with Britain remained strong until 1973 when Britain joined the EEC. Between 1949 and 1984, New Zealand politics was dominated by the conservative National Party. The economy prospered from the 1950s to 1970s, despite heavy government regulation. During this period, the Maoris experienced a population boom, growing from

45,000 to over half a million. Many moved to the cities and a growing movement for Maori rights developed. New Zealand abandoned its military alliance with the USA in 1987 due to its strong anti-nuclear stance.

A CHANGING SOCIETY

In the 1960s, the WASP view of America was challenged, both by economic, social, cultural and political pressures, and by calls for a more diverse United States. This challenge, and the response, provided the basis for the subsequent 'culture wars'. The net effect of the focus of hedonism on free will and self-fulfilment was a more multi-faceted public construction of individual identities, and a more fluid society that was ready to question authority.

The 1960s are often remembered in terms of pop festivals and alternative culture, including the consumption of narcotic drugs. However, the most prominent politician who emerged victorious from the decade was Richard Nixon, the Republican who won the American presidential election in 1968. Similarly, Edward Heath, the Conservative candidate, won the 1970 general election in Britain, and in France the similarly right-wing Georges Pompidou the 1969 French presidential election.

This paradox captured the extent to which the changes proposed and in part executed in the period also aroused opposition. These changes reflected the displacement of religion as a key element in cultural and social norms and an emphasis, instead, on free will. Youth culture, feminism, drugs and sexual liberation were international themes, as was the very public questioning of authority that was such a shock to the older generation. The emphasis was now on novelty, freedom and self-fulfilment, or, rather, and the distinction is important, on what were presented in this light.

1968

Opposition to the Vietnam War, in the United States and more generally, and a more widespread new-found assertiveness and radicalism of large sections of the young, became focused in a year of discontent in which there were large-scale disturbances, notably in Paris, Chicago and Prague. To some commentators there were echoes of the Year of Revolutions in

1848. They did not, however, have the political impact that might have been anticipated, in part because radical unity was difficult to sustain and because there was more conservatism in society than many commentators realized. This was true both in general and in particular. Thus, in France, the crisis of 1968, the *événements de mai* did not prefigure a repetition of the French Revolution of 1789, and, instead, was overcome. De Gaulle's conservative successor and one-time prime minister, Georges Pompidou, won the next presidential election in 1969. In Czechoslovakia, the reform of the 'Prague Spring' was nipped in the bud by Soviet military intervention in 1968.

Competing Generations

The 'Greatest Generation', those Americans who came of age in the 1940s and fought in World War II, were counterpointed to the '1960s' Generation', which was held to have abandoned their values, with damaging cultural and social consequences for the USA. Politics played a role in this culture war, with the Republicans especially keen

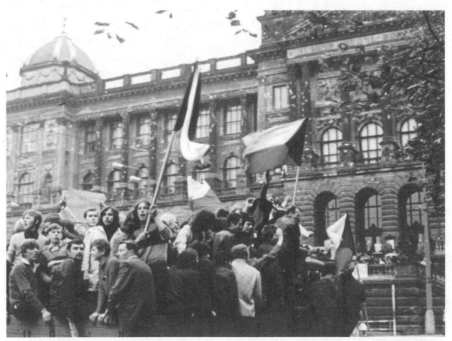

The Prague Spring. Communist reform movements were repeatedly defeated, as in Czechoslovakia in 1968, largely due to Soviet intervention, until in the late 1980s, the Soviet Union changed policy.

to appropriate the idea of the 'Greatest Generation', which was ironic because World War II, like the Vietnam War, was waged by Democrat administrations. Initially, the '1960s' Generation' presented itself in terms of harmony, love and peace, but optimism ran very low due to the experience of Vietnam and to a more general sense of malaise and disappointment. This was reflected in a shift in popular songs toward a new bleakness and discordance, as with the Beatles' *White Album* (1968), the Rolling Stones' *Let it Bleed* (1969), and the films *Easy Rider* (1969) and *El Topo* (1970). A sense of hope shattered was to the fore by the end of the decade.

It was a totally different disillusionment to the one that had given rise to far-left and far-right, anti-liberal radicalism from 1917, but there were common elements of a sense of cultural crisis. The short-term political repercussions of 1968 were limited, which encouraged some to resort to more radical ideas, and even terrorist movements in Italy and West Germany. The Red Brigade in Italy, the Baader-Meinhof Group in Germany, the Weather Underground in the United States, the Angry Brigade in Britain, and their counterparts in Belgium, Japan, Portugal and elsewhere, however, lacked the capacity to capitalize on the social, political and military upheavals of the time and to sustain a sense of revolutionary crisis.

CHINA

During the first few years of its rule, the Chinese Communist Party (CCP), under Mao Zedong, consolidated its hold over China. Lost territories, including Tibet and Xinjiang in western China, were reclaimed. Chinese troops supported Communist North Korea in its war against South Korea and the UN (1950–1953) and aided Communist insurgents in their struggle against France in Indochina (1946–1954). At home, the CCP attacked or expelled any vested interests that might present a threat to its authority, including the remnants of the KMT, foreign businesses and missionaries.

The government seized privately owned farms and redistributed the land to the peasants. Thousands of landlords were killed by vengeful peasant mobs. Under the first five-year plan (1953–1958), big businesses were taken into government control and peasants were forced to combine their holdings into large agricultural cooperatives. Rapid expansion of heavy industry ensued, although farm output increased only slowly.

In 1956, Mao expressed concern that revolutionary zeal had degenerated into authoritarianism, and encouraged intellectuals to criticize the party under the slogan 'Let a Hundred Flowers Bloom'. The policy may have been a trap, for the following year Mao launched the Anti-Rightist campaign, during which some half a million intellectuals lost their jobs or were imprisoned, often for the criticisms they had made.

Great Leap Forward

The second five-year plan was termed the Great Leap Forward. It was intended as proof of Mao's belief that human willpower alone could overcome such shortcomings as a lack of capital and modern technology. The rapid development of China's agricultural and industrial sectors would occur simultaneously, and, Mao predicted, within 15 years China's industrial output would surpass that of the UK. Steel was produced using thousands of backyard furnaces, workers were mobilized to work longer hours, and agricultural cooperatives were combined into vast communes to improve efficiency. The Great Leap Forward was a disaster. Industrial production halved between 1959 and 1962; grain was forcibly requisitioned from the countryside to feed workers, creating a famine in which more than 20 million died. By 1962, the government had abandoned the policy.

Mao survived the failure of the 'Great Leap Forward' of 1958–62. Rivals within the Communist Party were disgraced as 'right deviationists'. Wisely, Mao did not pursue further his limited gains in a successful border war with India in 1962: the United States supplied India, while the Soviet Union refused to help China.

Cultural Revolution

In the wake of the Great Leap Forward, Mao resigned as leader, though he remained Chairman of the CCP. Liu Shaoqi and Deng Xiaoping became China's new rulers, pursuing moderate, pragmatic policies to rebuild the economy. In 1966, Mao launched his 'Great Proletarian Cultural Revolution', a campaign to recapture the revolutionary zeal of the early days and purge the party of its 'liberal bourgeoisie' elements, particularly its new leaders.

At Mao's urging, students all over China formed themselves into militias called Red Guards and began denouncing intellectuals, college professors, teachers, journalists, scientists, bureaucrats, factory managers

and party officials – essentially anyone in authority whom they regarded as insufficiently revolutionary. Universities closed and the demonstrations became increasingly violent as Red Guard units were reinforced by workers and peasants. Senior party officials were forcibly expelled, while many others were imprisoned and tortured. Liu Shaoqi died in a detention camp and Deng Xiaoping was sent to work in an engine factory. By 1968, Red Guard factions had begun fighting each other and many areas descended into lawlessness. The army was called in and Red Guard units were disbanded. By 1970, the government and the country had begun to function normally again.

The Cultural Revolution attempted to imbue society and the state with the radical ideology of continual change and led to large-scale chaos, including the terrorizing of conservative elements by the Red Guards. In pursuit of bringing imperfect reality under control, there was a frenzied attempt to ensure that all the means of information, discussion and reflection were to be employed to legitimize and reiterate the nostrums of the Communist Party. The Cultural Revolution enjoyed some faddish support in the West, but it was highly destructive.

The military was finally used to restore order. Mao remained in charge and destroyed opposition within the regime; but was less in control of China than hitherto in the years before his death in 1976. By 2016, state-run newspapers were to refer to the era as 'utterly wrong, in both theory and practice'.

Break with the USSR

The Soviet Union had been a supporter of the People's Republic since its establishment, but by the 1960s relations had become strained. In 1956, China criticized the Soviet policy of 'peaceful coexistence' with the West as a betrayal of Communist ideals. In 1960, the Soviet Union ceased giving aid to China. When the USSR signed a nuclear test ban treaty with the USA in 1963, China broke off relations.

Modernization

In the early 1970s, the People's Republic established diplomatic relations with some Western nations, including the USA and Japan, and was admitted to the UN. Mao died in 1976, sparking a power struggle between radicals and moderates within the party. The moderates, led by Deng Xiaoping, triumphed, and in 1978 they began a process of

economic modernization. China expanded its cultural and commercial contacts with the West and imported foreign technology to improve its industry. Limited forms of private enterprise were introduced and the agricultural communes were disbanded. The reforms set in motion an economic boom that continued unabated into the 21st century.

Post-War Japan

Most Japanese were enthusiastic about the post-war reforms and eagerly set to work rebuilding their nation. By 1955, Japan's major industries had achieved their pre-war production levels. Thereafter, the Japanese economy began to take off at an astonishing rate. Between 1955 and 1973, Japan's GDP grew at an average yearly rate of 9 per cent, faster than any other nation at that time, and by 1968, Japan had the third-largest economy in the world. There were many reasons for Japan's 'economic miracle', including a stable, business-friendly government (the conservative Liberal Democratic Party, or LDP, remained in power from 1955 to 1993); the Japanese emphasis on developing a loyal, highly skilled labour force, disinclined to strike; and, not least, the endless appetite of Japanese people for consumer goods such as cars, gadgets and household appliances.

The World Economy, 1956–74

Buoyed by domestic demand, export markets and technological and organizational improvements, the global economy continued its growth of the 1950s into the 1960s, sustaining the 'Long Boom'. However, there was a shift in the success of particular economies. Rapid German and Japanese economic developments, which benefited from

more innovative manufacturing, from a better control over inflation and from a lack of the need to invest heavily in military capability ensured a shift from the United States and Britain. Thus, the American share of the total production of cars by the USA, Japan, Britain, France and Germany fell in percentage terms from 87.1 in 1960 to 37.7 in 1970. There was also economic expansion in the European Economic Community as a whole. In contrast, industrial growth in Latin America and Africa remained modest. Compared to the situation in the 2000s and 2010s, it was low in China and India, too.

Inflationary pressures in the USA owed much to the decision to pay for the Vietnam War and the 'Great Society' programme of social improvement by borrowing, rather than from taxation. The related loose money policies led to an inflation that spread, while balance of payments deficits contributed to a fall in American gold reserves, which underpinned the system of fixed exchange rates. Employing Keynesian demand management, the USA, under both Johnson and Nixon, was more prepared to tolerate inflation than Germany and Japan.

The different levels of inflation in particular economies made it very difficult to manage the international economy and exchange rates, and eventually shattered the Bretton Woods system of fixed exchange rates established in 1944. In 1971, Nixon suspended the convertibility of the dollar into gold, allowing the dollar to fall, which helped destabilize the price of oil.

Difficulties were turned into crisis in 1973 when, in response to the Yom Kippur War, and in order to put pressure on the United States, the major oil producers in the Middle East, grouped in the Organization of Petroleum Exporting Countries (OPEC), pushed up the price of oil dramatically. 'Stagflation', a combination of stagnation and inflation, followed, both in the United States and more generally.

NEW TRENDS

Becoming notable in the 1950s, and more popular in the 1960s, the Beat Generation, a group of American underground poets and writers, rejected commercialism and searched for new rhythms and vocabulary, which led them to look to jazz music and Eastern philosophies, especially Buddhism. Allen Ginsberg coined the term 'flower power', and the hallucinogenic drugs he and others used had an influence on their writing. Indeed, drugs became a part of late 1960s Western youth culture.

The disciplinary model of childcare was challenged in the *Common Sense Book of Baby and Child Care* (1946), a very influential work by Benjamin Spock, an American doctor. This focused on allowing children's intrinsic desires to develop. To a degree, the consequences were to be apparent in the 1960s.

Women's Choices

In the 1950s, the home and family were widely presented as the sphere of women, and the large number of women who worked were not fairly treated. The women's liberation movement was particularly important to the sense of change in the 1960s. The movement was diverse, as can be seen by contrasting texts, such as Betty Friedan's *Feminine Mystique* (1963) and Kate Millett's *Sexual Politics* (1970). Nevertheless, conventional assumptions and practices, including nuclear families, the authoritarian position of men within households and female sexual subservience, were all criticized, and there was a stress on 'consciousness raising' for women.

Demands for the recognition of an independent sexuality included an assertion of women's rights to enjoy sex, to have it before marriage without incurring criticism and to control contraception and, thus, their own fertility. These and related issues were discussed in literature and film. The introduction, and rapid spread, of the contraceptive pill from the late 1950s helped this shift towards an independent sexuality by making it easier to separate sexuality from reproduction. The theme was that of matching the sexual freedom enjoyed by men.

Meanwhile, labour-saving devices in the household reduced domestic drudgery and encouraged higher female participation in the labour market. Cultural shifts were also significant as women played the crucial role in asserting rights to abortion. Feminism, more generally, led to

pressure for lifestyles and social arrangements that put women's needs and expectations in a more central position.

Youth Culture

Youth culture became more important then, and remained so thereafter. The willingness of the young to break from their parents' examples and admonitions and to embrace new sounds and fashions helped prompt new cultural waves. Thus, in music, the young in Britain who had made 'The Twist' number 1 in the charts in 1960 and 1961, turned in 1964 to the Beatles, a British pop group that gained a worldwide reputation. Youth culture was staged with occasions such as the Woodstock festival in 1969 and was celebrated in the media, with films such as *Grease* (1978).

Technology also came to enhance the independence of youth. Sexual freedom that owed something to the contraceptive pill was important to the values and experience of this generation. Relatively inexpensive private transport restricted parental monitoring. The distinctive lifestyles of youth, notably its independence, mobility and flexibility, underlined a more general social fluidity, and was a consequence of the wealth produced by the 'Long Boom'. Moreover, a recovered memory of its past became important as this generation grew older. The newly energized, demanding and distinctive youth culture of the 1960s drew on new technology, and the mass production of modern industrial society yet again provided the goods for popular culture. Artificial fabrics were employed more actively, leading to the use of modern plastics, such as PVC (polyvinyl chloride).

Fashions changed rapidly, reflecting the mass marketing of consumer society and the concern of youth culture with novelty. Hairstyles and clothes changed rapidly. Although the ubiquitous jeans, very much an American item, were durable, as well as reflecting a willingness by women to adopt and adapt male fashions, the dominant theme was fashion appeal, not durability or other utilitarian goals. Consumerism had become the utilitarian end.

This was not only a matter of youth. The enhancement of product ranges and possibilities through new developments was open to all consumers. Fashion became more insistent, due to the spread of colour photography, in magazines and newspaper supplements, as well as in film and on television. It became common to replace goods even when they were still functional.

The World of Bond

The most successful film franchise of the late 20th century was launched into the cinema with *Dr No* (1962). James Bond, the creation of a British writer, Ian Fleming (1908–64), was at first a figure in novels, beginning with *Casino Royale* (1953). An agent of British intelligence in the Cold War, Bond appeared credible when Britain was a great power, and John F. Kennedy, who had Fleming stay in the White House, was a fan. In Fleming's later novels, however, as Britain's relative power declined, the tone became darker.

In the films, Bond was made significant to the American market by being repeatedly deployed to save the United States and its interests from attack, as in *Dr No* (1962), *Goldfinger* (1964), *Thunderball* (1965), *Diamonds Are Forever* (1971) and *Live and Let Die* (1973). Themes from elsewhere in this chapter played a role, notably space, as in *Diamonds Are Forever*.

The significance of a wider global market in turn became important as viewers for whom English was not the first language were more drawn to a cinematic world featuring plenty of chases and fights. The films also reflected changes in political correctness, with gender attitudes evolving greatly in the 1990s. 'M', Bond's controller, was played by a woman and Bond was made less sexist.

Elvis Presley (1935–77)

Referred to as the 'King of Rock and Roll', Elvis Aaron Presley was born in Tupelo, Mississippi, to Vernon and Gladys Presley. In 1948, the family moved to Memphis, Tennessee, and the teenage Elvis developed an interest in music. Though he could not read music and never had any formal training, he could play by ear. Recording a disc at Sun Records, ostensibly as a present for his mother, Elvis attracted attention, and it was while jamming a version of 'That's All Right' that he and the recording studio found the sound that would set him off on the path to fame. Television and film appearances, plus a stack of hit records, saw Presley

become a three-time Grammy Award winner and a record-winning performer with the most certified gold and platinum albums, among other accolades. But while he attracted the adulation of screaming fans and helped to bridge the divide between white and black American musical genres, his private life suffered. Divorced from his wife, Priscilla, in 1973, his health declined: twice he overdosed on barbiturates, his weight escalated and he was diagnosed with a series of ailments. On 16 August 1977, he was found unconscious in his bathroom at Graceland, his home near Memphis. All attempts to revive him failed, and his death was officially announced the following day.

Theorists of Cultural Power

Developments in linguistic theory were employed to probe issues of identity, power and meaning. Prominent theorists included Jacques Derrida, Michel Foucault, Clifford Geertz and Jürgen Habermas, from France, the United States and Germany. Information as an objective ideal and progressive practice was affected by the problematizing of meaning and power by Derrida and Foucault respectively. Each emphasized the subjectivity of disciplines and categories, such as nations, and the extent to which they reflected and sustained social norms. This relativism was seen as subversive of custom and practice, and as putting the emphasis on the individual.

Looking at the World: Rethinking Geopolitics

Arno Peters, a German Marxist, advocated an equal-area projection for maps as a way to move attention to the regions of the developing world that he claimed had hitherto lacked adequate coverage. His world map of 1973 was praised in, and used as the cover of *North-South: A Programme for Survival* (1980), sometimes known as *The Brandt Report*, issued by the

187

International Commission on International Development Issues.

Geopolitics was questioned and reconceptualized as part of the postmodern project, notably with the French journal *Hérodote* which appeared from 1976, the first number including an interview with the radical cultural theorist Michel Foucault. Rejecting traditional geography as a servant of the state, *Hérodote* engaged with a different range of issues, including ecology and global poverty.

Dario Fo

Awarded the Nobel Prize for Literature in 1997, Dario Fo (1926–2016) was an anti-clerical Italian Communist playwright who sought to be a provocateur on behalf of the people against the powerful through his concept of *Il Popolo Contro I Potenti* (The People against the Authorities in Church and State). Fo's plays focused on the corruption of power as in *Accidental Death of an Anarchist* (1970), which dealt with the real death of a detainee in police hands. *Can't Pay? Won't Pay!* (1974) tackled housewives turning to shoplifting as a result of very high food prices. Fo also took his plays to the people, having them performed in factories, rather than in conventional theatres.

The Age of Valium

Drugs dominated attention in the 1960s, particularly the hallucinogenic and mood-altering narcotics beloved of some of the young, notably LSD and marijuana. In practice, other drugs were more common. This was the age of aspirin, not the Age of Aquarius (as suggested by the 1967 American cult rock musical *Hair*). In terms of damage, tranquilizers became increasingly in demand and also addictive. The side effects of barbiturates led to the production, from 1953, of Miltown, later found to

be addictive, from 1960 of Librium (chlordiazepoxide) and, from 1963, of a synthesized form of the latter, Valium, which was a product of the openness of the USA to immigrant talent, since it had been invented by Leo Sternbach, a Jewish scientist who had fled Nazi-dominated Europe and who had also developed the sleeping drug Mogadon.

From 1969 to 1982, Valium was America's biggest-selling drug, and its sales peaked at close to 2.3 billion pills in 1978, making vast profits for its makers, Hoffmann La Roche. The misuse of tranquilizers, discussed in Jacqueline Susann's bestselling novel *Valley of the Dolls* (1966), led in the 1980s to the replacement of Valium by the selective serotonin re-uptake inhibitors. In turn, Prozac became very popular, leading Elizabeth Wurtzel to write *Prozac Nation* (1997).

Chaos Theory

The leading American modeller of climate, Edward Lorenz, through his work in the 1960s on the computer simulation of weather dynamics, demonstrated that a minor change in inputs had major consequences for the results. In 1972, he gave a talk with the title 'Predictability: Does the Flap of a Butterfly's Wings in Brazil Set Off a Tornado in Texas?' His work played a part in the growing interest in the 1970s in irregular occurrences and the resulting mathematics were developed as chaos theory by Mitchell Feigenbaum and others, and the theory was applied in a number of fields, including ecology, public health and aerodynamics. It was also relevant to fiction.

Tourism in the Age of the Jet

The ease of long-distance travel was enhanced with the building of the first jet-propelled airliner: the British Comet, which had its maiden flight in 1949 and went into commercial service in 1952. But it was to be the Boeing 707 that dominated jet transport, becoming the fleet aircraft not only in the USA but also for many carriers throughout the non-Communist world. Aircraft specifications improved, with the 1960s bringing more powerful engines and the wide-body design seen most successfully with the Boeing 747.

With time, aircraft became more fuel-efficient and could also carry more fuel. As a result, longer journeys could be scheduled without the need for refuelling. Former stops used for refuelling, such as Gander in

Newfoundland, Bangor in Maine, Shannon in Ireland, and the Azores, ceased to be of consequence. Instead, aircraft came to fly direct from Europe first to the east coast of the United States and then to the west coast and to Hong Kong.

The economic 'Long Boom' from the late 1940s to the early 1970s saw a major rise in tourism, one that included its extension down the social scale to reach not only the middle class, but also the working class. This process was driven by prosperity and longer holidays, and was greatly enhanced by innovations, notably the linkage of jet aircraft and system-built high-rise hotels to the package industry. Chains became important, with Hilton Sheraton hotels providing American tourists with predictable and reliable accommodation and food. Such hotels acted as anchors for resorts, as the Hilton did for Americans near Honolulu on the Hawaiian island of Oahu. In turn, United Airways developed air services to take American tourists to the resort.

Lax planning controls and the cheap price of land were also key enablers in the development of resort destinations, such as Acapulco and the Yucatán in Mexico, the Algarve in Portugal and the Costa Brava and Costa del Sol in Spain. There was a particularly rapid rise in tourism in the 1960s. The number of international tourists in Spain rose from 4 million in 1959 to 14 million in 1964. They were mostly from France and northern Europe, notably Britain. Germans increasingly dominated tourism to Italy. Air travel was a key enabler. The opening of an airport at Faro in 1965 was crucial to the development of tourism to the Algarve. Greece also became an important tourist destination. The Eastern European equivalents were East German workers going to the Bulgarian Black Sea resort of Varna. They largely went by train.

Domestic tourism also became more important, for example of Russians to Black Sea resorts such as Sochi, where Stalin liked to go, of Americans to Florida and Hawaii, and the French to the Mediterranean coast. As yet, there was scant Indian or Chinese tourism.

ENVIRONMENTAL PRESSURES

Concern about the environment was not new: Britain's National Trust and America's Sierra Club date from the late 19th century. However, the period from the 1960s has a unity in the sense of growing concern about environmental pressure, albeit accompanied by developmental demands for the transformation of the environment in the cause of progress. The

latter was particularly seen in the Communist states, but also, as with the cult of dams and hydroelectric power, in the Third World. Concern about economic progress in these cases was driven forward by resource pressures stemming from a rapidly rising population and their expectations of betterment.

Environmentalism, in turn, drew on the notion of Earth as a biosphere operating in an organic fashion and using natural feedback mechanisms to sustain life. This notion was underlined by views of Earth from space.

The Last Stages of the Cold War, 1975–1989

With the United States in grave economic and political difficulties by 1974, Britain tottering likewise, and the possibility that the fall of the Portuguese empire and the weakness of South Vietnam would lead to further Communist gains, it was not surprising that there was no confidence in any eventual victory in the Cold War for the West. Indeed, democracy, unexpectedly, was to triumph in the Soviet bloc, but not in China.

INTERNATIONAL RELATIONS, 1975–9

In 1975, the Apollo-Soyuz Test Project, an American–Soviet joint mission, suggested the end of the Space Race, while the mid-1970s saw a number of agreements, especially the Helsinki Treaty of 1975, that in practice recognized the interests of the Eastern bloc, and thus appeared to consolidate its position and stabilize the Cold War. Yet, while tension was reduced in Europe, the Cold War in reality continued, and it seemed that both East and West still had it all to play for in a world adapting to the end of the Western European empires.

There was a particular focus on the Middle East, and here the USA tried to ease regional pressures. The administration of Jimmy Carter (1977–81) helped to arrange a peace settlement between Egypt and Israel, with the Camp David Accords of 1978 followed by the Egypt–Israel treaty of 1979.

However, the overthrow in January 1979 of the Shah of Iran, America's leading ally in South Asia, and his replacement by a hostile theocratic state, led by the strongly anti-American Ayatollah Khomeini, combined with the Soviet invasion of Afghanistan at the end of 1979, suggested that the United States might lose the struggle for regional hegemony.

On the other hand, the Chinese attack on Vietnam, a Soviet ally, in early 1979, which began a long frontier conflict, demonstrated the strength

of rivalry within the Communist bloc. This rivalry helped to maintain good relations between China and the Americans. There were also to be no more 'dominos' to fall to Communism in South-East Asia.

In Africa, Haile Mengistu, the dictator of Ethiopia from 1977 to 1991, looked to the Soviets for support. His reign of terror indicated the degree to which the attitudes and policies associated with Stalinism continued after the Soviet leader's death. The Soviet envoy, Anatolii Ratanov, saw a similarity between the brutal activities of Mengistu's supporters within the Derg, Ethiopia's ruling junta, and the early revolutionary experience in the Soviet Union. Success in Africa in the 1970s, notably in Angola and Ethiopia, gave many Soviets a renewed sense of pride in their own achievements, and a conviction that the Soviet Union could contribute decisively to breakthroughs for Communism elsewhere.

SPEEDING UP THE WEB

Meanwhile, technology was changing. As with earlier innovations, such as aircraft and antibiotics, it was not only the initial inventions that are of note, but also their subsequent improvement, dissemination and integration. Carbon fibres, reinforced polymers and advanced alloys and ceramics all played a role. The silicon microchip permitted the creation of more effective communication methods. Initially, without miniaturization, computers were large and expensive and had a limited memory. When, with more effective circuity, they became far smaller and much cheaper, from the late 1970s, computers became widely available as office and then household tools. Fibre-optic cables, another advance of the 1970s, increased the capacity of cable systems, and the volume of telephone and computer messages they could carry. Thanks to electronic mail, more messages were sent, and more information transmitted, than ever before.

Companies that were to transform the industry were founded, for example Apple in 1976. Moreover, specifications changed rapidly. In 1984, Apple launched the Macintosh, a computer with a graphical interface controlled by a mouse, a new input device that was far more intuitive than its predecessors.

As a result, the equipment of the recent past became redundant or at least not used, whether slide rules and logarithmic tables for calculating, or teletype machines, manual typewriters and payphones for communications. Although telegraphy and telephones had been impressive earlier advances, they did not offer global communications

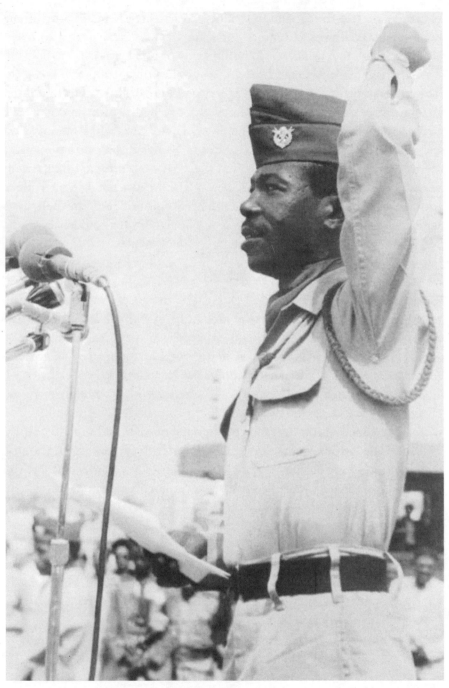

Haile Mengistu. The Ethiopian radical who seized power proved a bloody dictator who plunged the country into a series of civil wars that contributed to famine.

networks or real-time messaging comparable to those made possible by computers and fibre-optic cables.

THE ENVIRONMENT

The environment continued under pressure, not only thanks to the rise in the world's population and the related impact on resources, but also due to global warming, which gathered pace from the late 1970s. This affected the habitats and breeding patterns of animals, with some moving north, for example walruses and spruce bark beetles. However, the diminution of the ice in the Arctic made it harder for polar bears to hunt. At a more local level, wastewater emissions from power stations and factories raised water temperatures, and led to greater animal and plant activity nearby.

The growth in rubbish also provided opportunities for animals from bears to mice. Concern about competition took a variety of forms. Ideas of animals as part of God's creation were highly culturally selective. The successful film *Jaws* (1975) was the most vivid display of competition, in this case with sharks, and spawned sequels. The insistent rhetoric of exterminating natural enemies was supported by the filmic depiction of sinister parasites and insects, as in *Shivers* (1975) and the remake of *The Fly* (1986).

The resulting 'war' on insects and other species had unwanted side effects. In some cases, as in the battle against rats, there were signs of increasingly limited success, since the animals began to develop immunity to chemicals. Moreover, although DDT was used, with good results, against mosquitoes in the long battle with malaria, it also affected the animal and human population. In the meantime, malaria itself became more resistant to drugs.

Animals were also affected by human activity that removed other predators. For example, the decline in the number of wolves and big cats helped deer and antelope to multiply, which became a serious problem for fragile environments. By 2000, there were probably more deer in the United States than there had been in the 16th century. As yet, there was little of the wildlife protection that was to see the return of wolves in France and Germany in the 2000s. However, in the United States the Endangered Species Act (1973) helped to protect animals and plants, including the bald eagle.

The pressure on the environment was also seen in agriculture, not least with a chemical offensive in the shape of unprecedented levels of fertilizers,

herbicides and pesticides. The monoculture that came from an emphasis on a few high-yield crop strains lessened bio-diversity, and also provided a food source for particular pests. Furthermore, the organic matter in soil was widely degraded, while cultivated land, notably maize, left without a protective cover of vegetation suffered from the large-scale erosion of soil by wind and water. This was a particular problem where soils were thin.

There was also a major impact on water resources as the fertilizers that helped boost agricultural yields ran off into rivers with groundwater. Alternatively, the fertilizers were transferred into the water system through leaching or by means of evaporation and then distilling out, thus falling as rain.

The change in this period in fishing was greater than ever before thanks to the use of large 'factory ships' which were equipped with sophisticated finding devices. These industrial fleets greatly affected fish stocks, notably in the North Atlantic, where squid was fished out in the 1980s, and in the Pacific, where overfishing hit the major catches, such as the anchoveta in the 1970s and the chub mackerel in the 1980s. Industrial fishing then became an increasing problem in other waters, for example in the Indian Ocean, where it drove suffering Somali fishermen to piracy, and in the South Atlantic, as off Namibia.

In response, an effort was made in many areas, for example Indonesia and Scotland, to develop fish farming. In Vietnam, the Mekong delta saw the development of shrimp, catfish and shellfish farms. This industry, however, consumed resources, not least fishmeal, and led to a serious accumulation of waste and toxins.

Environmentalism became more active in the 1980s, notably with the activities of Greenpeace. In 1985, its ship *Rainbow Warrior*, seeking to focus attention on the damage done by French nuclear tests in the Pacific, was sunk in Auckland harbour by mines attached by French agents. This focused attention on the organization, which pressed on to help obtain a treaty, signed by 37 countries, to end the maritime dumping of radioactive waste. Other agreements followed, such as the Montreal protocol to limit the emission of ozone-depleting gases, and the 1991 Antarctic environmental protocol which prohibited drilling on the continent for 50 years. A new *Rainbow Warrior* was launched in 1989, the year in which the spill of 37,000 metric tonnes of oil from the grounded *Exxon Valdez* tanker in Prince William Sound in Alaska led to an environmental disaster.

Air Conditioning

Greatly affecting the ease of life across hot parts of the world, air conditioning drove up electricity consumption. Air conditioning became integral to buildings and cars, reflecting the extent to which the constraints of physical geography could be altered. It helped make areas such as the Persian Gulf and the American South liveable for all of the year, and also more attractive to migrants from cooler climates, for example the American north-east. In place of opening the window or switching on the fan, turning up 'the AC' became a norm. The need for reliable electricity provision greatly increased.

Chernobyl, 1986

The disastrous explosion at the Chernobyl nuclear plant in modern Ukraine, and the dishonest and inefficient response of the Soviet government, helped to suggest that the entire Soviet system was weak and negligent. The plant managers decided to run a safety test by withdrawing all primary and secondary safety back-up measures. As a result, the air pressure inside the dome increased 1,400 times within four seconds and the dome exploded. The Soviets waited two weeks before reporting the accident, ensuring that the necessary precautions against radioactivity could not be taken, either in the Soviet Union or further afield. The radioactivity spread across much of Europe, affecting water and livestock. The episode led to a reaction against nuclear power, which had detrimental consequences for the environment as the emphasis shifted back toward fossils fuels such as coal to power electricity generating plants. The use of coal for electricity generation was pressed hard in China and India, and that affected trade, notably the movement of coal from Australia to China.

The Role of Oil

The politics of the Middle East were made more significant on the global scale due to its role as the world's major source of oil. The Middle Eastern OPEC states held two-thirds of the world's known reserves in 2000, with Saudi Arabia alone controlling a quarter. Prior to the later major development of the fracking industry, America's oil needs led to

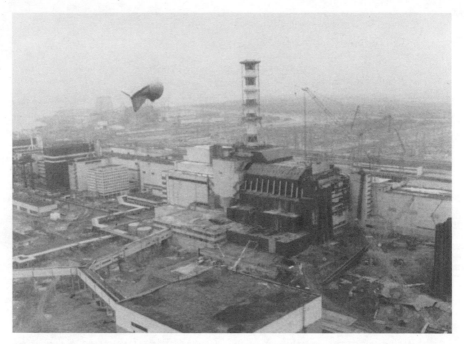

The Chernobyl power plant after the explosion. The disaster at the Soviet nuclear reactor at Chernobyl was a product of poor management and safety processes, and served as a symbol for the decline of the Soviet state.

it importing over half the oil it consumed by the end of the century, by which time the USA consumed a quarter of global oil output. This dependence increased America's concern with the Middle East.

On the global scale, rising energy needs reflected the growth in both per capita and aggregate energy consumption, in response to shifts in economic activity, social processes and living arrangements, and also the increasing range of energy uses. Thus, oil-based additives became important in agriculture. Moreover, the spread of agricultural machinery increased demand for oil as labour was replaced by mechanization.

The American lack of investment in fuel economy, including public transport, had a grave impact on the environment. The highest per capita emissions of greenhouse gases were in the USA, in large part caused by the strength of the car culture there. A combination of cars and the petrochemical industry led to the Houston conurbation in the United States alone sending skywards 200,000 tonnes of nitrogen oxide annually by the late 1990s. At the same time, industrialization in China and India greatly increased international demand for oil, not least because they

lacked domestic sources. Both states became major consumers of oil from the Middle East.

Green Movements

During the 1970s, a powerful 'green' movement developed, pressuring political leaders to enact legislation to protect the environment. Organizations such as Greenpeace, Friends of the Earth and the World Wildlife Fund lobbied for change. Some used non-violent confrontation as a means of drawing attention to environmental destruction. By the late 1980s, these organizations had become global with offices throughout the world and central headquarters to coordinate their campaigns.

The first green political parties were founded in New Zealand and Australia in the early 1970s, aiming to effect change through the democratic system. In 1979 the first green member of a national legislature was elected in Switzerland, and in 1981 four greens won seats to the Belgian parliament. The most successful environmental party was the German Green Party, founded in 1980, which managed to win 8.4 per cent of the national vote in 1987, and in 1998 even formed a coalition government with the Social Democratic Party. During the 1990s, green party members were elected to the legislatures of many countries and served as mayors in European cities such as Dublin and Rome.

Ecoterrorism

A few environmental groups and individuals turned to violence as a means of bringing about change. These ecoterrorists targeted industries that they viewed as seriously damaging the environment, such as logging, mining and some forms of manufacturing. Examples of ecoterrorist activities included plugging factory waste outlets, setting fire to car dealerships and driving spikes into trees so they couldn't be logged. Tree spiking was first used by members of EarthFirst! in 1984. Some animal rights groups vandalized stores selling fur products and bombed laboratories that performed experiments on animals.

International cooperation

From the late 1960s, efforts began to be made both at national and international level to protect and conserve the environment. The first Earth Day was celebrated in the USA in 1970. Its founder, Gaylord Nelson, hoped to spread environmental awareness following an oil spill

off the coast of Santa Barbara in 1969. The first major global conference on the environment, held in Sweden in 1972, led to the creation of the United Nations Environment Programme (UNEP). A major role of UNEP has been to encourage 'sustainable development' – increasing standards of living without destroying the environment.

Many international agreements followed, including the 1975 Convention on International Trade in Endangered Species and the 1982 moratorium on all commercial whaling. One of the most effective treaties was the 1987 Montreal Protocol on Substances that Deplete the Ozone Layer – the thin band in the upper atmosphere that shields the Earth from the Sun's harmful ultraviolet rays. Chlorofluorocarbons (CFCs), used in refrigerators and aerosol sprays, damaged the ozone layer, causing it to develop a hole. The agreement banned manufacturers from using CFCs.

The 1992 'Earth Summit' in Rio de Janeiro, Brazil, was the largest gathering of world leaders in history and produced two major treaties, one being for nations to voluntarily reduce carbon dioxide (CO_2) emissions, and the other requiring nations to protect endangered species and habitats. By 1997 it was clear that the voluntary emissions targets set at the Earth Summit would not be met. At another conference at Kyoto, Japan, agreement was reached to reduce 1990 emission levels by 5 per cent by 2008–2012.

AMERICA UNDER REAGAN

The unpopularity of Jimmy Carter, the Democrat president from 1977, assisted Ronald Reagan, the Republican candidate, to victory in 1980. Easily re-elected in 1984, Reagan proved both popular and divisive. He was a successful head of state, helping to change the model from 'can't do' to 'can do', and providing a strength of conviction that helped to overcome the sense of failure associated with the 1970s in America.

Reagan became less conservative in office than he had been earlier in his career, and was more of a social liberal and less of a religious conservative than most Republicans on the right of the party. However, he was a more questionable chief executive. Although tax cuts and deregulation fostered economic growth, and thus contributed to the defeat of the Soviet Union in the Cold War, his low-tax, anti-government policies hurt the poor. Reagan justified himself by arguing that government action had failed: 'We waged a war on poverty and poverty won.'

Canada

Like the USA, Canada enjoyed a post-war economic boom. Consecutive Liberal governments promoted social welfare and aid for the poor, sick and elderly. In 1949, Newfoundland, which had reverted to colonial status in 1934, rejoined Canada. In the 1960s, Quebecois nationalists began a campaign to make their province a separate nation. Prime Minister Pierre Trudeau (1968–1979, 1980–1984) negotiated the patriation of the (originally British-created) Canadian constitution in 1982. This was rejected by Quebec, which demanded a special status. When this was granted in 1987, it antagonized the other provinces. Quebec citizens voted in a 1994 referendum to remain part of Canada. In 1999 Canada gained a new territory, Nunavut, separated from the Northwest Territories, to give greater autonomy to the majority Inuit population.

The Reagan Presidency Abroad

Reagan was initially associated with a marked intensification of the Cold War. Military expenditure was greatly increased, notably on the navy, and there was an active engagement against radicalism in Latin America, notably in Nicaragua and Grenada, and against pro-Soviet states in Africa, especially Angola. The Soviets lacked the money and borrowing facilities to compete. American proficiency in weaponry reflected the vitality of its applied technology, and led to talk of a space-based defence system, nicknamed 'Star Wars'. Tensions between the USA and the Soviet Union, which Reagan provocatively termed the 'evil empire', rose to a peak in 1983, with each side preparing for attack by the other. War, however, was avoided.

Very differently, with the *mujahideen* in Afghanistan, UNITA in Angola and Solidarity in Poland, the USA backed movements to weaken opponents. In Nicaragua, the left-wing Sandinista guerrilla movement, which had gained power from the Somoza dictatorship in 1979, faced American pressure. This included the mining of harbours and the secret arming from 1981 of the Contras, a counter-revolutionary movement based in neighbouring Honduras. Although the Contras helped to

destabilize Nicaragua, inflicting considerable damage, they could not overthrow the Sandinistas and, instead, increased their bellicosity.

The World Economy, 1975–89: The Global Financial System

American public finances put pressure on much of the world. The inflow of foreign capital into the USA was encouraged with the ending in 1984 of the withholding tax on interest on income paid to non-residents. This inflow led to a large-scale foreign purchase of Treasury bonds, which ensured that the federal government could readily borrow large amounts of money in order to cover expenditure, including a major build-up of military expenditure.

Attractive American interest rates in the 1980s kept the demand for the dollar in foreign exchange markets strong, and this demand helped ensure that global capital flows focused on the United States. Thus, Middle Eastern 'petro-dollars', revenues obtained from oil, were invested in, and through, the United States. This focus, however, put enormous pressure on states that had borrowed heavily in the 1970s, notably in Eastern Europe and Latin America. The resulting pressure both challenged existing systems and made American responses significant. East Germany for example was in effect bankrupt by 1989. In part, this pressure reflected the failure to introduce structural economic reforms to make it competitive and in part the raising of foreign loans to finance imports of consumer goods in the 1970s and 1980s.

Finance provided a way in which the world operated as a system to a degree that closely linked domestic economies and international power politics. Increasingly, more money than goods was traded. The major financial centres remained London and New York, but the growing prominence of the German and East Asian economies ensured that Frankfurt, Tokyo, Hong Kong and Singapore were of greater significance than in the past. The deregulation of financial centres, notably

of London in the 'Big Bang', further increased volatility. Innovative practices, for example the development of Eurobonds, were important in providing credit and unlocking assets built up in particular sources.

However, there was also mis-selling, poor credit practices, bad resource allocation and, sometimes, fraud. The Savings and Loans scandal in the United States was a key instance of these problems. It affected the popularity of the administration of President George H.W. Bush, and played a role in costing the Republicans the presidential election of 1992.

THE END OF THE COLD WAR

The inherent economic problems of the Soviet system had been concealed during the Long Boom, but the economic downturn of the mid-1970s exacerbated these issues and the government of Leonid Brezhnev lacked an effective response. Heavy investment in arms was a major problem, but so also was a failure to develop the consumer sector and thus win adequate popularity. Nevertheless, conventional Communist ideology was underlined in 1977 with the new constitution of the Soviet Union, which essentially confirmed that of 1936 produced under Stalin, and asserted without revision the role of the Party which was declared both the leading and guiding force of Soviet society and the force that determined the course of Soviet domestic and foreign policy.

Solidarity

Poland proved a lightning rod for the unpopularity of Communist rule, with the added ingredients of traditional hostility to Russia/the Soviet Union, and a strong national Christian commitment. Large-scale strikes in 1980 were precipitated by an increase in the price of meat, but the establishment of an unofficial trade union, *Solidarno* (Solidarity), challenged the authority of the government and spread concern to other Communist regimes. The Soviet defence minister supported military intervention, but his colleagues were reluctant to do so, while the Soviet Union was warned not to by Reagan. There was also anxiety that the Poles would fight Soviet forces and concern about the effect that an invasion would have on Soviet troops.

Instead, the Polish state, directed by General Wojciech Jaruzelski, prime minister and first secretary of the Polish Communist Party, imposed control. With Soviet encouragement, martial law was declared in December 1981, and paramilitary forces were used to seize Solidarity's leaders and thousands of others.

Margaret Thatcher

In Britain, the election in 1979 of the Conservative Party under Margaret Thatcher meant a defeat for the left in the shape of the Labour Party under James Callaghan, prime minister from 1976 to 1979. Comfortably re-elected in 1983 and 1987, Thatcher provided constant encouragement to Reagan. The crises that faced her were not all related to the Cold War, notably the war with Argentina in 1982 that arose from its unexpected seizure of the Falkland Islands, a British colony in the South Atlantic. The British rapidly regained the Falklands in a display of successful resolution that helped Thatcher to re-election. However, there were Cold War dimensions to the attacks by the IRA, Irish nationalist terrorists armed by the Communist bloc, who tried to kill her, and to the coal miners' strike of 1984–5 which was designed in effect to bring down the government. She defeated these challenges, but eventually exhausted the confidence of her parliamentary colleagues and was driven to resign in 1990. Divisions over relations with the EEC (later EU) were important to this process.

The Fall of the Soviet Union

Poor Soviet leadership in the early 1980s contributed greatly to a sense of political paralysis and economic failure. At the popular level, rampant alcoholism reflected the limited appeal of Communism, which, indeed, combined inefficiency with oppression.

In 1985, the arrival of a younger leader, Mikhail Gorbachev, as general secretary of the Communist Party, committed the Soviet Union to reform at home and good relations abroad. There was a marked lessening in Cold War tensions thanks to successful negotiations with America on

arms control. These led to the Intermediate-Range Nuclear Forces Treaty in 1987, a treaty that remained in force until 2019, and the withdrawal in 1989 of Soviet troops from Afghanistan where their invasion of 1979 had been followed by a long struggle with guerrilla opponents.

Gorbachev's domestic policies had more of an impact. Economic reform, in particular *perestroika* (restructuring), which loosened much of the command economy, led unexpectedly to economic problems, including inflation, shortages and demands for political change.

Supporting *glasnost* (openness) in government and society, including freedom of expression in the media, literature and arts, Gorbachev was confident that the Soviet Union and the Communist Party would not only be able to survive the challenges of change, but would be mutually strengthened by them. He was to be proved totally wrong. In 1986, Gorbachev was faced with the disaster of the Chernobyl power plant explosion.

Unintentionally, Gorbachev's policies delegitimized the Communist Party and unravelled the precarious domestic basis of government control in the Soviet Union, while his encouragement to reform in Eastern Europe had a more immediate and disruptive effect. This confusion and criticism

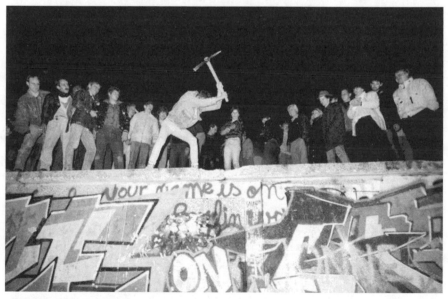

The Fall of the Berlin Wall, 1989. An important practical and symbolic moment in the end of the Cold War, the overthrow at the epicentre of this conflict of the means and mark of Communist control.

might be seen as an inevitable consequence of any loosening of the inefficient and unpopular Soviet system.

The governments in Eastern Europe had resisted reform pressures, notably in Poland. However, in 1989, the Eastern European governments found themselves without Soviet support, political or military, and, in the face of popular protest, notably against their sclerotic system, they all collapsed. In general, this was a peaceful process that reflected the unpopularity of the Communist regimes. The most dramatic episode was the opening of the Berlin Wall on the evening of 9 November, as demonstrating crowds in East Berlin took advantage of the new weakness of the East German regime in the face both of a large protest movement and the large-scale movement of citizens to the West. In 1990 East Germany was reunited with West Germany. Nevertheless, in Romania the secret police resisted the change until it was defeated by the army.

A NEW DIRECTION IN CHINA

In China, the Communist Party went in a very different direction, using military force to overcome pressure for reform, notably so in Tiananmen Square in Beijing in 1989.

The death of Mao Zedong in 1976 had been followed by the thwarting of Communist hardliners (the radical 'Gang of Four' including Mao's widow, Jiang Qing) by Hua Guofeng, the premier, who became chairman of the Central Committee. He, in turn, became less powerful as his more pragmatic rival, Deng Xiaoping, rose. Deng's leadership was confirmed in 1978, when a new constitution called for 'planning through guidance', and he remained in power until 1997. In 1980–1, suspected counter-revolutionaries, including Jiang Qing, were subjected to a show trial as part of the way in which Deng sought to castigate the Cultural Revolution and to revive Socialist legalism.

Deng favoured not only alignment with America, but also a re-evaluation in terms of economic liberalization, rather than a revolution focused on Marxist purity. The development of Taiwan, South Korea and Singapore convinced Deng that capitalist modernization worked. In 1979, formal diplomatic relations with America were established and Deng visited the United States, the first Chinese Communist leader to do so. He toured the NASA headquarters and the Boeing plant. The Japan–China peace treaty of 1978 helped consolidate China's new position.

Deng favoured party control alongside a measure of economic liberalization, a bargain challenged by the demonstrators in 1989. They enjoyed some support within the party, notably from Zhao Ziyang, but he was dismissed and the army was used to regain control of Beijing and other cities. In the aftermath, economic liberalization, in the shape of free-market reforms, and an opening to the outside world, was still pushed forward, but party control was maintained. The reforms challenged the viability of the state-controlled heavy industries and, with the introduction of Western technology and management skills, an economic restructuring began. In Cuba, the Communists retained control, but without this liberalization.

Tibet

The staunchly Buddhist state of Tibet was occupied by the People's Republic of China in 1950. China's harsh rule and religious intolerance provoked an uprising in 1959. The rebellion failed, and Tibet's ruler, the Dalai Lama, fled to India, replaced by his deputy, the Panchen Lama. China imposed military rule, forcibly redistributing land and requisitioning grain to feed its troops. Chinese settlers took over senior administrative jobs. In the 1980s, the Chinese softened their approach, reopening some shrines and monasteries and giving farmers more freedom. Yet Tibetan traditional culture remained under threat due to mass immigration of Han Chinese to the region.

Protests

Unlike the Soviet Union, the CCP did not relax its political grip on the country. In the late 1980s, students called for greater democracy and an end to government corruption. This led to a pro-democracy demonstration in Beijing's Tiananmen Square in 1989, which was brutally crushed in what became known as the Tiananmen Square Massacre.

Economic Slowdown in Japan

The long boom ended in the early 1970s, due mainly to a rise in the yen, which hit exports. Following economic reforms, growth resumed, but at a

slower rate than before. In the late 1980s, Japan experienced a speculative frenzy, as millions tried to make money in stocks and shares. Japanese businesses rushed to invest overseas in South-East Asia and the USA. In 1990 the bubble burst, ushering in a long recession. Unemployment rose and consumer spending declined.

Japan was simultaneously beset with political troubles. In the late 1980s and early 1990s, the ruling LDP was accused of corruption and the party fell from power.

North and South Korea

Following the Korean War, Kim Il-sung established a Communist dictatorship on the Soviet model. His government organized the countryside into large collective farms. Economic development focused on heavy industry and the military at the expense of consumer goods, and living standards fell. Kim Il-sung died in 1994 and was succeeded by his son Kim Jong-il. North Korea suffered a severe famine in the mid-1990s and hundreds of thousands perished.

Meanwhile, the partition and the war had left South Korea weak. Rhee's government fell in 1960, replaced by a military government under Park Chung-hee. The economy grew rapidly under Park, but his government became increasingly autocratic. After Park was assassinated in 1979, the new government ended some of the restrictions on free speech. In 1987, a democratic constitution was introduced, guaranteeing Western-style political freedoms for all.

INDIAN TENSIONS

After China, India was the most populous country in this period. Aligned with the Soviet Union, it did not act as a major world power, in part because it did not have a tradition of long-range power projection and had to be mindful of the opposition of China and Pakistan. The former defeated India in a short war in 1962, but Pakistan was beaten in more major wars in 1948, 1965 and 1971. The last led to East Pakistan becoming an independent state as Bangladesh.

The Indian economy stuttered along in part due to an overlarge bureaucracy. The greater authority of the central government from the 1960s reflected not the response to external challenges, but rather a shift, also seen in other countries, from politics and government understood as an accommodation of a number of interests and centres of power to a

more centralized and less pluralist notion of authority. This owed much to a conviction of the value of government intervention and planning as a means to modernization and growth, but also reflected the difficulty of securing the latter. In India, living standards were affected by a rising population and a labour force much of which was poorly educated.

Sectarian tensions were a major problem, notably in the Punjab where the government used force against Sikh separatists in 1984 which led, in turn, to the assassination of the prime minister, Indira Gandhi, by Sikh bodyguards and then to the mob killing of about 8,000 Sikhs. There were also separatists in the north-east, as well as in Kashmir, where the Indians occupied much of the region in 1948. In east-central India, the Naxalites launched a Maoist rebellion against savage economic inequalities. Whereas the Congress Party supported multi-culturalism, the Hindu sectarianism of the BJP focused on antipathy toward Muslims, which in India was the largest Muslim minority in the world.

Pakistan

Independent Pakistan comprised two territories, West and East, united by religion but separated by over 1,600 km (1,000 miles) and a cultural and linguistic gulf. Increasingly resentful of West Pakistan's political and economic dominance, in 1971 East Pakistanis rioted. The protests gained momentum and in March of that year East Pakistan declared its independence as Bangladesh. India supported the rebellion. After bloody fighting in which over a million died, Pakistan surrendered.

A military dictatorship throughout the 1950s and 1960s, Pakistan held its first elections in the early 1970s. Its first prime minister, Zulfikar Ali Bhutto, was overthrown by General Muhammad Zia ul-Haq, who imposed martial law. After Zia's death in 1988, democracy was restored and two parties alternated in power, one being Bhutto's Pakistan People's Party, later led by his daughter Benazir.

Bangladesh

One of the world's poorest countries, Bangladesh had to cope with enormous reconstruction costs following its war of independence. Its fragile democracy was frequently interrupted by periods of military dictatorship during the 1970s and early 1980s. Democratically elected governments have ruled since 1986, although charges of electoral fraud have been common. The country suffered frequent devastating floods

caused by cyclones that led to widespread death and destruction, as well as famines and extreme poverty.

Sri Lanka

Sri Lanka won its independence in 1948, along with India. From 1983, the government, representing the majority Sinhalese, fought a long and bitter civil war with the Tamil minority. The most powerful Tamil group, the Tamil Tigers, attempted to establish an independent state in the north of the island.

In 1971, the government faced an armed uprising by a Communist organization called Janatha Vimukthi Peramuna (JVP) during which insurgents managed, briefly, to capture parts of southern and central Sri Lanka. The JVP rose again in 1987 using small cells to commit terrorist acts, forced strikes and murder. By early 1990, government forces had captured or killed the JVP leadership, ending the insurrection.

THE IRANIAN REVOLUTION

The unpopularity of the Shah led to his overthrow in 1979. Ayatollah Khomeini, the leader of the Islamic Revolution and Guardian of the Islamic Republic, saw America, which had earlier supported the Shah, as 'the Great Satan'. He instigated the seizure of the American embassy in 1979, creating a hostage crisis that lasted until 1981. When told that international law was being violated, the Ayatollah claimed that the observance of such principles should always be secondary to Islam and asked what international law had ever done for the people of Iran. Moreover, the fate of the 52 hostages became significant in American domestic politics, with the inability of President Carter's attempt to rescue them in 1980 serving as a symbol of his weakness, which contributed to his failure to win re-election. The attack on the embassy was both symbolic and an attempt to close down what was seen as a rallying-point for those opposed to the Islamic Revolution. The Ayatollah told the Soviet envoy that there could be no mutual understanding between a Muslim nation and a non-Muslim government.

Hoping to exploit the overthrow of the Shah, Saddam Hussein, the dictator of Iraq, invaded in 1980; but he found himself involved in a war that he could not win. Lasting until 1988, this was the most deadly war of the decade, and also one that helped the Islamic Revolution consolidate its authoritarian grip on Iranian society.

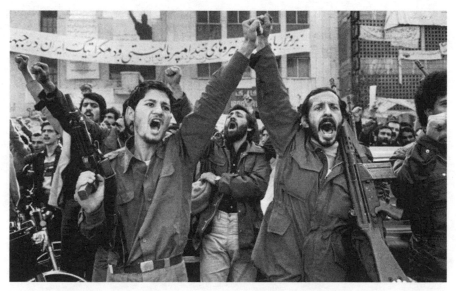

The Iranian Revolution. The unpopularity of the Shah ensured that his regime had few resources when faced by large-scale unpopularity in 1979-80. However reformers were rapidly overthrown by Islamic fundamentalists.

Ayatollah Khomeini

Ruhollah Khomeini (1902–1989) was born Ruhollah Musami to a family of Shi'ite scholars in the village of Khomeyn near Tehran. Throughout his life he was acclaimed for his depth of religious learning. When he was five months old, his father was killed on the orders of a local landlord. After studying in various Islamic schools, he settled in the city of Qom in 1922 and took the name of his hometown as his surname. Khomeini started his career as a theologian, then became an Islamic jurist. He wrote extensively on Islamic philosophy, ethics and law, but he initially took little part in politics. In the mid-1950s, he was acclaimed as an Ayatollah or religious leader. After the death of Ayatollah Mohammed Boroujerdi in 1962, Khomeini spoke out, attacking the Shah for his ties with Israel. He denounced a bill giving the vote to women as anti-Islamic, opposed land reform and condemned the

proposal that allowed American servicemen stationed in Iran to be tried in US military courts. For him America was the 'Great Satan'. His religious zeal and his anti-Western stance won him a large following in Iran, and his arrest in 1963 sparked anti-government riots. After a year's imprisonment, the Shah exiled him to Turkey, hoping that he would be forgotten. But cassette tapes of his sermons were smuggled back to Iran, and he became the most prominent leader of the exiled opposition. In January 1979 the Shah fled to Egypt. Two weeks later, Khomeini returned to Iran in triumph, and he began laying the groundwork for a clerical state. He closed the new parliament, suppressed the opposition and drafted an Islamic constitution. In June 1989 Khomeini died, but the theocracy he had created lived on.

THE ARAB-ISRAELI CONFLICT

Israeli concern about Palestinian terrorism led to a covert war against terrorism globally, as well as to Israeli intervention in Lebanon, as in 1982. The latter, however, proved unsuccessful, as it was impossible to sustain a result that satisfied Israel's security needs.

However, the move of Egypt into the American sphere of influence brought a fundamental security to Israel. Jordan was also in this sphere. This situation was accentuated by the impact of the Iran–Iraq war. As a result, Israel only had to fear attack from across its relatively short northern border.

However, in 1987, a new challenge emerged in the shape of the *Intifada*, a rebellion against Israeli rule in occupied Arab territories, specifically against the pace of Israeli settlement on the West Bank. Beginning with stone-throwing crowds challenging Israeli authority, the *Intifada* demonstrated the fragility of imposed political settlements in the Middle East when the bulk of any population felt alienated. With the Israeli High Command finding it difficult to deal with what to them was a novel form of warfare, the *Intifada* also exposed the limitations of regular troops in the face of popular resistance. There were riots in many of the towns and cities of the occupied territories. By the time the *Intifada* ended in 1992, over 1,000 Palestinians had been killed.

AFRICA

The rapid rise in Africa's population reflected a continuation of high birth rates alongside falling death rates. This was challenged by periodic famines, notably in Ethiopia in 1983–5, in which 200,000 to 1,200,000 people died. Moreover, resource pressures contributed to tribal tensions that interacted with civil wars, as in Angola and Sudan. Dictatorships were common. Thus, Ahmed Sékou Touré, the president of Guinea from independence from France in 1958 to 1984, ran an authoritarian state with frequent purges known as the 'Tropical Gulag'.

The widespread lack of democratic processes meant that across much, but not all, of Africa force was the principal means of politics, and that situation led to a focus on army attitudes. As in Latin America, stability was further eroded by heavy international debt burdens. Violence was all-too-frequent.

In Angola, the Popular Movement for the Liberation of Angola (MPLA), a Marxist insurrectionary movement supported by the Soviet Union and Cuba, which gained power in 1975, was opposed by the American and South African-backed National Union for the Total Independence of Angola (UNITA), but also faced opposition from dissidents within the MPLA who were against the dictatorial rule of their leader, Agostinho Neto. In 1977, the regime crushed an attempted coup by MPLA 'factionalists' led by the interior minister, Nito Alves. Between 2,000 and 70,000 Angolans were then slaughtered as Neto consolidated his control, with Cuban forces playing a role in the carnage. The resulting culture of silence was linked to this becoming a massacre that was remembered by Angolans, but lacked any public attention. With foreign commentators largely supportive of the MPLA because they were critical of UNITA, there was scant foreign attention. Such omissions are all too common in the history of the 20th century.

LATIN AMERICA

Although many Latin Americans would have been horrified by the comparison, there was much that was similar to the problems of Africa, not least in environmental degradation, military rule and debt burdens. In Latin America, there was the addition of its key role in the international drug trade, notably of cocaine. Nevertheless, there was a move towards democracy in the 1980s, especially in Brazil, Bolivia, Peru and Paraguay.

Military Regimes

The success of the Cuban Revolution in 1959 inspired revolutionary and socialist movements in other parts of Latin America. Roman Catholic priests developed 'liberation theology', which emphasized the Christian mission to bring justice to the poor and oppressed through political activism. Military leaders and conservative landowners feared revolution. A wave of military coups swept Latin America during the 1960s and 1970s. A coup in Brazil in 1964 ushered in 20 years of military rule. Argentina experienced several military coups, and the elected socialist government of Chile was overthrown by US-backed General Augusto Pinochet in 1973. The leaders suppressed Communism and political opposition of all kinds. Their regimes presided over a growing debt crisis in the 1970s and their high defence spending diverted funds from social welfare.

The Argentine military junta that seized power in 1976 had used terror and murder to repress signs of dissent in a 'Dirty War' in which at least 8,900 were killed while children were seized and handed over for adoption. The junta launched an ultimately unsuccessful war with Britain over the Falkland Islands in 1982, and its failure led Argentina to become a democracy the following year.

During the late 1970s and 1980s, armed uprisings overthrew several military regimes in Latin America. Others returned peacefully to civilian rule, including Argentina (1983), Brazil (1985) and Chile (1990). By 1990, Cuba was the only non-democratic Latin American country. In Brazil, the military regime came to an end in 1985; an election produced an opposition president and, in 1988, a democratic constitution was introduced. Since then, Brazil has remained a democracy with an element of statist corporatism.

Metropoli

In Latin America, as elsewhere, the urban population became both greater and proportionately more important. Thus, the population of São Paulo in Brazil rose from 1 million in 1930 to 17.1 million in 1990, that of Buenos Aires in Argentina from 2 million to 12.6 million, and that of Rio de Janeiro in Brazil from 1.5 million to 11.2 million. Push as well as pull factors, the lack of opportunities in rural areas and the apparent offerings and opportunities of urban life played a part. However, the urban

infrastructure struggled to cope there and elsewhere, most notably with housing and the provision of clean water. As a result, Rio de Janeiro was framed from the 1940s by *favelas*, or shanty towns, in which the authority of the state and the power of the police were very much limited. Shanty towns were found around many other growing cities, such as Cape Town.

Neoliberalism

The state-led model of economic growth favoured by governments of the 1960s and 1970s had proved a failure, and in the 1990s most Latin American governments adopted neoliberal economic policies, supporting free-market activity, privatizing industries, cutting back on social programmes and encouraging foreign trade. Mexico joined NAFTA, a trading bloc with the USA and Canada, in 1993, which led many American companies to relocate to Mexico, where wages were lower. Thousands of Mexicans have migrated to the USA seeking employment opportunities. Argentina, Brazil, Paraguay and Uruguay formed an equivalent trading bloc, MERCOSUR, in 1995.

Neoliberalism improved efficiency, but produced unemployment and a growing discontent. In 1994, an Amerindian group, the Zapatistas, revolted against the NAFTA treaty, capturing several towns in southern Mexico. Despite the reforms, Latin American economies remained largely driven by exports of raw materials, lacking the industrial development to compete with North America and Europe.

Shining Path

The insurrection in Peru begun in 1980 by the *Sendero Luminoso* (Shining Path) movement drew on longstanding traditions of peasant activism, but was also open to Maoist ideas of social revolution and redistribution. Shining Path initially agitated successfully among the poorer indigenous regions in the Andean Mountains neglected by the capital Lima, but, with time, it lost backing as its terrorist acts alienated support. The capture in 1992 of the movement's leader contributed to its decline.

THE DRUG TRADE

Consumerism took many forms. Despite domestic and international police action, drug consumption and the drug trade grew greatly in the second half of the century. Greater wealth contributed to the trade, and also a practice of self-help in leisure and health. Indeed, the latter characterized much of life, including in therapy and religion. Drug-taking was also an aspect of the consumption of stimulants which became an aspect of the speeded-up character of society, as well as an expression of the innovation that was so important across the economy and culture as a whole. New developments included the cheap, smokable and highly addictive crack cocaine, which was invented in the early 1980s.

By 2000, the retail sale of drugs was worth about $150 billion annually (tax-free, as the industry was illicit and cash-based), of which about 40 per cent was in the USA. Thus, an appreciable portion of the population became familiar with breaking the law, while the inability of the government to suppress the trade was a powerful demonstration of the difficulties of policing society and of influencing social habits. The trade and consumption of drugs contributed to lawlessness in many states, such as Colombia and Mexico, and to a murder rate of 23.7 per 100,000 people in Brazil in 2000.

Trade routes for drugs were important. The principal source for drugs became Latin America, notably with cocaine, most of which was produced in Colombia, and the major market was the United States. In the 1970s, small aircraft were used to transport the drugs, followed in the 1980s by very fast boats. There were also supplies from South Asia to Europe, particularly of heroin.

CULTURAL ISSUES AND VOICES

The rejection of existing canons was seen across the arts. Thus, in painting, Pop Art sought to conflate the comic-book character of popular culture with established methods. Similarly, Abstract Expressionists, such as the Americans Jackson Pollock and Mark Rothko, broke with conventional methods, not only of representation but also of ways of painting. Another American, John Adams, did the same in opera, as in *Nixon in China* (1987) and *The Death of Klinghoffer* (1991). Rejecting Western norms, Third World artists rose in prominence.

The brat novelists of the 1980s, such as the Briton Martin Amis, with *Money* (1984) and *London Fields* (1989), and the Americans Jay

McInerney (*Bright Lights, Big City*, 1983; *Story of My Life*, 1988), Tama Janowitz (*Slaves of New York*, 1986; *A Cannibal in Manhattan*, 1987), and Bret Easton Ellis (*American Psycho*, 1991), were concerned about a society apparently lacking in values and immersed in selfish consumerism. A satire on success, *American Psycho* showed a Wall Street banker keen on the good things of life as well as serial killing. Tom Wolfe voiced similar concerns in his *The Bonfire of the Vanities* (1987), which offered a dystopian view of New York that was more insightful than the popular *Batman* films.

Writers and filmmakers found much to engage with in AIDS. First recognized as an infection in 1981, AIDS was a sequel to the HIV immune-deficiency virus. It is probable that AIDS derived from the consumption of primates as human settlement expanded into parts of Africa. The reasons for the spread of AIDS led to controversy, not least due to its relationship with sexual practices, notably homosexuality, and drug taking.

The response to AIDS reflected social norms, political pressures and prosperity. For example, in the USA and Europe there was a greater openness to public education in sexual health, including about homosexuality, than in Asia, which led to a far higher use of condoms, including among prostitutes. Expensive antiviral strategies were available in the USA and Europe, but not in Africa. Writers tended to focus on the homosexual dimension in part because an overt engagement with homosexuality was a relatively new aspect of writing other than for niche markets.

Meanwhile, as an indication of the variety of life, including claims to experience, unidentified flying objects (UFOs) continued to be regularly reported. Far from the imaginative role of aliens receding with human exploration, it actually became more pronounced. Encouraged by cinema, this process indicated the strength of alternative accounts to those grounded in science, as well as the desire to make the apparently unknown readily explicable.

Pope John Paul II (r. 1978–2005) also dealt in the relatively unknown. In a marked rejection of criticism of the miraculous, he canonized 482 new saints, over four times the number canonized in 1000–1500, and also beatified another 1,341 individuals, fully half of the entire number of papal beatifications since the process began in the 1630s. Looked at differently, it could be said that sanctity in practice became detached from the miraculous.

Time Travel

While long-distance manned space travel did not progress as that of unmanned vehicles did, there was developing interest in time travel. In part, this was due to the growing understanding of the origins of the universe and the nature of black holes. This interacted with a long-standing popular engagement with time travel, as in H.G. Wells's novel *The Time Machine* (1895), and the hugely successful British television series *Doctor Who* (1963–89; 2005–present). Although not all time-travel writing supports it, there is also an interest in the idea that, by going backward in time, it is possible to change the future, as with films such as *Back to the Future* (1985), *Peggy Sue Got Married* (1986) and *Twelve Monkeys* (1995).

Gun Culture

Guns, a more traditional and frequent means of death than AIDS, were readily available in the USA, but ownership declined in Europe, especially in urban areas, and was very low in China, Japan and India. American gun ownership recorded social change, not least in the marked growing rate of female ownership. Gun ownership was seen in much of Europe and East Asia as a social pathology, and notably so in urban life where it was not associated with hunting or vermin-control. In the United States, in contrast, ownership was presented as affirming individual rights and self-reliance. Indeed, it was vociferously defended on those grounds, and with reference to the Constitution.

However, gun ownership was also a facilitator to criminality, while rioting in Los Angeles in 1992 underlined the dangers posed to social stability and political order. The killing of others, including the prominent, such as John Lennon in New York in 1980, by those enabled to act out their fantasies by gun ownership was an aspect of the democratization of violence that was a characteristic of American society, and one that interacted with individualism.

Guns and shooting also played a powerful, frequently iconic and pivotal role in the arts, as in 1980 when the character J.R. Ewing was shot in the television series *Dallas*, and in 1994 with Quentin Tarantino's film *Pulp Fiction*. In practice, the gory detail of wounds was kept hidden from viewers. So too were the accidental deaths in the United States due to the widespread ownership of firearms, and also their responsibility for a high rate of death by suicide, notably among young men, but also among women.

The Architecture of Control

As terrorism and other political threats became a greater threat across the world so there was an emphasis on control. This was particularly seen with airports, which had become a major target of terrorist activity. The hijacking of aircraft, prominent from the 1970s, encouraged another line of defence at airports, that against passengers bringing on to planes material that might aid hijacking or an explosion. X-ray machines and other forms of detection became a key element in the resulting protection systems.

For buildings, the standard pattern of protection became one of blast-proof features, narrow slit-type windows with toughened glass, barbed wire atop walls, outside obstacles in order to prevent any direct or close approach by vehicles and protected compounds. Cameras were seen everywhere. Alarm systems, including night-time motion detectors, were an aspect of the defences.

A CONSERVATIVE DECADE?

With the United States under Reagan (1981–9) and then George H.W. Bush (1989–93), Britain under Thatcher (1979–90), West Germany under Helmut Kohl, and Communism in crisis, the 1980s can appear a conservative decade. So also with the situation in Italy and Japan. In South Korea, trade unions were repressed. The apartheid regime remained in control of South Africa. Yet, reflecting contrasting circumstances and ideologies, the conservative turn could mean different things, as any comparison of the Reagan and Kohl governments will reveal. Moreover, François Mitterrand, president of France from 1981 to 1995, was the first Socialist to hold that office under the Fifth Republic. Left-wing governments, moreover, continued to govern in parts of the Third World, although not in the populous states of Indonesia and India.

However, the idea of a generation is a helpful one, not least because it captures the combination of time and space. There are many potential generational groups, mostly defined in terms of decades. Thus, the 1950s, a decade of attempted stability in response to World War II and the Cold War, the 1960s, and the 1980s; but not, generally, the 1940s and the 1970s. At the same time, as already indicated with the 1960s and, more particularly, the 68ers, this concept faces difficulties.

The nature of conservatism as of reform is repeatedly in question. In the Communist bloc, it could mean both the defence of established

systems and, conversely, the attempt to challenge them using the values enjoyed in the West. That is a crucial point as the most significant year, 1989, saw very different trajectories in China and Eastern Europe, and the broader significance of these differences have to be handled with care. In particular, the weight to be placed on contingency is a factor, and in both cases. The same applies to considerations of how far contrasting developments reflected different political cultures, an argument also employed when discussing the populism of the Islamic revolution in Iran.

The New Right

In the late 1970s, the US experienced economic decline and a series of foreign policy failures, notably the 14-month seizure of American hostages in Iran. Many Americans were dissatisfied with the progressive policies pursued by governments since the 1960s, such as the promotion of minority and women's rights and the legalization of abortion. Various right-wing groups, including conservative evangelical Christians, coalesced to form the New Right movement. With New Right support, Ronald Reagan won the presidency in 1980. Reagan lowered taxes, reduced the role of government, promoted business interests and expanded the military.

The Unipower, 1990–9

The end of the Cold War was followed by the collapse of the Soviet Union in 1991. The United States dominated the subsequent decade both politically and economically. It encountered criticism and opposition, but American power was such that it was increasingly termed a unipower and not a superpower, a status it had had to share during the Cold War with the Soviet Union.

THE FATE OF THE SOVIET UNION

While separatist nationalisms developed, there was no protracted attempt to use the extensive military resources of the central state to prevent the collapse of the Soviet Union which Gorbachev sought to preserve, if necessary only as a loose confederation. When the republics declared their independence, Gorbachev supported the attempt to maintain the authority of the Soviet Union. Nationalism, meanwhile, developed in a new direction when Boris Yeltsin in 1990 launched a Russian nationalist movement against the remaining Soviet structures. Hard-line Communists mounted an unsuccessful coup in Moscow in August 1991, and, in doing so, revealed their lack of popularity and their inability to act as they had done in Prague in 1968. The coup's failure was followed by the rapid unravelling of the Soviet Union as the republics declared independence and Gorbachev was unable to react. In December 1991, the Soviet Union was declared defunct.

The Failure of Totalitarianism

Short-term factors were important to the crises of 1989–91, but long-term factors were also crucial to the fate of Soviet Communism. These pressing factors ranged from grave economic mismanagement to stultifying military expenditure. Totalitarian regimes were command systems that were inherently prone to impose inefficient processes. Moreover, the Soviet Union was another instance of the fall of empires that had been a

major theme of 20th-century history, from the 1910s on. Nevertheless, the rapid collapse, without direct external pressure, of the Soviet bloc would have surprised most commentators as late as the mid-1980s. Many Sovietologists failed to understand the situation, in part because they did not appreciate the limitations of state-controlled systems.

This collapse served as an instance of the unexpected character of history. Other empires did not collapse but crushed opposition in the 1980s and 1990s: India doing so in the Punjab and Kashmir, and China in Beijing and Tibet. In a crisis beginning in 1999 and culminating with independence in 2002, Indonesia withdrew from East Timor in the face of large-scale local opposition and international pressure, notably from Australia, but maintained control of Sumatra and Western New Guinea.

The Former Communist Bloc

Yugoslavia, a federal republic, did not survive the strains of separatism. Slovenia broke free with ease in 1991 to become an independent country, but, thereafter, the situation became far more difficult. The expansionism and ethnic aggression of Serbs and Croats helped cause chaos. The precipitant was the declaration of independence by Croatia, one of the republics, in 1991, and a Serbian insurrection in the Krajina and Slavonia regions of Croatia that saw vicious slaughter and the driving out of large numbers of Croats. A short-term settlement in 1992 was followed by a widening of the conflict to include Bosnia, where a Bosnian Serb army was formed and murdered large numbers of Muslim and Croat civilians. There and elsewhere, large-scale 'ethnic cleansing' was widely used as part of warfare. Western settlements were finally imposed: at the expense of Serbia, in Bosnia in 1995 and in Kosovo in 1999. American air power played a crucial role in each crisis. The Serbs unsuccessfully looked for Russian support, and this lack of a response to countervail NATO reflected the reduction of Russian interventionism in the 1990s.

New Histories

The overthrow of Communist governments led to the presentation of a new history. The sites of imprisonment and

torture under their rule became sites of commemoration and visit, as with the Museum of Terror in Budapest, the Stasi headquarters and jail in Rostock, East Germany, and the Lonsky Street prison in Lviv in western Ukraine.

In former Soviet Central Asia, dictatorships replaced the Communist republics. Meanwhile, in the Caucasus, in 1992–4, newly independent Armenia fought newly independent Azerbaijan in a bitter conflict that tends to be overlooked.

In Afghanistan, the government established by the Soviets did not long survive the departure of their troops. It was overthrown by competing warlords and they in turn lost control of much of the country in 1996 to the Taliban, a fundamentalist Islamic movement.

Central Asian Republics

Following the break-up of the Soviet Union in 1991, eight new nations, situated in the Caucasus and along the Iranian and Chinese frontiers, declared their independence: Armenia, Azerbaijan, Georgia, Kazakhstan, Kyrgyzstan, Tajikistan, Turkmenistan and Uzbekistan. While Armenia and Georgia adopted democratic constitutions and appear to be moving towards Western-style parliamentary democracy, most of these newly independent states quickly fell under the rule of harsh autocratic regimes of varying degrees of corruption and repressiveness.

THE END OF HISTORY?

The success of the Gulf War led in the early 1990s to increasing talk of 'a new world order' and the 'end of history'. These claims rested on the belief that the terminal crisis of the Soviet Union in 1989–91 represented a triumph for American-led democratic capitalism, and that, with America dominant, there would be no future clash of ideologies to destabilize the world. The anchoring of East Asia, notably China, to the dynamic

American economy, and the major rise in American foreign trade from 1993 to 2002, appeared to vindicate this view.

'The End of History', an article published in 1989 in *The National Interest*, a prominent American neoconservative journal, by Francis Fukuyama, Deputy Director of Policy Planning under President George H.W. Bush (r. 1989–93), referred to 'the universalization of Western liberal democracy as the final form of human government'. However, Fukuyama also wrote 'clearly, the vast bulk of the Third World remains very much mired in history, and will be a terrain of conflict for many years to come ... terrorism and wars of national liberation will continue to be an important item.' Indeed, there was, for example, a bloody, albeit ultimately unsuccessful, Islamist insurrection against military rule in Algeria, as well as sectarian conflicts in the Caucasus and the former Yugoslavia.

Fukuyama went on to publish his work in book-length: *The End of History and the Last Man* (1992), by when his argument appeared especially prescient, as well as conducive to American commentators arguing for the importance of American norms and to the need for American action to enforce them. American commentators, indeed, were to the fore in the discussion of international relations in the 1990s, a reflection of the extent to which the use of American power dominated world politics.

The Clash of Civilizations

An article published by Samuel Huntington in 1993 became the basis for his much-cited 1996 book *The Clash of Civilizations and the Remaking of World Order*. Rebutting Fukuyama, Huntington, another American writer, predicted not the triumph of Western values but, rather, the rise of 'challenger civilizations', especially China and Islam which, he argued, would be an aspect of a relative decline of the West. Huntington claimed that the established concept of a global community of nation-states accepting a shared rule of international law and a set of assumptions could no longer work. This approach left the state-building favoured by

Western liberal opinion in a difficult position, but that stance was favoured in the 1990s by Bill Clinton in the US and Tony Blair, British prime minister from 1997 to 2007.

PEACE PROCESSES

In the early 1990s, Israel began engaging in peace negotiations with its Arab neighbours and the PLO. One outcome of this was a peace treaty with Jordan in 1994. Talks with the PLO led to the Oslo Accords, signed in 1993. Under its terms, Israel agreed to a staged withdrawal from the occupied territories. Israel would retain military control there while a newly established Palestinian Authority (PA) would take civil control. By the late 1990s, the peace process had stalled. Islamist groups within the Palestinian community, such as Hamas and Islamic Jihad, opposed any peace with Israel and carried out terrorist attacks against Israel, hardening Israeli attitudes. Israel continued to build Jewish settlements in the occupied territories, further inflaming Arab opinion. In 1998, Israel and Palestine signed another peace agreement, the Wye River Memorandum, which called for Israel to transfer more territory to the Palestinians in exchange for Palestinian curbs on terrorism. But the agreement sparked more Islamist violence, and so Israel refused to cede any more territory.

The Good Friday Agreement

On Good Friday 1998, the Belfast Agreement brought a solution to 'the Troubles' – the conflict between Catholic and Protestant communities that had beset Northern Ireland since 1968. Under the terms of the agreement, Northern Ireland remained part of the United Kingdom but got its own elected parliament, the Republic of Ireland gave up its claim to Northern Ireland, and violent paramilitary groups on both sides of the divide agreed to give up their weapons.

AFRICA

Confidence about a new world order was swiftly dissipated, notably as a result of conflict in Africa and the former Yugoslavia. The unsuccessful UN intervention in Somalia in 1992–4, in which the Americans played a major role, proved a huge humiliation. This deterred the Americans from acting to prevent a genocide in Rwanda in 1994.

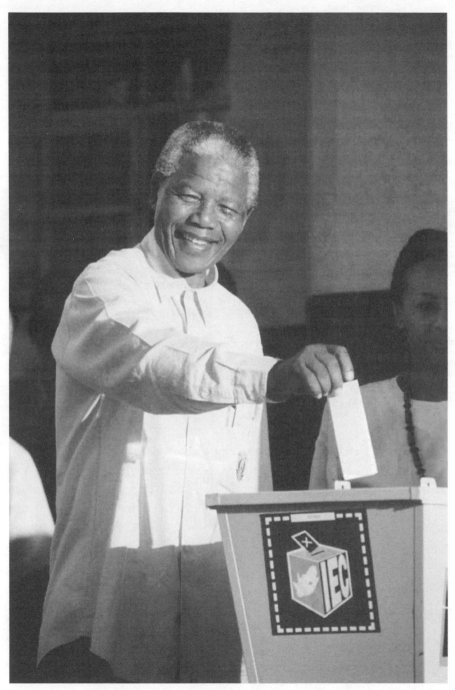

Nelson Mandela casts his vote in 1994 – a powerful affirmation of democratic values in post-apartheid South Africa.

The headline news in Africa was the end of apartheid in the most populous state, South Africa. Without American support, notably as a result of the Anti-Apartheid Act of 1986, the white-minority government felt that change was the only way to avoid disorder. In 1994, democratic elections were held. Nelson Mandela, who had been imprisoned from 1962 to 1990, became South Africa's first black president, from 1994 to 1999, and helped to ease the impact of the experience of apartheid, while his conciliatory tone and policies were important in prevention of disorder.

Nelson Mandela

Elected South Africa's first black head of state in 1994, Nelson Mandela had a long and arduous road to the presidency.

A member of the Thembu royal family, Mandela became a lawyer in Johannesburg where he became involved in African nationalist politics, joining the African National Congress in 1943. When the white-led Nation Party established apartheid, a system of racial segregation advantageous to whites, the ANC committed to the system's overthrow. Rising through the ranks of the ANC, Mandela was arrested repeatedly for sedition. Joining the banned South African Communist Party he became increasingly militant, leading a sabotage campaign against the government. Arrested and imprisoned in 1962, he was sentenced to life imprisonment for conspiring to overthrow the state.

He spent 27 years in prison, and became the focus of anti-apartheid campaigns locally and globally. Fearing a racial civil war, in 1990 President F. W. de Klerk orchestrated Mandela's release. Together, they led efforts to negotiate an end to apartheid, which resulted in the multiracial 1994 general election in which Mandela led the ANC to victory. He served as President from 1994–9 and established a new constitution.

Though a controversial figure for much of his life, Nelson Mandela was hugely respected at home and overseas, winning

the Nobel Peace Prize with de Klerk in 1993. His contribution
to a more democratic South Africa cannot be underestimated.

Also in 1994, however, in Rwanda, an extremist group of Hutus
took over the government, slaughtering probably over a million Tutsi
and moderate Hutus in a butchery launched in April 1994 in order to
prevent power-sharing between the two groups. The genocide revealed
the continued strength of ethnic divisions, as later was also to be seen
in a more sustained fashion in Congo and Sudan. The genocidal regime
was overthrown in July 1994 by the Tutsi-run Rwanda Patriotic Front.
In 1996, it went on to attack Hutu extremists who had taken refuge in
Congo and then, in 1997, as its intervention gathered pace, to overthrow
the ineffective Mobutu government there. Linked to Mobutu's overthrow,
and subsequently, there was a combination in Congo of civil war (1997–
2003), intervention by neighbouring powers, notably Rwanda, Angola,
Chad, Namibia, Uganda and Zimbabwe, and social breakdown, in which
up to 5.4 million died, largely due to disease and starvation. It is a sad
commentary on recent history that many are unaware of this disaster, or
of its scale.

Some other African states had stability and democracy, notably
Botswana, Namibia, Zambia, Tanzania, Kenya and Senegal; but there
was dictatorship in many other states, for example Cameroon and Egypt,
and both civil war and dictatorship in others, including the Central
African Republic, Chad, Sierra Leone, Liberia and Sudan. The end of the
Cold War, however, meant that international intervention by the great
powers was limited.

AMERICAN SUPREMACY

Aliens inevitably attacked the United States in blockbuster films of the
period such as Independence Day (1996). This phenomenon reflected the
dominance of American audiences as well as the sense that only America
was worth such attention and would be able to repel it. Such views were
not only held in America but were also present, explicitly or implicitly,
across the world. The image of America helped ensure that it was a
focus of immigration, such that in 1991–2004 close to 14 million new
immigrants arrived there legally, while about another ten million were

living there illegally. That America was also the focus of envy and hatred was to be demonstrated by the attacks on New York and Washington launched in September 2001 by a virulently anti-American Islamic terrorist organization, Osama bin Laden's al-Qaeda movement.

The Gulf War, 1991

The heavy financial cost of the Iran–Iraq war of 1980–8 and his own zeal for action led the opportunistic Saddam Hussein to conquer oil-rich, but militarily vulnerable, Kuwait in 1990. He ignored international diplomatic pressure orchestrated by the United States to leave and, in 1991, an American-led coalition rapidly defeated the Iraqi forces, with heavy Iraqi casualties, and led to Kuwait being freed. The war displayed the sophistication of American weaponry and the skilful professionalism of the military in its application. Saddam, however, clung to power in Iraq, suppressing a rebellion, while relative Iraqi weakness made neighbouring Iran more powerful and encouraged its ambitions. These factors greatly accentuated the instability of the Middle East, leading to more conflict in the 2000s.

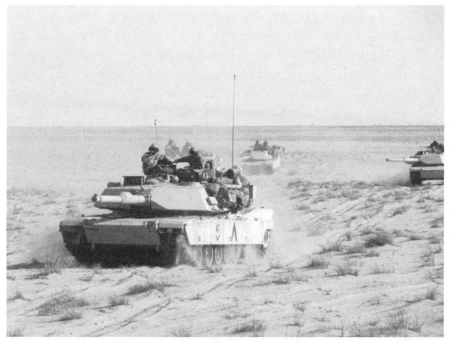

American tanks cross the desert during the Gulf War of 1991.

The Clinton Years

Bill Clinton, the Democratic president from 1993 to 2001, was a brash and bold populist who benefited from economic growth in the United States. Like Johnson, Carter and Al Gore (who won more votes, but not the presidency, against George W. Bush in 2000) he was a Southern Democrat, a group squeezed by the Republican advance in the South that had developed under Nixon. Sound fiscal and economic fundamentals helped ensure sustained growth without inflationary pressures. At the same time problems were built up for the future, not least with over-easy lending contributing to asset bubbles, especially in bank mortgages. Clinton failed in 1994, in the face of the strong conservatism of the political system, to provide universal health insurance. Nevertheless, despite serious personal scandals, he won re-election in 1996.

Race in America

In the United States, as in Brazil, the poor remained disproportionately black. The percentage of black people below the poverty line in the USA was 35.7 in 1983 and 22.5 in 2000 (compared to 8–9 per cent for non-Hispanic whites), while, at the end of the century, black mothers were twice as likely as their white counterparts to give birth to a low-weight baby, their children were twice as likely to die before their first birthday, and black people were disproportionately more numerous in the prison population.

Due to Hispanic and Asian immigration, there were significant population changes. In 1960, whites made up 159 million of the population of 179 million, but by 2000 they were only 211 million of the 281 million. Hispanic immigration was greatly encouraged not only by opportunities in the United States, but also by lawlessness, corruption and limited social mobility in Latin America.

The Development of Neoconservatism

Alongside liberal interventionism, came the development of what was to be known as neoconservatism, an American-led trend. In part, this was an attempt to revive what were presented as the essential elements of the Reagan administration and in part it was reaction against the policies of Clinton. The 'Project for a New American Century', launched in 1997, emphasized the need to 'shape circumstances' and pressed for the preservation and extension of 'an international order friendly to our

security, our prosperity, and our principles'. This prospectus looked toward the policies of President George W. Bush (2001–9), and many 'neocons' served in his government.

OPPOSITION TO AMERICA

An imploding Soviet Union, and its economically weak Russian successor, did not challenge American hegemony. Moreover, many states looked to the USA, for example Turkey under its modernizing prime minister from 1983 to 1989 and president from 1989 to 1993, Turgat Ozäl.

Across much of the world, however, identity and conflict were shaped and expressed in terms of ethnicity, a practice that did not provide opportunities for American leadership. Furthermore, the internationalism that had greatest impact was that of religion, especially Islam, but also Christianity which spread, like Islam, in sub-Saharan Africa.

In many countries, hostility to globalization meant opposition to modernism and modernization, and thus could draw on powerful interests and deep fears. The hostile focus was frequently on the alleged standard bearers of globalization, especially the United States and multinational companies, both financial and economic.

There was also more traditional left-wing opposition to America, as with Hugo Chávez, a pro-Cuban populist military figure who gained power in Venezuela in 1999. Hostile to capitalism, Chávez claimed that immediately before he gained power Venezuela had been weakened by a 'neo-liberalism' that he blamed on the USA.

There was also traditional nationalist opposition. Thus, in 1994, France, then under a right-wing government, passed the *Loi Toubon* (Toubon Law) making it obligatory to use French in the education system and in contracts. This measure was taken against what was seen as an Anglo-Saxon globalized culture. There was nationalist opposition in specific countries from left and right, and these showed the limited character of the popular grounding of globalization and, indeed, cosmopolitanism.

At the same time, one of the major driving forces behind modern Islamism was a hatred of the USA, not least because of its consistent support of Israel. With its vast economic power, America can often persuade Muslim governments to act in its interests, and many perceive it as a latter-day colonial power. Anti-Americanism has been a radicalizing influence on numerous young Muslims because they feel their culture is

under threat from an all-pervasive American culture, conveyed through movies, television, books, food and fashion. They are also offended by 'decadent' Western attitudes to gender roles, sex and alcohol.

US military intervention in Islamic countries was also a cause for concern. In 1993, US troops intervened in Mogadishu in Muslim Somalia, trying to restore order as warring ethnic groups fought for power. Islamists celebrated when the Somali militia defeated American forces. It demonstrated that the United States was not invincible. That same year, an Islamist terrorist, Ramzi Yousef, used a truck bomb to attack the World Trade Center in New York City. The attack killed six and injured over a thousand. Yousef's motivation had been to punish the US for its support of Israel.

Al-Qaeda

The most well-known Islamist organization is al-Qaeda, led by Saudi-born terrorist Osama bin Laden, who rose to prominence in the Afghan War against the Soviet Union. Here he developed a network of Islamic militants, which later evolved into al-Qaeda, an international terrorist organization dedicated to fomenting Islamist revolutions in Muslim countries.

Bin Laden was infuriated by the Saudi government's decision to allow American forces to be based there during the 1991 Gulf War. He therefore moved his operation to Sudan and began to sponsor attacks not just against regimes in Muslim countries, but against US interests in the Middle East and North Africa. In 1995, bin Laden relocated to Afghanistan, where al-Qaeda allied itself with the Taliban. From 1996, al-Qaeda launched increasingly audacious assaults on American targets, starting with a failed attempt to assassinate President Bill Clinton in the Philippines in 1996. In 1998, al-Qaeda simultaneously bombed the US embassies in Tanzania and Kenya, killing 224 and wounding over 4,000.

ASIA: CONFLICT AND DEVELOPMENT

With the majority of the world's population living in Asia, its economic development, albeit occurring at different rates, helped unlock considerable potential. This was especially true of China, although per capita performance there was less impressive than aggregate growth figures. It was the same for India, which did not match the social capital produced in China by its more egalitarian policies. In contrast, poor health and

educational outcomes continued to be the fate of many millions in India, with illiteracy a particular problem. Discriminatory caste practices were a contributory factor. The potential for Asian economies was enhanced by free-market policies in much of the First World, notably the United States. In practice, the latter used cheap Asian labour and the flexibility of Asian economies to maintain its living standards. Moreover, regional growth was not without its weaknesses, and these were seen in 1997–8 in an emerging markets crisis that began in Thailand and spread rapidly, particularly to Indonesia. While most of the Pacific Rim countries became each other's consumers and suppliers in a synergy of economic activity, North Korea was separate to this process due to its isolationist politics, while Laos and Cambodia could not match the development of Vietnam.

Population Changes
Percentage of the world's population living in:

	Asia	USA and Canada	Europe
1950	55	6.7	23.2
1980	58.9	5.7	16.5
1996	59.7	5.1	13.9

China
China's economic development took place in the shadow of American power and benefited from the export market provided by American economic growth. The Communist Party maintained control, but economic liberalization continued. The extent and range of resources, not least of population, was also important, as was a combination of entrepreneurship and social control that the Soviet Union could not match but that ensured a low standard of living that kept labour costs down. In the 1990s, Chinese GNP rose more than sevenfold, increasing incomes and taking large numbers of Chinese out of poverty. However, as earlier with the Soviet Union, the reliability of Chinese government statistics is a matter for debate.

As market reforms, or at least partial market reforms, were increasingly pushed, China became, by 2000, the second largest recipient of international

investment after the USA. America was also an important source of technology, as part of a process in which American companies offshored manufacturing. China's economic links with the USA grew in importance, complexity and political sensitivity. China's quest for resources, notably to support its manufacturing, made it increasingly significant across much of the world. China did not exert itself against American leadership, as it was very much to do in the 2010s. Hong Kong and Macao, longstanding imperial enclaves, were gained peacefully from their rulers: Britain and Portugal respectively, in 1997 and 1999. Nor did China take part in distant conflicts or war with new neighbours. Partly as a result, China's potential as a great power was much underrated. In the 1990s, it did not show the naval build-up that was to be seen from the 2000s.

Japan

In contrast to rapid growth in China, there was declining growth in Japan. No longer a low-wage economy, the structural rigidity of the economy was a problem, as was serious fiscal mismanagement. Government intervention did not prove benign. Moreover, a declining population increased the burden of supporting an ageing society. By the late 1990s, talk of Asian dominance no longer focused on Japan, which had been the subject of the book *The Coming War* (1991), the war in question being with the United States. In practice, Japan was cautious in international terms and reliant on the United States for protection from China and the Soviet Union, and it did not become a major military power.

Asian Conflicts

The 1990s saw both continuing and new conflicts. Withdrawing from Afghanistan, the Soviets had left Mohammad Najibullah in power, but the fall of the Soviet regime meant that there was no more money to pay the army, and in 1992 he was overthrown when the *mujahideen* entered Kabul. However, regional tensions escalated, notably between the non-Pashtun northerners and the Pashtuns of the south. The latter were more ready to adopt radical Islamic policies, particularly those of the Pakistani-backed Taliban movement which, in 1996, overran much of the country, presenting itself as a Pashtun national movement offering Islamic justice and benefiting from the weakness and divisions of the warlords.

Afghanistan was devastated by civil war and poor management. By the end of 1996, over a fifth of the population, over 3.5 million, were refugees in Pakistan, and over a half of the population were unemployed. Water and electricity supplies in Kabul, the capital, had collapsed, and inflation was about 400 per cent. Unable to manage the economy, the Taliban were also socially conservative, for example banning women from working.

Also, in 1996, the People's Liberation Army of Nepal, a Maoist movement, launched the *Janayuddha* (People's War). The insurgents had many women and children among their forces, but were outnumbered by the army and police. However, helped by the mountainous and forested terrain, by Chinese assistance from across the Tibetan border and by their own brutality, the Maoists were able to keep in operation. They benefited from support from low-caste groups and others who felt excluded from opportunity. The Chinese intervened in part in order to weaken Indian influence, which was an aspect of an Asian cold war.

Iraq

The regime in Iraq, under Saddam Hussein, invaded neighbouring Iran in 1980, sparking a bloody eight-year war in which over a million soldiers and civilians died. During the war, Iraq used chemical weapons against Iranians and Iraqi Kurds. In 1990, Iraq occupied Kuwait, but was forcibly driven out the following year by a US-led international force. The West continued to view Saddam as a major threat to political stability in the region, particularly as intelligence reports indicated that he was developing weapons of mass destruction (WMD). In 1998, the US and the UK carried out a bombing campaign called Operation Desert Fox, targeting Iraq's air defence systems, weapon depots and army bases to try and degrade Saddam's ability to manufacture and use WMD.

EUROPE

Two separate processes occurred in the 1990s. In Western Europe, in response to the ambitious Maastricht Agreement of 1992, most of the members of the European Economic Community, which had become the European Union in 1993, chose to adopt a new currency, the Euro, as an aspect of a degree of federal convergence and to aid economic integration. The currency was introduced in 1999, although it proved difficult to cope with different economic fortunes at the national level, and, in particular, the extent to which the economies of southern Europe – Greece, Italy, Portugal and Spain – found it hard to meet the constraints of a system driven by the financial circumstances and requirements of northern European economies, notably that of Germany.

In contrast, in Eastern Europe, there was the dismantling of Communist systems and the attempt to create capitalist and democratic ones. This was easiest for East Germany which was reunited in 1990 with a West Germany that bore the fiscal burden of the new state, including large-scale transfers to invest in social capital in the old East Germany. Elsewhere, the situation was more difficult, with corruption proving a major problem, notably in the disposal of state assets. This was especially so in the Soviet Union, but was also seen across Eastern Europe, particularly in Bulgaria and Romania. A new élite was created accordingly.

Moreover, the exposure of Communist-era economies to international competition proved very difficult. Many manufacturing concerns went bankrupt and unemployment rose. This was more serious because the dismantling of social welfare contributed to increased poverty and social polarization.

The Soviet Union had been a major economy, but its successor states were to prove less than the sum of the former whole. In particular, it proved difficult to establish effective monetary and fiscal mechanisms, while turning to Western ideas on economic and financial policies contributed to a more general crisis in Russian self-confidence. Western loans were necessary in order to prevent a total collapse of Russia in the 1990s; but Russian debt payments caused a severe crisis in 1998, leading to default and devaluation. Corruption was rampant.

In the ex-Communist world, economic disruption and problems affected political stability, although there were also the problems of establishing and bedding down new political and legal systems and

practices. Western investment was anxiously sought. At the individual level, there was considerable emigration, notably from the former East Germany to the former West Germany, although more followed the entry of Eastern European states to the European Union. Moreover, there were abrupt changes in expenditure and appearance. DIY became popular, houses were repainted in bright colours, and a less functional approach to personal appearance was taken. In place of the Trabant, East Germans spent money on West German cars.

The World Economy, 1990–9: Financial and Economic Trends

The central role of the United States in the international financial system was shown in the successful risk management seen in the 1990s, especially in the management of the Mexican financial crisis of 1994–5, the Asian liquidity crisis of 1997–8 and the Russian debt non-payment in 1998. These crises indicated the strains, in the shape of large-scale financial volatility, created by extensive investment, and the major rise in liquidity; but also revealed that the financial architecture of the post-1944 world was stronger than its inter-war predecessor. This strength owed much to the institutions created and sustained from 1944, to the intervening growth in the world economy and to American leadership in the 1990s.

The benefits of economic growth were distributed unevenly between, and in, countries, but they were spread. This was helped by a long-term rise in productivity, which was spurred by innovation and the creation of new areas of demand. At the same time, the balance of economies tipped, with a greater stress on services, in sectors from medical care to retail, and notably so in Europe and North America. Because a smaller percentage of the global population could produce necessities such as food and clothing, more of the workforce was available for other tasks, for example working in healthcare and the leisure industries. In addition, greater average wealth meant that more money was spent on services.

There were also major changes in the distribution of manufacturing. Building on earlier developments in Japan and South Korea, more of East Asia became a key area of production, including coastal China and Vietnam. In contrast, in relative terms, high-wage European producers declined, except in niche areas, such as machine-tools and pharmaceuticals, although, with its accumulated resources, skills and wealth, Europe remained an important economic zone.

In North America, traditional manufacturing declined, in part because tariff reduction helped imports, notably from China. In another light, this was an outsourcing of American manufacturing jobs, a process that owed much to the quest for cheap labour, which was greatly encouraged by Western investment in parts of the Third World, for example Mexico and Vietnam. Furniture manufacture moved to Mexico.

As an aspect of this outsourcing, jobs had already moved from northern American states where labour regulation and trade unions were stronger, and wages higher, to southern counterparts where none of this was true. Thus, car manufacturing declined round Detroit, but expanded in southern states such as Alabama. By 2000, Japanese, South Korean and German models were responsible for nearly half the cars sold in the USA. In Europe, car manufacturing developed in lower-wage societies, such as Slovakia and Spain.

SOCIAL TRENDS

Linked closely to economic developments, income inequalities around the world increased markedly in the 1980s and 1990s. Social contrasts, very much apparent in diet and life-expectancy, were further accentuated by the impoverished institutional networks accessible to the poor: fewer or no banking facilities, poorer schools, less healthcare in most countries, fewer work possibilities, social isolation and discrimination. The poor had fewer opportunities to get into universities, let alone good ones, than their more affluent counterparts; and that at a time when educational attainment had become increasingly important for jobs and income. As a result, the possibility of upward social mobility, through business or

governmental hierarchies, declined – although, across much of the world, the military continued to provide a route. This was particularly so in Latin America and Africa, but the military was also a key economic and political force in other states, including Indonesia and Pakistan.

Income inequality was not only a matter of wages, but also of capital, savings, dividends, interest and rents, which all yielded high returns in the 1980s and 1990s. House purchases and property prices were important agents of social differentiation, both reflecting and sustaining the latter.

Social differentiation foreshadowed later populist pressures, whether in opposition to the impact of globalization on economic developments, the consequences of large-scale de-industrialization in parts of North America and Europe, or through hostility to immigration. In the USA, Ross Perot, an unsuccessful independent presidential candidate in 1992 and 1996, claimed that, as a result of the North American Free-Trade Agreement of 1994 there was a 'giant sucking sound' of jobs moving to Mexico. Although it was to be important in the 2010s, the potency of this argument was reduced by economic growth in the 1990s in the United States and much of the world. Nevertheless, the corrosive effects of money were presented in the arts, as in the 1993 American film *Indecent Proposal*, in which a Las Vegas playboy offers a million dollars for sex with a happily married young woman whose devoted husband wants the money.

Family Structure

Cohabitation and divorce became increasingly common in many societies, although not in Islamic ones. Cohabitation before, and instead of, marriage ensured that more children were born outside marriage. Divorce became more common from the 1960s, so that the percentage of children living without both parents increased. Divorce also led to high rates of second and third marriages, largely replacing the death of women in childbirth as a reason for such marriages.

Partly as a consequence of divorce, the percentage of households that were occupied by the 'nuclear family' – two parents and their children – fell, and notably so in North America and Europe. This was a fundamental social shift, not least because of changes in resulting assumptions about what constituted normal behaviour, or the mismatch between conventional assumptions and current reality.

Rising divorce figures challenged established conventions, notably male norms about family structure, and led to an increasing number of families headed by women who were not widowed. This helped to ensure that the position of these women played a greater role in debates about social issues, and were to feature in literature and the media, as with the positive portrayal of Mrs Gump in the successful film *Forrest Gump* (1994). These women could no longer be treated as an adjunct of their husbands.

A very different treatment of women was seen in the large-scale and growing imbalance between male and female children in East and South Asia, due to selective abortion and infanticide, notably in India and Pakistan, and the abandonment of female babies, often for adoption outside Asia, particularly Chinese girls by Americans. In turn, in China, poor rural girls were kidnapped to provide wives, while women were also procured from neighbouring Laos, a much poorer society.

Religious Trends

Changing attitudes to divorce were an aspect of a more general pressure on established norms that drew on religious sanctions. Religion itself is one of the aspects of the century that tends to receive inadequate recognition in general histories. In practice, the rise in the world's population ensured that there have never been as many religiously observant people as in the 20th century, just as there have been as many irreligious people. Christianity became less obvious a theme in European life, but remained strong in the Americas, in sub-Saharan Africa and in the Pacific. Although bloodily divided, Islam also continued to be powerful. However, in China, the state succeeded in suppressing most religious activity.

Religion overlapped with other attempts to find meaning. In her song *I Feel Lucky* from the album *Come On Come On* (1992), Mary Chapin Carpenter, an American singer, referred to turning to the newspaper for 'my daily dose of destiny', the horoscope.

Christianity did not collapse in Western Europe. It declined, but there were still many committed believers. However, for both believers and for the less or non-religious, faith became less important. Permissive 'social legislation' flew in the face of Church teachings and left the churches confused and apparently lacking in 'relevance'. There were political battles over divorce, contraception, homosexuality and abortion, as the influence of the Catholic Church was contested.

Intelligent Design

In the United States, politics and religion were difficult to keep apart. The teaching of creationism (the Biblical account of creation) was an issue of dispute, with the Supreme Court determining in 1987 that teaching creationism in the science classes of state schools was an unconstitutional erosion of the boundaries between church and state. This decision encouraged the formulation of the thesis of intelligent design, which argued that an intelligent being shaped the origins of life. This was a form of creationism that did not mention God and that was seen as the form most likely to survive legal challenge. The struggle went back and forth, with public debate and the democratic mandate playing a role alongside judicial decision. In 1999, for example, the Kansas Board of Education decided that creationism should be taught alongside evolution, although the guidelines were repealed in 2001.

Changing Fashions

Developing gender imaginings and roles fed into lifestyle choices, in matters such as clothes, hairstyles and food. Vegetarianism became more common in the West, particularly among women, and was followed by veganism. There were related changes in other consumer products, with a rise of toiletries and products linked to aromatherapy, while decaffeinated hot drinks became more popular, and the range of teas, coffees, soft drinks and bottled water all spread. There were also changes in the popularity of alcoholic drinks as younger customers and women became more prominent. The relative popularity of whisky, brandy, port and sherry declined, while that of gin and vodka increased. Sales of red wine and stout beer declined, while those of white wine and lager increased.

Pets

A major group in the human-dominated world, pets in the early decades of the century were essentially aspects of a largely rural utilitarian world

in which dogs helped with hunting while cats battled rats and mice, and thus preserved food stores. In these terms, pets became less important as the world's population increasingly urbanized.

In turn, the pet industry became particularly apparent in areas of affluence, notably in the United States. A trend from dogs to cats reflected the growing percentage of Americans living in small dwellings, as well as the decreased ability or willingness to take dogs for walks, which, in part, was a consequence of other leisure options, such as the cult of the gym, as well as pressure on leisure time. The greater independent role of women as consumers also played a role in pet choices.

The Age of Obesity

Even many pets in the West faced the challenge of obesity, which became more apparent for humans in most parts of the world, despite the continued challenge of famine. A reflection of a range of factors, including diet, notably the rising consumption of saturated fat and cholesterol, a lack of exercise, and poverty (the urban poor have fewer opportunities for exercise), obesity was linked to the marked rise in diabetes and to problems with mobility and joint abnormalities. Consumer products, such as cars, were altered in order to accommodate larger average sizes. The seats on Chicago buses were changed from 42.5 cm (16.75 in) wide, to 43.1 cm (17 in) in 1975 and 44.5 cm (17.5 in) in 2005. Other countries followed suit.

Changing Death Patterns

Whereas infections were a major cause of death, they have been increasingly supplanted by later-onset conditions, especially heart disease and cancers. In 1999, circulatory disease, including heart disease, was responsible for 30 per cent of American deaths, and cancers for 23 per cent. This pattern was increasingly more common around the world.

The Rise of the Retirees

Across the world, increased life expectancy led to a greater percentage of old people in the population. There was less of a rise in the dependency ratio than might have been expected because working life was extended due to the increase in service sector employment and thanks to medical advances. In the Third World and in some prosperous societies, such as Japan, extended families continued to be important and to provide care for the elderly.

In others, such as the United States, retirement communities were a practical consequence of the breakdown of extended families that reflected the geographical mobility in old and young alike. This tendency added to the role of lifestyle enclaves, in which people of the same class tend to live in similar neighbourhoods, shop at the same stores and eat at the same restaurants.

Rising life expectancy, and the resulting demand for support, contributed to the expansion of the service component of employment and to pressure on the public provision of social welfare, notably healthcare. In contrast, there was less of a willingness to increase expenditure on education.

Gated Communities

By the mid-1990s, about 2.5 million American families lived in gated communities. Initially, these were private streets and fenced compounds for the affluent, notably on the East Coast and in Hollywood. From the late 1960s, the practice spread, first to retirement developments, subsequently to resorts, and then to suburban tracts. Similar patterns were seen in other countries, for example South Africa. Gated communities were another aspect of rising gun ownership in the United States, and security considerations were mentioned in advertisements for house sales and renting.

Continued Slavery

> *Almost one million bonded labourers in 4,000 brick kilns across the country... Physical and sexual abuse, especially of children, was common.*
> Human Rights Commission of Pakistan, 2006.

Slavery continued and 'human trafficking' took on new forms, notably for prostitution and cheap labour. Modern estimates are of 20–30 million slaves worldwide, but there are issues of definition. Racism continues to be a factor, notably in Mauritania and Sudan with blacks enslaved by lighter-skinned Muslims. In Mauritania, this continues despite slavery being abolished by the French colonial rulers, and again in the independence constitution of 1960, and in 1980 and 2008.

Cinema

In *Independence Day* (1996), the potent aliens destroy all they can, beginning in Los Angeles with those gathered to welcome them, and stop only when they are in turn destroyed. The leading global film centre remained nearby Hollywood, because India's challenger, Mumbai's Bollywood, found it difficult to win foreign markets, as did the growing Chinese film industry. *Mars Attacks* (1997), the brilliant skit on *Independence Day*, was also American-made.

Hollywood's share of the world market remained strong. Indeed, as an instance of soft power, the world-wide production and distribution interests of the American film industry became more important in the 1990s; although this was a part of a global industry in which, as an aspect of the flow of capital, crucial American icons were bought by foreign companies. In 1985 the Australian Rupert Murdoch acquired Twentieth Century Fox; in 1989–90, the Japanese electronic conglomerates Sony and Matsushita took over Columbia Pictures and MCA/Universal respectively.

The impact of Hollywood increased as film was brought more easily to the television screen, first with video cassettes and then, from 1997, with DVDs. A different form of impact was created by the very popular Disney theme parks: Anaheim (1955) and Orlando (1971) in the USA, and Tokyo (1983), Paris (1992) and Hong Kong (2005).

Unlike in authoritarian countries, where the media were closely controlled, cinema elsewhere offered a variety of tones. Alongside the comedies, with their general theme of a benign order made awry by misunderstanding, there were challenges to the system, as in the feminist *Thelma and Louise* (1991), and adventure films in which the hero faces dishonest hierarchies or colleagues, as in the hugely successful *Mission: Impossible* (1996) and its sequels. Computer animation transformed film-making, especially cartoons, and the American company Pixar was at the centre of this.

ENVIRONMENTAL CONCERNS

The pace of climate change accelerated toward the close of the century. The rate at which Arctic sea ice receded is dramatic. In 1980, it covered 7.9 million sq km (3 million sq miles) at its summer minimum, but by 2000 only 6.4 million sq km (2.47 million sq miles), and with thinner ice.

Global temperature change was greater in the Arctic than elsewhere in the world. Whereas in 1900–30, the temperature on average was less than the 1850–1900 average, but by less than 0.25° centigrade, the situation from 1940–1980 was of an average closer to 0.25° centigrade more; and thereafter the trend was upwards.

The burning of fossil fuels was the key element. In 1900, it produced about 2 billion tonnes of carbon dioxide, in 1950 about 5 billion, and by 2000 about 24 billion. The carbon dioxide level, in parts per million, rose from 320 in 1965 to 360 in 1995. There were also profound regional variations. European CO_2 emissions declined in the 1990s, in response to pollution-control measures and deindustrialization, while those in Africa remained very modest, but that of both the United States and, later, China grew greatly over the century.

Concern about global warming resulted in 1992 in the Earth Summit in Rio de Janeiro which accepted the Framework Convention on Climate Change. This, in turn, led in 1997 to the Kyoto Protocol, under which the major industrial countries agreed to reduce, by 2008–12, their emissions of the greenhouse gases held responsible for global warming to an average of about five per cent below their level in 1990.

However, there were major differences over the way to distribute reductions. Among the prime polluters were newly industrializing countries burning more fossil fuels than in the past, especially China and India, which felt that they should bear a much lighter burden than those countries in Europe and North America that had already industrialized.

As the Arctic ice receded, the prospect of sea passages to the north of Canada and Russia opened up. Climate change was also particularly apparent in areas of desertification, such as the Sahel belt to the south of the Sahara Desert, in China south of the Gobi Desert, and in Kazakhstan and Uzbekistan round the rapidly shrinking and heavily polluted Aral Sea, which by 1991 was ten per cent of its original size. The movement of climate zones was an aspect of what became an environmental crisis, with major consequences in terms of social strife and violence, notably between herdsmen and farmers, as in northern Nigeria and Sudan.

Pressure on water supplies was a major issue around much of the world, with increased extraction from rivers, such as the Colorado, Euphrates, Mekong, Nile and Tigris leading to disputes. Moreover, rising consumption of water also led to the depletion of natural aquifers and to the movement of salt to the surface, which greatly affected soil quality,

for example in California. The 1999 Global Environment Outlook report of the UN Environment Programme discussed the possibility of 'water wars' in Asia in the first quarter of the coming century. Water shortages may also accelerate large-scale population movements. Other instances of the interaction of crises occurred with rice production, as in the Mekong delta, the centre of Vietnamese production and export. Dam construction upstream has interacted with salt water intrusion into the delta and global warming has harmed yields.

Water crises were in part addressed by supply-side solutions, notably dam construction and related water transfer schemes, but these created problems. Los Angeles, a city built in the middle of a desert, with a population of 100,000 in 1900 and 3.7 million in 2000, symbolized the determination to locate human activity wherever it desired and to move resources accordingly. The major role of water in local political culture, and the bitter struggles to control its supply, had an echo in the arts, most powerfully with Roman Polanski's 1974 film *Chinatown*, which covered the role of crime in the development of Los Angeles' water system.

The Perils of Development

In his novel *La forma dell' acqua* (*The Shape of Water*, 1994), the Sicilian novelist Andrea Camilleri provided a bleak account of 'the ruins of a large chemical works inaugurated... when it seemed the magnificent winds of progress were blowing strong... leaving a shambles of compensation benefits and unemployment.'

CHAPTER 10

Conclusions

From the perspective of the present, much about the 1990s appears very familiar, but there are also major differences. In terms of the familiar, there is environmental anxiety and degradation. Concerns raised from the 1960s now appear increasingly prescient. In 1999, the arrival of the West Nile virus close to the major international airports in New York led to the aerial spraying of the city, a dystopian scene reminiscent of disaster movies that was a vivid demonstration of vulnerability, but also of the readiness to act. Nevertheless, although concerns were increasingly pressed, the pace of change by 2020 would have surprised most commentators in 1990, and certainly in so far as the retreat of the Arctic ice was concerned.

THE AMERICAN CENTURY?

Major political differences are also apparent between 1999 and the present. Whereas the 20th century was clearly the American century, a process culminating in the end of the Cold War and America as the unipower of the 1990s, this position was challenged thereafter by Chinese growth, the Chinese–Russian alignment and grave problems for the United States in the Islamic world. The 'Make America Great Again' slogan of Donald Trump in his 2016 presidential campaign was misleading in some respects, but it also captured a sense among many Americans of relative decline, if not failure, compared to the situation in the second half of the 20th century.

This sense looked back to an age of American greatness that in reality had always been more conditional than is appreciated in hindsight. In the 1950s, this greatness was overcast by fear of Communism, in the 1960s by ethnic strain, social division and failure in Vietnam, in the 1970s by serious economic difficulties, in the 1980s by the downside of Reaganite growth, and in the 1990s by political division and the social problems sharpened by the issue of healthcare. At the same time, the relative position of the United States was certainly stronger in the 1990s than today. Moreover, although

the Cold War had shadowed America's position from 1945 to 1990, there had been scant doubt in that period that America was the leader of the non-Communist world, nor that China was a far weaker economic power than the United States. The Cold War was also perceived in the United States as ending with American victory, a verdict driven home by the result of the Iraq War in 1991.

Moreover, American influence appeared dominant in the cultural sphere, with Hollywood joined by the written, visual and verbal aspects of the Internet. In addition, American influence helped ensure that English remained the world's leading language, and, indeed, became more so.

AN UNPREDICTABLE AGE

Looking back on the 20th century therefore is a matter of capturing an age that has seen similarities and differences, and with the temptation being to draw clear trend lines both during the century and to the present. That temptation, however, looks much less reasonable if the perspective is looking forward into uncertainty, whether from 1914, 1919, 1930, 1939, 1945, 1975 or even 1983. Indeed, in reaction to the confidence of his age in prediction, Henri Poincaré (1854–1912), a noted French mathematician, emphasized the role of 'nonlinearities', the small events or effects that had significant consequences, and argued that they put major limits on forecasting. Poincaré argued that the error rate in prediction grows very rapidly with time, and that this means that near-precision is not possible because this error rate ensures that the past has to be understood with infinite precision.

DISEASE AND POPULATION

The rise in population was a tornado for the world's environment, notably consuming far more energy, but the cause was certainly more than a butterfly's wings flapping. A key element in population growth was the reduction in the impact of many diseases, notably cholera, yellow fever and plague, the successful battle against tuberculosis and polio and the ability to make former killers, such as (very differently) diarrhoea and malaria generally survivable. With major variations by disease, place and time, this process was due to scientific advances in understanding, pharmaceutical successes in remedies, triumphs in public health, notably in water supply, the diffusion of best practice and, to a degree, acquired resistance, even immunity, as far as humans and host animals were concerned.

At the same time, as a reminder of the variations in the world, throughout the century there were major contrasts in death rates between, and within, countries. These contrasts reflected social circumstances, including nourishment and housing density, and infrastructure, notably access to clean water and sewage systems. Africa came off worse throughout the century, but the situation of the numerous poor in India remained dire.

Variations in family limitation programmes had a similar effect. Indeed, the significance of population growth was such that China's one-child policy was one of the more important episodes of the century's history. Established in 1979 and bringing the two-child policy introduced in 1970 to a close, the one-child policy lasted until 2015, although it was adapted in the 1980s to permit rural parents, a very numerous group, to have two children if the first was a daughter, a concession to peasant views and needs. Incentives, restraints and punishments, including large-scale sterilization, were applied accordingly. The claim by the Chinese government that 400 million births were prevented as a result of its policies has been queried, but it may indeed have been an even higher figure. Whatever the figure, the marked decline in the fertility rate affected China's age structure, gender balance (more boys were born) and overall population, and led to India moving ahead in population growth.

KEY CHANGES

Futurologists unsurprisingly and frequently proved wayward in their predictions, as the pace of change accelerated and its nature expanded. It is easiest, when assessing futurology, to comment on technological change and its implications, which transfixed contemporaries, notably with powered manned flight, and later manned flight to the Moon. Nevertheless, to many, the changing relationships of men and women, or of the generations, would have appeared more remarkable still. The decline of deference, the rise of choice and the individualism of social norms were all strikingly different to prior attitudes, and none was limited only to élite groups.

Yet, there have also been major variations between societies, not least in terms of choice and individualism, because authoritarian states and practices have proved more resilient than might have been anticipated. If the 1970s saw the fall of autocracies in Greece, Portugal and Spain, they saw new ones seize power in Chile and Iran. If the Communist Party lost control of the Soviet bloc in 1989–91, it remained dominant in China. Indeed, as revealed in this book, this has been a century of

multiple uncertainties and many possible paths. This underlines the importance and fascination of the 20th century, one that richly repays attention as the background to the century of the now, and its different identities and ideologies.

Index